Renaissance & Mannerism

Renaissance & Mannerism

Diane Bodart

Renaissance & Mannerism

STERLING

New York / London
www.sterlingpublishing.com

Translated from the Italian by Patrick McKeown

STERLING and the distinctive Sterling logo are registered
trademarks of Sterling Publishing Co., Inc.

Library of Congress Cataloging-in-Publication Data

Bodart, Diane.
 [Rinascimento e manierismo. English]
 Renaissance & Mannerism / Diane Bodart.
 p. cm.
 Includes bibliographical references and index.
 ISBN 978-1-4027-5922-2
 1. Art, Renaissance. 2. Mannerism (Art) I. Title. II. Title: Renaissance and Mannerism.
 N6370.B5813 2008
 709.02'4--dc22

 2008018511

10 9 8 7 6 5 4 3 2 1

Originally published as *Rinascimento e Manierismo* by Giunti Editore, S.p.A.
© 2005 Giunti Editore S.p.A., Florence-Milan, Italy
www.giunti.it

Printed by Giunti Industrie Grafiche S.p.A., Prato, Italy
English edition published by Sterling Publishing Co., Inc.
387 Park Avenue South, New York, NY 10016
© 2008 by Sterling Publishing Co., Inc.
Distributed in Canada by Sterling Publishing
c/o Canadian Manda Group, 165 Dufferin Street
Toronto, Ontario, Canada M6K 3H6
Distributed in the United Kingdom by GMC Distribution Services
Castle Place, 166 High Street, Lewes, East Sussex, England BN7 1XU
Distributed in Australia by Capricorn Link (Australia) Pty. Ltd.
P.O. Box 704, Windsor, NSW 2756, Australia

Printed in China
All rights reserved

Sterling ISBN 978-1-4027-5922-2

For information about custom editions, special sales, premium and
corporate purchases, please contact Sterling Special Sales
Department at 800-805-5489 or specialsales@sterlingpublishing.com.

For the Italian edition
Project manager, Gloria Fossi; graphics for the series and cover, Lorenzo Pacini; layout, Los Tudio, Firenze;
iconographical research, Claudia Hendel; indexes and revision, Francesca Bianchi.

Photographs
© Archivio Giunti, Florence; Archivi Alinari, Florence; Cameraphoto, Venice; Corbis;
Maria Brunori, Florence; Araldo De Luca, Rome; Nicola Grifoni, Florence; Foto Vasari, Rome; Erich
Lessing/Contrasto, Milan; Rabatti & Domingie Photography, Florence; Giovanni Rinaldi, Rome; Scala,
Florence; The Bridgeman Art Library/Alinari, Florence.
Works from National Galleries and Museums have been reproduced with permission from the *Ministero per
i Beni e le Attività Culturali.*
The original publisher Giunti made every effort to locate the owners of images used in this publication.

The Renaissance

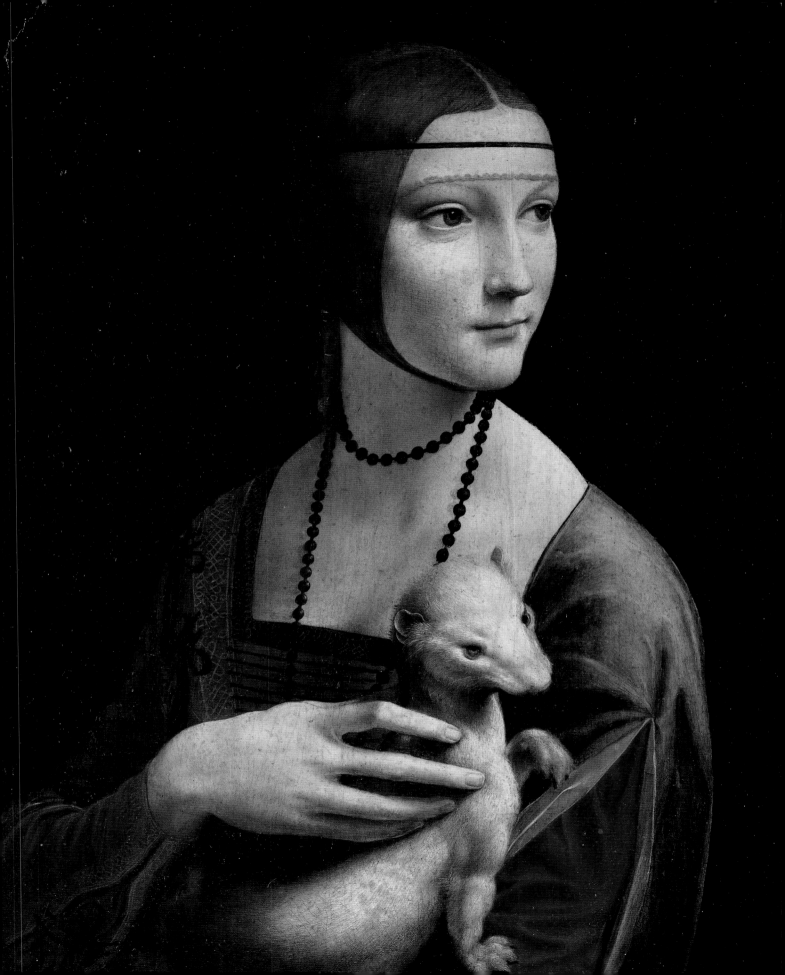

Previous page:
Leonardo da Vinci
*Lady With an Ermine
(Portrait of Cecilia
Gallerani)* detail
1488–90, oil on
wood panel.
Krakow, Czartoryski
Museum.

Andrea del Castagno
The Last Supper, detail
c. 1447, fresco.
Florence, Museo del
cenacolo di
Sant'Apollonia.

The Renaissance:
A Cultural Project

In 1553, French naturalist and antiquarian Pierre Belon was already referring to the felicitous and much hoped for renaissance that could be seen in "every kind of good discipline" as a veritable springtime after a long winter of darkness, oblivion, and ignorance. Three decades earlier, Albrecht Dürer had spoken of *Wiedererwachsung* (or "rebirth") in the art of painting, which had been buried for centuries. Dürer attributed this rediscovery of painting to the Italians. In 1550, writing in his *Lives of the Artists*, the Tuscan Giorgio Vasari defined the "rebirth" in architecture, sculpture, and painting as "progress" that spanned "three ages." Begun under Cimabue and Giotto, the re-birth progressively shrugged off the mistakes made during the previous periods of the "Gothic," "Barbarian," and "Greek" manners until it reached the peak of perfection that was the "modern manner," embodied in Michelangelo. And that was how

the Renaissance thought of itself. It was one of the rare historical periods that was indeed the fruit of its own time, rather than the product of some historiographic sleight of hand, after the fact. The driving force propelling the idea of rebirth was the return to the model of perfection represented by antiquity, which had been forgotten, and indeed destroyed, in the interviening fallow periods.

In conceiving of its own present in terms of new life, light, and truth, the Renaissance gave itself a cyclical past. The period identified the Classical Age as an exemplary epoch to which it applied the collective label of "antiquitas" or "venerable antiquity" and positioned itself as a clear break from the invented negative image of the Middle Ages (in neo-Latin called *media aetas* or *medium aevum*).

Taken as a historical period, the term *Renaissance* may be misleading because, far from corresponding to a general resurgence in politics, society, and the economy (which in many respects were going through a period of

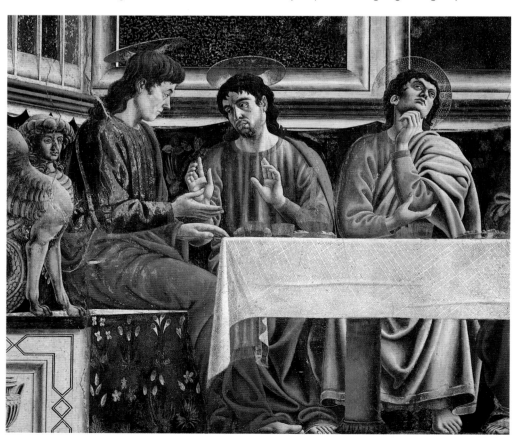

Benedetto da Maiano
Bust of Giotto
1490, marble.
Florence, Cathedral.

upheaval and decline), the Renaissance was essentially a cultural phenomenon.

Such developments were all the more noteworthy, given their deliberate nature. The Renaissance began as a veritable project for renewal in fourteenth-century Italy. Petrarch was the first to evoke the grandeur of antiquity as a model to redeem the mediocrity of his age, while hoping for the advent of a new era that would be able to dissipate the darkness and make it possible to return to the "sheer splendor of the past." Boccaccio acknowledged Petrarch as the initiator of this process, after the poet had ensconced Apollo in his former sanctuary once again and reclad the Muses in their ancient beauty. Following the principle formulated by Horace, *ut pictura poesis* ("as in painting, so in poetry"), he also applied the notion of rebirth to the art of painting.

Having been obscured by ignorance for many centuries, the art of painting had regained public prominence thanks to the extraordinary talent of Giotto. Already praised by Dante as an innovator, Giotto had been capable not only of painting nature "similar to the same," but his works were so lifelike as to appear real (Boccaccio). The idea was further developed and honed. Around 1381–82, writing in his *De origine civitatis Florentiae et eiusdem famosis civibus* ("The origins of the city of Florence and the chronicles of its famous citizens"), the Florentine Filippo Villani included for the first time among the ranks of the city's illustrious citizens painters who had the merit of restoring painting's former dignity and fame. In Cimabue he saw Giotto's precursor.

While it was true that the principle of renewal was applied in the same way to both poetry and painting, the reference models for the two arts were inevitably different. Painting had nothing equivalent to the revered classical texts, rediscovered and studied by the humanists, which were the driving force behind the resurgence in literature, while no ancient work

on painting was known at the time. The model of nature was used in lieu of classical examples, all the better if interpreted jointly with the famous, and lost, paintings of antiquity recorded in the sources. Indeed, in their praise of the degree of verisimilitude achieved by the painters of their time, the humanists were inspired by the ancient criteria of perfection that appraised painting in terms of a faithfulness to real life that bordered on illusionism.

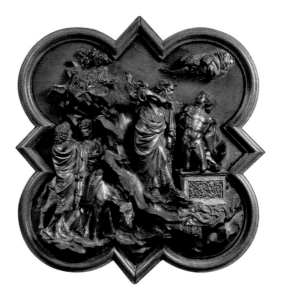

Florentine Foundations for the Rebirth of the Arts

If the idea of rebirth had been associated with painting from the fourteenth century onwards, the artistic Renaissance really saw the light in the early decades of the fifteenth century. It was at this time that the model of antiquity was intentionally used as a vector for renewal, although not of painting but of architecture and sculpture, through study of the

Lorenzo Ghiberti
The Sacrifice of Isaac
1402, gilded bronze.
Florence, Bargello.

Paolo Uccello (attr.)
Five Masters of the Florentine Renaissance or Fathers of Perspective
c. 1450 (?), tempera on wood panel.
Paris, Louvre.

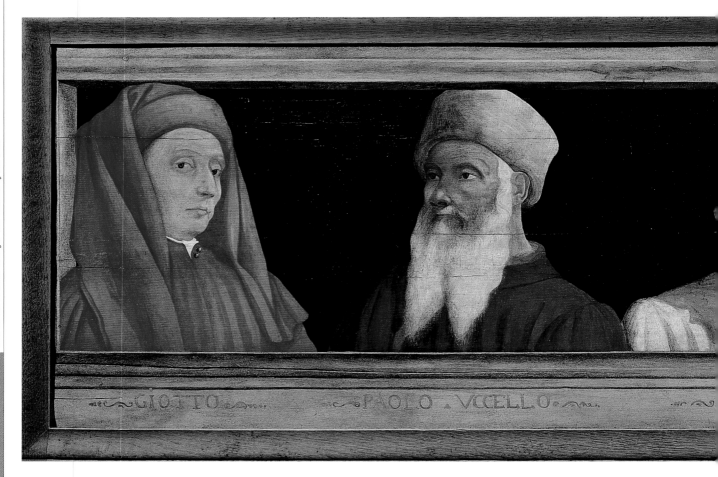

GIOTTO · PAOLO · VCCELLO

remains of ancient Rome. Brunelleschi is praised by his biographer, Antonio Manetti, for having rediscovered "this way of building known as the Roman or antique style," while Cristoforo Landino dubs Donatello as "the great imitator of the ancients." Landino reserves his highest praise for Massaccio, whom he qualifies as "the most excellent imitator of the ancients." The nature of Florence's relationship with antiquity took shape amid the rivalries and critical debates that informed the construction work and sculpture commissions for the baptistery, cathedral, and church of Orsanmichele. Ghiberti won the competition to design the north door of the baptistery in 1402, and in his view works from antiquity offered a model to be assimilated into tradition. Two decades later, Brunelleschi won the commission to build the dome of Santa Maria del Fiore and he sought as the structural secret underpinning the greatness of buildings from antiquity in terms of order, measure, and symmetry. Brunelleschi's innovative stance and his technical achievements contributed to the growing

Filippo Brunelleschi
The Sacrifice of Isaac
1402, gilded bronze.
Florence, Bargello.

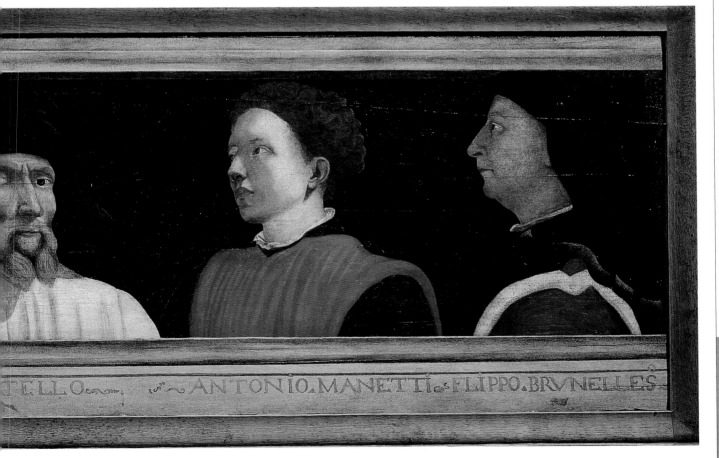

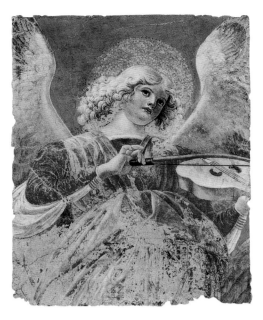

12

Andrea della Robbia
Foundling in Swaddling Clothes
1487, glazed terracotta. Florence, Portico of the Hospital of the Innocents.

Melozzo da Forlì
Angel Musician
1478–80, fresco fragment. Vatican City, Pinacoteca Vaticana.

Pier Jacopo Alari Bonacolsi called **L'Antico**
Venus
late fifteenth century, partially gilded bronze. Vienna, Kunsthistorisches Museum.

architectural and sculptural motifs while giving new life to iconographic themes from the past, known from surviving works or literary sources. Painting restored the classical allure to these works, and in the same way, renewed its former partnership with poetry.

In the meantime, the dichotomy between the ancient and natural models that had marked the early years of rebirth had been transformed into a dialectical relationship that was fundamental to the Renaissance concept of art, a concept that sought to embrace both the exact, thus "true," representation of nature and the quest for beauty, exemplified by classical perfection. Moreover, the new scientific and poetic foundations shared by architecture, sculpture, and painting paved the way for the disciplines to be defined as the "sister arts," as well as vindicating their claim to equal dignity as intellectual activities, a clear break from their traditional association with the "mechanical arts," or work of the craftsman. The growth in the number of texts written by artists, the increased frequency with which artists signed their work, as well as the number of self-portraits produced, all bear witness to this understanding of their rise in society.

awareness that a real artistic revolution was under way. The principles and tools of this revolution would soon be theorized, especially by architect and theoretician Leon Battista Alberti. Far from being merely copied, the classical example was analyzed and interpreted in the attempt to (re)found an artistic concept of universal scope. The central criterion of this art form would be *concinnitas*, that is, the harmony obtained from the regular correspondence between the different parts and between the parts and the whole, which could be traced back to the exact, mathematical measurements derived from perfect human proportions. In order to apply this notion to the field of representation, a geometrical tool was invented. Linear perspective made it possible to bring proper order and clear articulation to any composition, defining in a scientific manner the diminishing proportions of figures in relation to distance, and thus to project with precision how the various bodies stood out from the flat surface. This rationalization of the artistic process embraced at one and the same time architecture, sculpture, and painting, and it is hardly surprising that Leon Battista Alberti set out the rules for linear perspective in his treatise *De pictura* ("*On painting*"), or that he dedicated the 1436 vernacular edition of his work to Brunelleschi. Despite its ties to the natural model, painting was an integral part of this reborn art, and over the next century it would assimilate the explicit references to antiquity, appropriating formal

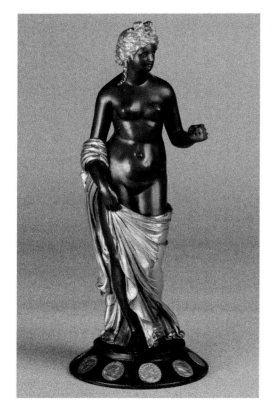

The new approach to art that arose in the Renaissance would eventually lead to the modern notions of "work of art" and "work of the intellect."

Differences and Diversity in Figurative Languages

The overriding emphasis on Tuscany's role in "the progress of rebirth" that can be ascribed to Vasari, who wrote his *Lives of the Most Excellent Architects, Painters, and Sculptors* in defense of the primacy of Florentine art, is certainly biased but not without foundation. By the time the two editions of Vasari's biographies were published (in 1550 and 1568, respectively), the artistic principles that had been elaborated in Florence around 1420–30 had been adopted across Italy, and during the sixteenth century had begun their march across Europe. In other words, those principles had become common currency. While it is true that the rational Florentine model was the keystone of Renaissance art, it was not the only element involved; other figurative languages played a part in its final configuration. Unlike Vasari's doctrinaire sixteenth century, Italy in the

fifteenth century had openly embraced a plurality of artistic languages. The quest for the exact representation of the natural model, which in Florence had been tied to the legacy of antiquity, was the hallmark of much of the figurative arts across Europe in the fifteenth century. By the turn of the century, the international Gothic style that held sway throughout the courts of Europe as far as Bohemia had already begun to incorporate impressive analytical depictions of plants and animals into the style's elegant linear formality, the material refinement of the colors used, and the sumptuous backdrops in gold. The attention paid to nature was usually limited to the representation of an occasional episode, rather than involving the whole composition, which was, instead, achieved through the application of a number of stylized layers. In Italy, this refined courtly style first arose towards the end of the fourteenth century in Lombardy and Veneto (regions of Italy) and became especially popular towards the mid-fifteenth century, in particular as a result of the works of Gentile da Fabriano and Pisanello.

The use of the natural model as the underlying principle of representation took hold not only in Florence in the decade 1420–30 but also in the

Tullio Lombardo
Bacchus and Ariadne
late fifteenth–early sixteenth centuries, marble.
Vienna, Kunsthistorisches Museum.

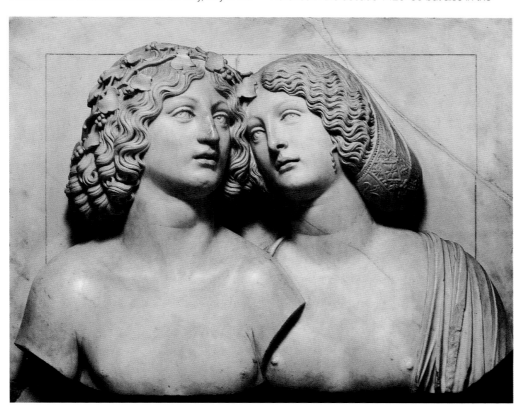

Above:
Stephan Lochner
Madonna of the Rose Bush
c. 1450, oil on wood panel.
Cologne, Wallraf-Richarts Museum.

Right:
Master of Flémalle (Robert Campin?)
Saint Joseph in His Workshop
detail from the Merode Altarpiece, pre-1427, oil on wood panel.
New York, Metropolitan Museum.

Far right, top:
Rogier van der Weyden
Saint Luke Drawing a Portrait of the Virgin Mary
detail, c. 1435–40, oil on wood panel transferred to canvas.
Saint Petersburg, Hermitage.

Far right, bottom:
Konrad Witz
The Miraculous Draught of Fishes
1444, oil on wood panel.
Geneva, Musée d'Art et d'Histoire.

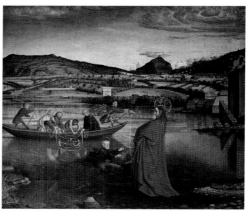

Netherlands, where a comparably significant revolution in painting took place, founded this time not on scientific rationalization but rather on the search for perceived verisimilitude. The origin of this process can be traced back to the Franco-Flemish miniature tradition of the first half of the fifteenth century and first saw the light in the works of the Master of Flémalle, and in particular in the paintings of Jan van Eyck, conceived as windows opened onto the representation of the visible world.

Back in Florence, Alberti also defined the framing of the painting as a window, which circumscribed the measured construction of the composition inside, as though the frame were complete, an element unto itself. Flemish painters held that the frame opened the way to a wider view, which extended, ideally, beyond the edges of the scene and reached out into the spectator's space.

This new way of conceiving the surface of the painting was supported not by a geometric tool, such as linear perspective, but by the use of oil paint, which allowed the artist to achieve remarkably precise effects of depth and relief, thanks to the highly physical rendering of light falling on different surfaces. Rogier van der Weyden would push this lifelike painting into an exploration of expressive intensity, seen in the clear, analytical precision of his most excruciatingly accurate details. Although it did not start what could be called a real international style, Flemish

painting did spread across Europe, by way of the trade and diplomatic routes, reaching Germany, France, and Spain. There the style infused the late Gothic figurative language with a new sense of plasticity in the brushstroke, as well as emotional intensity (pathos) and spatial unity. It was also the spur for more unaffected interpretations, such as the works by Konrad Witz, Jean Fouquet, Enguerrand Quarton, Nuño Gonçalves and Bartolomé Bermejo. In Italy, the Flemish model which so dazzled because of its supremely painterly qualities added the truth behind its own perceptive values, with its exquisitely physical rendering of light and color, as well as the exact, if plastic and linear, ideas of perspective stemming from Florence. At the same time, in tandem with the spread of humanism, the Italian model expanded across Europe. Here, the model was first used as an ornamental motif in the ancient style to give a new breath of life to traditional figurative devices.

The Renaissance became European in scope under Albrecht Dürer, towards the beginning of the new century. Dürer was the first artist outside Italy who sought to investigate the conceptual principles of the rebirth of the arts in Italy from the

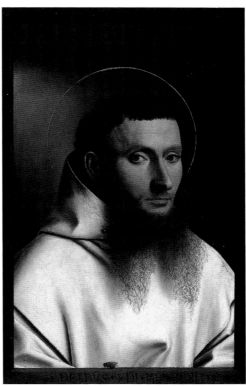

Petrus Christus
Portrait of a Carthusian
1446, oil on wood panel.
New York, Metropolitan Museum.

Below left:
Jaime Huguet
Consecration of Saint Augustine
detail, 1463–80, tempera on wood panel.
Barcelona, Museu Nacional d'Art de Catalunya.

Below right:
Nuño Gonçalves
Altarpiece of Saint Vincent
detail, pre-1481, oil on wood panel.
Lisbon, Museu Nacional de Arte Antiga.

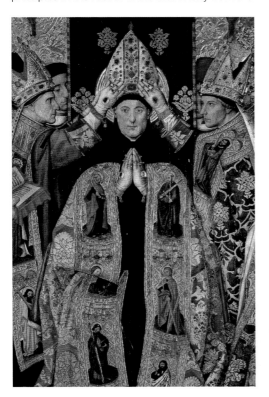

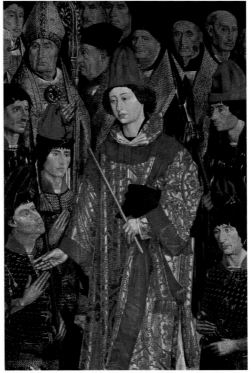

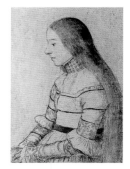

Hans Holbein the Younger
Anna Meyer
c. 1526, charcoal and colored pencil.
Basel, Kunstmuseum, Kupferstichkabinett.

Anthoni Pilgram
Self-portrait on Organ Shelf
1513, stone.
Vienna, Stephansdom, cathedral.

Facing page:
Conrad Meit and others
The Sibyl Agrippa
detail from the *Tomb of Philibert "The Handsome" of Savoy*
1526–32, marble.
Brou (Bourg-en-Bresse), Saint-Nicolas de Tomentin.

Hans Holbein the Younger,
The Dead Christ
1521–22, oil on wood panel.
Basel, Kunstmuseum.

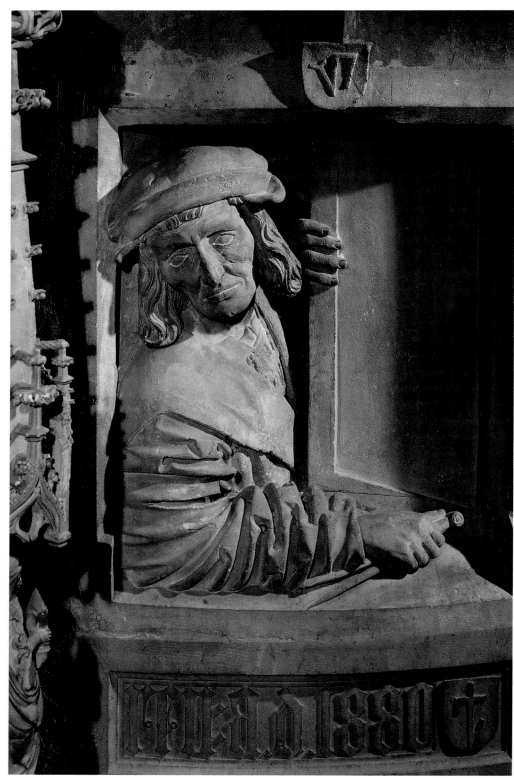

inside. We see here an effort to understand their hidden harmonies, an attempt to profoundly renew his own culture's art in accordance with universal criteria.

The art of the Renaissance reached its apex, in term of classical balance, during the first decades of the sixteenth century, when it was focused in Leonardo da Vinci, Michelangelo, and Raphael. At the time when its dominion was pushing into Europe, it would soon become much more widely known than ever before thanks to Mannerism, its hugely successful, if somewhat extreme, interpretation.

Requirements of space and conciseness, both editorial and for the series in general, mean that this book is divided into two main parts. The first, "Renaissance," reviews the foundations of the new approach to art and the new artistic mentality over a period of time that coincides roughly with the *Quattrocento*, or fifteenth century. The second part is dedicated to "Mannerism," and investigates the principles and successes of this style during the sixteenth century. From this editorial choice, it should not be inferred that Renaissance and Mannerism correspond to two different and successive periods; the Renaissance as a historiographic period also embraces the sixteenth century. Among the different figurative languages of the sixteenth century, Mannerism was the style that continued, but reacted against, its classical ideals, defining the artistic *lingua franca* at the European level. To this end, and in order to define this style in keeping with its own chronology, it is possible to coin the expression "Mannerist Renaissance," which is not as paradoxical as it may at first seem.

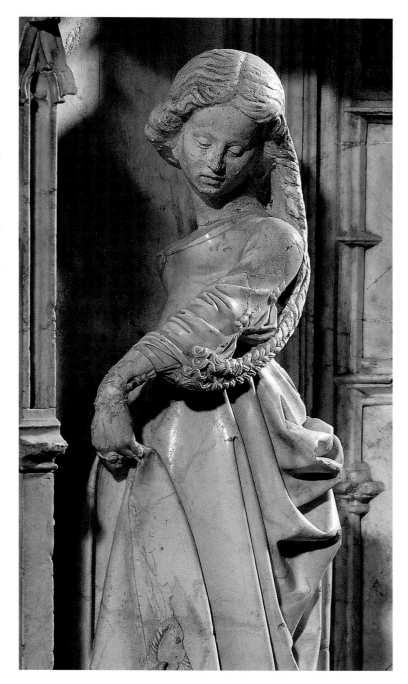

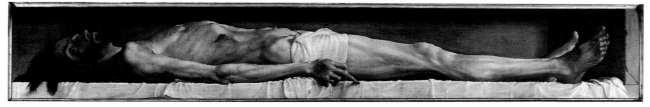

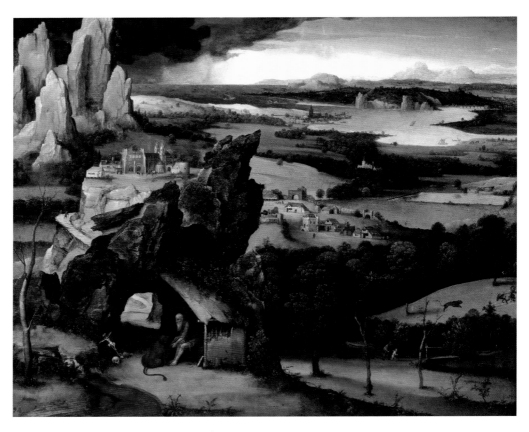

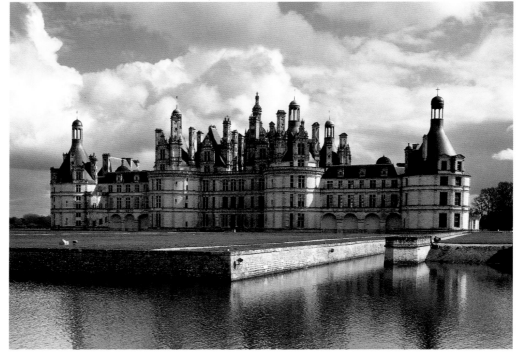

Albrecht Dürer
View of the Arco Valley
1495, pen and ink,
watercolor and gouache.
Paris, Louvre.

Leonardo da Vinci
Storm in an Alpine Valley
c. 1506,
red (sanguine) chalk.
Windsor Castle,
Royal Library.

Above right:
Joachim Patinir
*Saint Jerome in a
Rocky Landscape*
c. 1520–24, oil on
wood panel.
Madrid, Prado.

Right:
Château de Chambord
post-1519.

Facing page:
Portal of the University
c. 1490–1520, Salamanca.

Perspective

According to his biographer, Manetti, and to Vasari, Filippo Brunelleschi was the inventor of perspective, the scientific method that makes it possible to determine changes in size in proportion to distance. The artist gave two practical demonstrations of the technique in two lost paintings of the Palazzo della Signoria and the Baptistery in Florence, respectively; the paintings overlapped the buildings perfectly when seen from a given, preestablished viewing point. Indeed, the baptistery panel was meant to be seen from behind, through a little hole. The viewer saw the baptistery and then, holding up a mirror, would see an exact mirror image. The geometric rules behind "artificial," or "linear," perspective (as opposed to the natural perspective of optics) were later theorized by Leon Battista Alberti in his treatise *On Painting*, and Alberti dedicated the vernacular edition of his work (1436) to Brunelleschi. In Alberti's view, there was overlap between the definition of both the painting and the perspective used because the picture surface represented a kind of "cutaway" or "intersection" on the visual pyramid that draws the eye to the object it beholds.

Perspective, or "legitimate construction," allows the artist to reproduce exactly on a flat surface the outlines of figures and the proportions in relation to distance that exist with

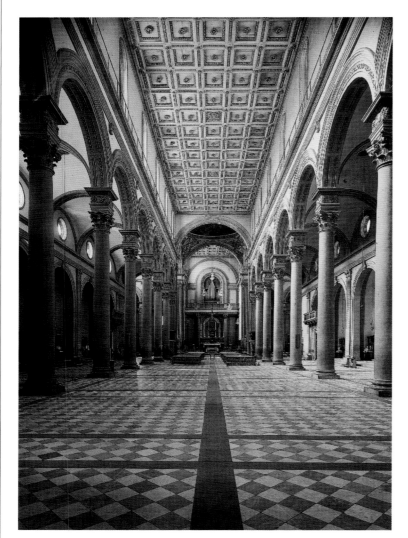

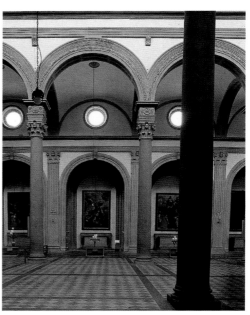

Filippo Brunelleschi
Views from the nave towards the transept and from the right-hand aisle with a glimpse of the chapels
1420–70.
Florence, basilica of San Lorenzo.

For Brunelleschi, perspective was a regulating principle that guaranteed a clear structural distribution based on symmetry and proportions. In the basilica of San Lorenzo, the aisle arches and chapels were designed with a common vanishing point, creating a proportional relationship in height and contributing to a flowing definition of depth.

three-dimensional depth, as if they were observed through "translucent glass." In other words, the painting is an "open window through which I look upon that which shall be painted there." And just what is to be painted there, the *istoria* ("story"), is arranged on a gridded surface whose extreme point of depth is fixed by a central point. The vanishing point is located where the "central ray" (or the height line of the visual pyramid) "wounds" the painting at right angles, and towards which all the lines converge. The progressive geometric reduction in the intervals between the central ray's orthogonal lines (the lines parallel to the bottom edge of the painting) determine distance ratios in the painting. Perspective's open window is thus not an illusionist representation; rather, it is the geometric and abstract rationalization of the measurements of the world, united around a single, central point of view. It is hardly a coincidence that both Alberti and later Piero della Francesca (writing in *De prospectiva pingendi* [*On Perspective for Painting*], published before 1482) use the term *commensuratio*. The central tenet here is that perspective makes it possible to produce an exact, and thus true in its fundamental principles, reconstruction of a vision of the world commensurable with man, with the proportions of the human body providing its unit of measure. In historical terms, it is clear that perspective did not spring out of nowhere.

Desiderio da Settignano
Tabernacle of the Corpus Domini
c. 1450, marble.
Florence, San Lorenzo.

The Masaccio-style perspective design is revisited in bas-relief to frame the door to the tabernacle with trompe l'oeil architecture. In contrast to Masaccio's fresco, the internal structure is clearly visible thanks to the definition of the floor created by using a raised vanishing point. The introduction of the angels gives a sense of depth.

Above:
Masaccio
Holy Trinity
c. 1426–27, fresco.
Florence, Santa Maria Novella.

The perfect perspective design and conformity with Brunelleschi's models suggest a collaboration with the architect. With a very low vanishing point at the foot of the cross, Masaccio creates a trompe l'oeil from the ground up that simulates the borders of an impenetrable holy place, divided by the figures of the donors outside the arch.

Empirical perspective plans were being used in Tuscan workshops in the fourteenth century, as well as in Flanders in the early fifteenth century, in particular by Jan van Eyck. It is true, however, that linear perspective based on mathematical principles was developed in Florence sometime between 1420 and 1430, years in which Brunelleschi, Donatello, and Masaccio worked in close proximity. Linear perspective quickly became the accepted tool for the rational and unified organization of space, or of the locus of representation, in the three disciplines of architecture, sculpture, and painting. There were other practical solutions, including Paolo Uccello's "bifocal" perspective, which located vanishing points to the left and right of the scene, in order to allow for a multifaceted vision. Uccello was an enthusiastic student of perspective and applied his research to the stereometric representation of solids, and used the image of perfectly foreshortened headgear as a kind of signature in a number of works. Writing in his treatise on perspective in painting, Piero della Francesca provided the mathematical basis for the geometric rendering of different bodies required for the exact elevation of the object and for rendering its perspective on the flat surface of the painting. Towards the end of the century, Leonardo da Vinci

Paolo Uccello
Man With Mazzocchio, detail from *The Deluge*
c. 1450–60, fresco.
Florence, Cloister of Santa Maria Novella.

The circular *mazzocchio* used by the Florentines to attach cloth headgear was chosen for its polyhedral shape and became the symbol of perspective studies of geometric solids, to which Paolo Uccello dedicated several drawings. Vasari criticized the excess of this research as "something only useful to those doing marquetry."

Piero della Francesca
Perspective study of the "torculo" (or "mazzocchio") from De Prospectiva Pingendi (On Perspective for Painting)
pre-1482.

The shape of the *mazzocchio* appears among the geometric solids chosen by Piero della Francesca to define the mathematical rules of elevated perspective.

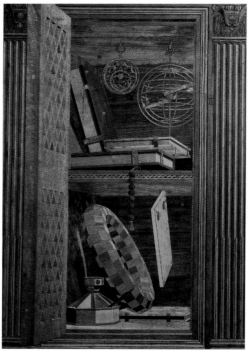

Baccio Pontelli
Cupboard with trompe-l'oeil books, scientific instruments and "mazzocchio"
c. 1476, wood intarsia.
Urbino, Palazzo Ducale, Duke of Montefeltro's study.

The *mazzocchio* motif was also a favorite of workers in intarsia since its multiple facets were well suited to compositions using inlays of various types of wood.

was critical of the abstraction of linear perspective, which he defined as both "bridle and rudder of painting," refuting the value of the exact representation of the measurements of this world. Alberti's "legitimate construction" rested on the scaled reduction of a fixed, monofocal vision, whereas visual perception is spherical, mobile, and bifocal. In the view of Da Vinci, the man who conceived the founding principle of the changing nature of motor energy, linear perspective could constitute a universal tool of knowledge. Da Vinci corrected perspective by introducing irregular elements, such as how and where the light fell, or imprecisely executed outlines in relation to distance. Finally he added aerial perspective, which alters forms and colors seen from a distance in relation to atmospheric humidity or the how blue the sky is. Alberti's geometric scheme was thereby infused with a vital spark that spread to every particle of human knowledge. By the middle of the sixteenth century, when Vasari poured scorn on Paolo Uccello's dogged pursuit (the artist used to respond to his wife who was concerned to see him study so late into the night, "Ah, what a sweet thing is this perspective!"), the "legitimate construction" had lost its appeal as an intellectual tool, while still remaining necessary to practioner's of drawing.

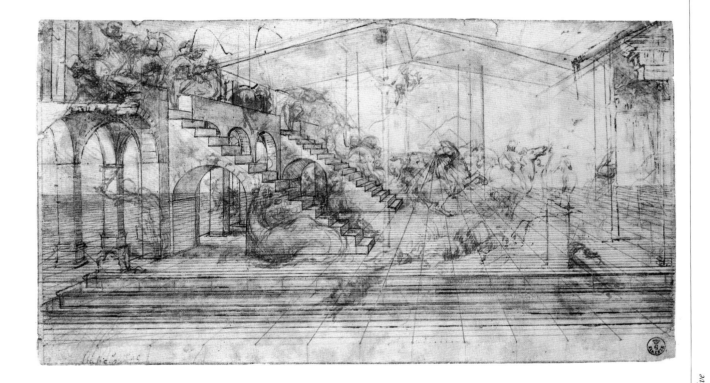

Facing page:
Paolo Uccello
Study for a "mazzocchio"
mid-fifteenth century,
pen on paper.
Florence, GDSU
(Gabinetto disegni e
stampe degli Uffizi),
1757A.

Leonardo da Vinci
Perspective study for the Adoration of the Magi
1481–82, sketch.
Florence, GDSU, 8r.

At first glance, a seemingly perfect application of Alberti's principles, this preparatory study actually shows various irregularities, particularly in the alignment of the pillars, and only deals with the background of the painting. For Leonardo, the perspective scheme acts as a structural support to the forms in motion.

Proportions

If linear perspective is a tool for the geometric reconstruction of three-dimensional depth on a flat surface, for the theoreticians of the fifteenth century its ultimate use was the representation of humans in their setting, that of the *istoria*, or story. The human being was thus the unit of measurement for perspective, because the human form defines the size of the spatial structure, while reductions in height determine the distance ratios. Perspective is intrinsically connected with the theory of human proportions, a relationship with deeper implications if considering the Christian view that the person is made in God's image and that human proportions mirror the perfection of Creation, at least according to the medieval system of analogy between microcosm and macrocosm. ("As above, so below.") This system of correspondences was tied to ancient notions, the mathematical rules of which were set out by Vitruvius, who decreed that the plans of religious buildings must conform to human proportions, because the "well-figured man," with arms and legs outstretched, fits ideally inside the square and the circle, the two perfect geometric figures. This image proved to be profoundly striking for the artists of the Renaissance, leading to general graphic interpretations such as Da Vinci's well-known *Vitruvius Man*, and other, more detailed works. In his *On Perspective in Painting*, Piero della Francesca applied the

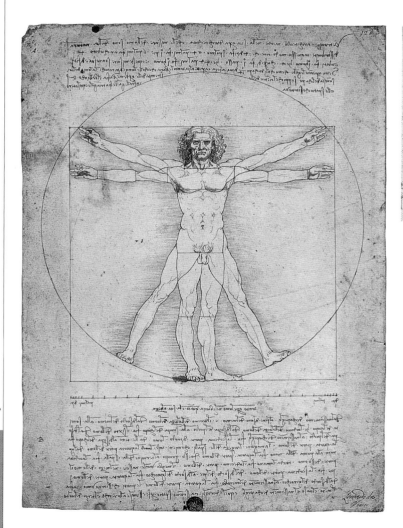

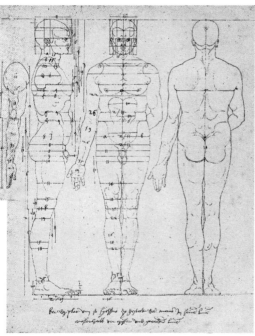

Leonardo da Vinci
Vitruvian Man: Study of the Proportions of the Human Body as Described in Vitruvius
c. 1490, pen and pencil on paper.
Venice, Accademia, 6r.

The superimposition of the two poses of the man, drawn respectively in the square and the circle according to the principles of Vitruvius, shows Leonardo's interest in the study of proportions in relation to movement.

same geometric principles to the perspective projection of a capital or the human head, while Francesco di Giorgio Martini or Fra Giocondo superimposed the head on the capital, the body on the column, and the open arms on the basilica layout. In his comment on Vitruvius's text (1521), Cesariano pointed out that given its proportions, the human body makes it possible to "commensurate all things that are of the world." This manmade unit of measurement was established in relation to the Vitruvian canon, which divides the length of the body in ten "faces" (lengths of the face, or head), or the pseudo-Varronian canon (of Byzantine origin and easier to apply), which uses nine lengths. The mathematical relationship between microcosm and macro-cosm thus became a canon of beauty which translated into a universal harmony founded on the proportional relationship between the different parts, and between the parts with the whole. The most searching reflections on human proportions were produced by two artists: Da Vinci, who raised the question of the static layout in relation to the nature of movement, and Dürer, who introduced the notion of variety and compiled seven male and female prototypes after "examining two or three hundred live people."

Facing page:
Albrecht Dürer
Lateral, frontal, and rear view of the male nude, woodcut from *Four Books on Human Proportion*
Nuremberg, 1528.

Dürer was aware that his proportional system was didactically abstract, and considered his demonstrative figures "so straight and rigid they can be of no use" as models for concrete application. However, his treatise met with great success in Italy as well as in the rest of Europe.

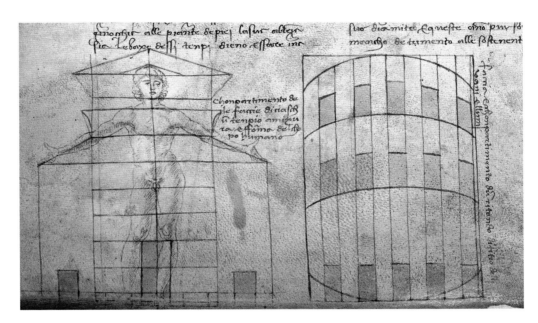

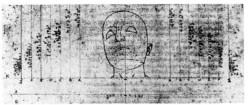

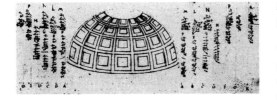

Above:
Francesco di Giorgio Martini
The male body inscribed on the façade of a church
post-1477. Florence, B.M.L., ms. Ashb. 361, 21r.

Left:
Piero della Francesca
Study of a foreshortened head and a dome from *De Prospectiva Pingendi* (*On Perspective for Painting*), pre-1482.

Vitruvius's concept of human proportions, conceived as a unit of mathematical measurement in spatial representation, gave inspiration to a surprising series of anthropomorphic architectural studies.

The Ideal City

Perspective, formulated by Brunelleschi in Florence's Piazza della Signoria and Piazza del Duomo, was next used in the invention of squares, or *piazzi*. This new tool for measuring spatial relationships was the starting point for a rich and varied debate on the image of the ideal city, which was focused around its epicenter, the town square, or *piazza*. The three very famous *Architectural views* (Galleria Nazionale, Urbino; Staatliche Museen, Berlin; Walters Art Gallery, Baltimore), of uncertain attribution, show three variations on the theme of the paved square. The visual rhythm is established by the perfection of the perspective layout of the stone slabs, used as a regulating and unifying principle for this urban space, and defined by the presence of geometrically perfect buildings with circular or square layouts. In its stone and marble abstraction, the ideal city, enhanced by the harmony of the mathematical relationships between the full and empty spaces, is as much an intellectual as a monumental space. The immense energy employed in researching urban planning actually bore little fruit in the form of material constructions. Among the few projects realized were the transformation of Corsignano into modern-day Pienza (near Siena), under Bernardo Rossellino, working for the humanist Pope Pius II. The heart of the new city is the cathedral square; the piazza is enclosed by the bishop's palace and Palazzo Piccolomini (the Pope's family name), and presents clearly symmetric proportions. The unifying design is emphasized by

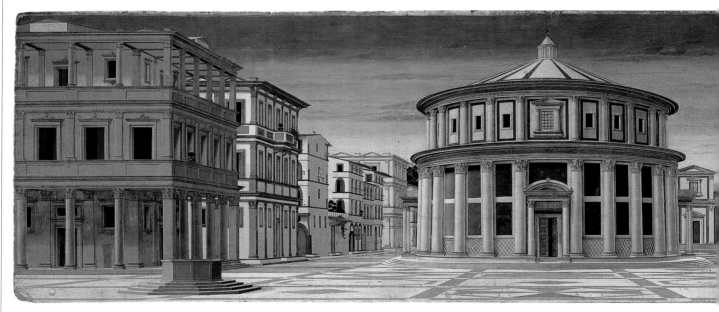

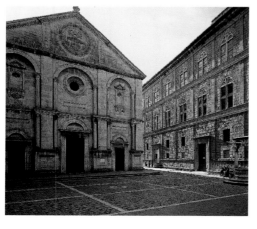

Bernardo Rossellino
Piazza di Pienza
1459–62.

A student of Alberti, Rossellino applies the master's lessons in perspective on an urban scale, creating a piazza with clear geometrical distribution around the axis of the monumental façade of the cathedral, enhanced by variations in the planes of the pilaster-strips, arches, niches, and oculus.

Above:
Ideal city
c. 1460–80,
oil on wood panel.
Urbino, Galleria Nazionale delle Marche.

Circular, square, and octagonal (in the well-curbs) architectural solids are arranged following a central perspective scheme with the vanishing point above the half-open door. The porticos and loggias opening onto the piazza express the relationship between full and empty spaces.

the lines of the paving stones, rather like the architectural view conserved in Urbino. The expansion of the city of Ferrara planned by Biagio Rossetti for Duke Ercole I d'Este also recalls the painted ideal cities, especially because of the same rarified atmosphere of a place of geometric perfection devoid of life, because the new monumental district, laid out like a checkerboard, remained no more than an uninhabited, sumptuous setting. Research into perspective was also closely tied to cartographic studies (to which artists such as Alberti and Da Vinci also applied themselves), and the plan of the ideal city was usually enclosed either within the harmonic shape of the circle, such as the project for Sforzinda by Florentine architect and sculptor Filarete (Antonio Averulino), or within the human form. Francesco di Giorgio Martini applied the human form to town planning projects; the head corresponded to the fortress, the navel was aligned with the center of the square, and the city walls followed the extension of the limbs. The harmony among the parts and their relation to the whole took on a political dimension: The relationship between the fortress and the town proper reflected that of the ruler to the ruled. It is hardly surprising that at the time, Francesco di Giorgio was reordering that "city in the form of a building" constituted by the ducal palace of Urbino, residence of Federico da Montefeltro, the ruler who was then the icon of good government.

Right:
View of Urbino and Palazzo Ducale

The palace, designed by Laurana and Francesco di Giorgio beginning in 1468, overlooks the town and the surrounding territory that Federico da Montefeltro could contemplate from his *studiolo*, or small study, in the upper loggia of the turreted façade. As Francesco di Giorgio stated, the head, or place of the prince, must be elevated in order to judge and view the body of the city and thus the State.

Francesco di Giorgio Martini
Study of the relationship between the human body and the plan of a fortified city, drawing post-1477.
Turin, Biblioteca Reale, Trattato I, c. 3r.

Francesco di Giorgio explained: "I think I shall design the city, fortress, and castle in the form of a human body, giving the head and attached limbs the corresponding functions so the head becomes the fortress, and the arms the added fortifying walls that separately surround and bind the rest of the body of the city."

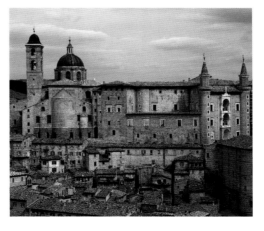

The Palazzo and the Villa

Under the reign of Federico da Montefeltro, Urbino's old fortress was transformed into a princely palace (see page 27). Extensions to the original structure connected the building with the cathedral and the rest of the urban fabric, and a relationship was established with the surrounding territory by means of the wide prospect that remade the city's profile. The harmonious façade above the escarpment was designed by Luciano Laurana in 1467 and finished by Francesco di Giorgio Martini after 1477. This façade is graced by two slender towers which, no longer serving any military function, indicate the prince's abode; the three arcades looked down over the duke's territorial possessions. No longer an expression of military might or control, the palace was now the image of the forward-thinking power of the ruler who guaranteed peace, while the defenses were repositioned along the borders of the duchy, made up of a network of fortresses built from an innovative design by Francesco di Giorgio that made the towers difficult to take by artillery. The haitus between fortifications and the inhabited area, where dwellings existed, was part of a general trend in civil construction projects in fifteenth-century Italy that produced a number of new architectural forms, such as the square-shaped building organized around a central inner courtyard, that were developed in Florence. The geometric solid, opened at the center by the arcades of the courtyard, and closed off from the exterior by the uninterrupted flow of the façades, is nevertheless

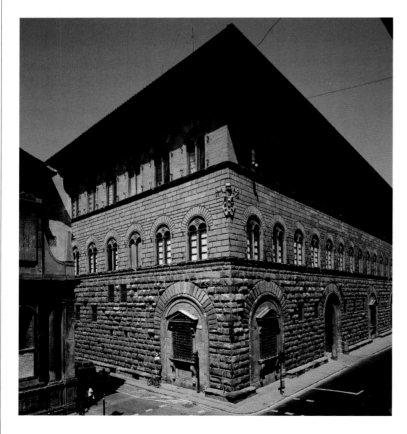

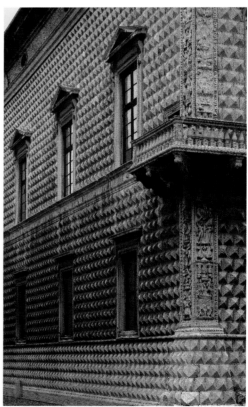

Michelozzo
Palazzo Medici
1444–64, Florence.

The clear division of the floors, patterned by the cadenced arches and radial, double-lancet windows, finished by the cornice, epitomizes the exterior model for a Florentine palazzo. The rustication gives a solid aspect to the ground floor and progressively flattens going up the façade with light and dark nuances.

Biagio Rossetti
Palazzo dei Diamanti
angular view, c. 1491, Ferrara.

The balcony underlines the function of the palace as a landmark at the crossroads of the quarter, designed by Rossetti for Ercole I d'Este. The pointed, diamond-shaped rustication may be of Catalan origin.

part of the surrounding urban space through the clear lines of the layout of the floors and the chiaroscuro effect achieved with the ashlar walls. Palazzo Medici, designed by Michelozzo (1444–64), exemplified the new principles shaping aristocratic homes; the model was inspired by contemporary thinking from Alberti on Palazzo Rucellai and Brunelleschi working on Palazzo Pitti, and would undergo a range of developments (Benedetto da Maiano, Palazzo Strozzi, after 1489). The way the façade was treated produced a hugely successful geometric variation in the diamond-effect ashlar used in Naples, Bologna, Cremona, Rome, or Ferrara (the so-called Palazzo dei Diamanti, c. 1491). It was also around 1480 that the villa ceased functioning as a kind of stronghold. For the Medici villa at Poggio near Caiano

(1480–85), Giuliano da Sangallo designed a graceful rectangle set up on a base of arcades. For the now lost Poggio Reale villa near Naples, Giuliano da Maiano pierced the façades with loggias (c. 1490), a solution that was to prove enduringly successful. In Venice, where they were naturally protected by the lagoon, the façades had long since been conceived as thin diaphragms that opened onto the exterior by means of elegant arcades and dual-light mullioned windows. Towards the end of the century, Mauro Codussi, a Bergamasque architect, reordered the layout in keeping with principles inspired by Florentine trends.

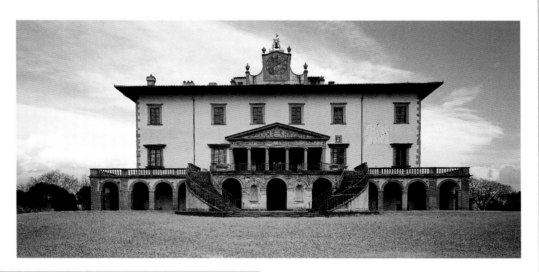

Giuliano da Sangallo
Villa Medicea
1480–85.
Poggio a Caiano (Prato).

Compared with the fortified castles built by Michelozzo for Cosimo de' Medici in Cafaggiolo and Careggi, the elegant expanse of the new villa for Lorenzo the Magnificent opens onto the surrounding gardens thanks to the arcade around its base.

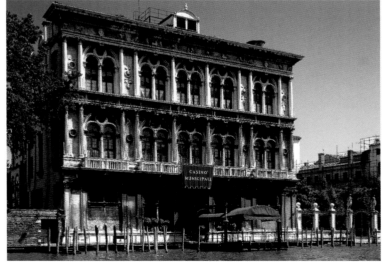

Left:
Mauro Codussi
Palazzo Vendramin Calergi
late fifteenth-early sixteenth centuries, Venice.

Entirely covered in broad double-lancet windows, the façade of the palace is nonetheless strictly organized by the overhang of the floor trabeations and the rhythm of the columns, delicately refined by modulations of dark and light that come together in a house built on the water.

The Church

In the ideal city, the church stands at the center of the main square, and its façade acts as a convergence point for all of the perspective lines, while influencing the rhythm of proportional relationships. The ambitious decision to consider the front view of the church as a model for urban space made planning and designing façades an altogether more complex business, as can been seen in the anguished history of so many unfinished church frontages in Florence, including Brunelleschi's basilicas of San Lorenzo and Santo Spirito. In light of this situation, the fact that Leon Battista Alberti managed to finish the façade of Santa Maria Novella is a remarkable feat but also a testament to his working method. The job was made all the more difficult by the presence of preexisting Gothic elements, the pointed arches around the base, and the oculus, which Alberti managed to integrate into the new design without betraying his principles, which were based on the harmony existing between the parts and the whole. Alberti designed a two-level façade, divided by an attic and joined by two wide volutes; the façade is completed by a classical pediment. While the marble finish of the church was inspired by pre-Renaissance buildings such as the church of San Miniato al Monte, the distribution of the various elements is given unity by clear proportional relations, based on the geometry of the square, and regular subdivisions into further squares. The church's façade acts as the keystone of the main square's harmony, unfettered by the exact

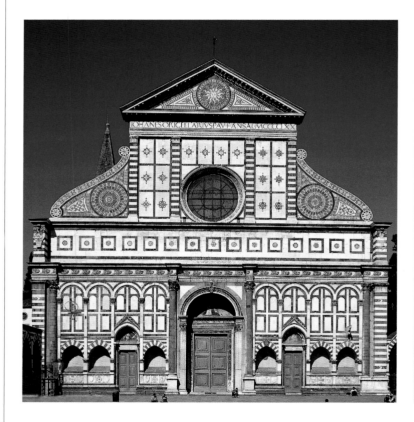

Leon Battista Alberti
Façade
1439/42–70, Florence, Santa Maria Novella.

"To help what has been done and not spoil what is to be done." This is how Alberti conceived his innovative interventions on pre-existing buildings. As reported on the inscription, the façade was financed by Giovanni Rucellai who also commissioned Alberti with building a palace and the Tempietto del Santo Sepolcro in the family chapel in San Pancrazio.

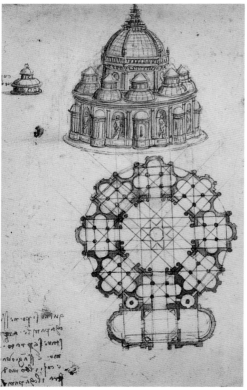

Leonardo da Vinci
Study for a church with a central plan
1487–90, ink on paper.
Paris, Bibliothèque de l'Institut de France, manuscript B, c. 95r.

correspondence with the interior of the church and the height of the naves. All the same, Alberti's ideal church was circular, enclosed by a circle, the most perfect geometric figure, symbol of the relationship between the microcosm and macrocosm, and of the infinite nature of Divinity. In his treatise *On Building* (c. 1450), Alberti made it clear that there should be a directly proportionate relationship between the diameter of the church and the height of the walls, that the church should be surrounded by a colonnade completed with an entablature, and that the building should be located on an elevated and isolated area at the center of the main square. The circular layout for buildings, of which many examples from antiquity had survived, exercised the imagination of Renaissance artists who studied every possible variation of the circular form, as can be seen in the sketches of Francesco di Giorgio Martini or Leonardo Da Vinci. Due to liturgical reasons, and because of the symbolic force of the cross, there were few practical applications of the circular plan, among them the Greek cross layout of the church of Santa Maria delle Carceri in Prato designed by Giuliano da Sangallo. The circular plan was put to greater use in the more restricted field of the design of side chapels, following the example of the Old Sacristy of the church of San Lorenzo or Brunelleschi's Pazzi Chapel. It was only towards the start of the sixteenth century that Alberti's ideal church finally began to take shape, although on a reduced scale, in the form of the small church of San Pietro in Montorio, built by Bramante in Rome.

Perugino
The delivery of the keys,
detail (entire painting
on p. 93)
1481–82, fresco.
Vatican City, Sistine
Chapel.

Raphael
*The Wedding of the
Virgin,* detail
1504, oil on wood panel.
Milan, Brera.

In *The Delivery,*
Perugino had already
introduced the building
on a central plan as a
symbol of the Church by
virtue of its "divine
harmony." The octagonal
motif was taken up again
as the Temple of
Jerusalem in *The
Wedding of the Virgin*
(1504–5) , which Raphael
translated into an almost
circular polygon, opened
by a perfectly
proportioned portico that
evokes Bramante's
Tempietto.

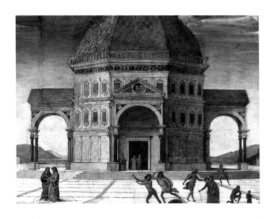

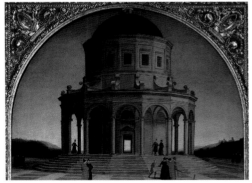

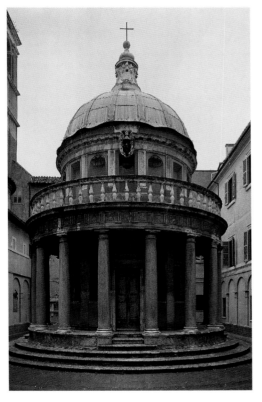

Bramante
Tempietto of Saint Peter in Montorio
1502–06. Rome.

This structure, composed of ideal forms, rose as a symbol of the Church, built around the presumed hole left in the ground by the cross on which the Prince of the apostles was martyred. The original project envisaged the opening of a circular piazza in accordance with Alberti's concepts.

The Renaissance The Church

Configuring Space

The Renaissance's enthusiasm for the circular plan was also fueled by the cupola, or dome, the hemispheric crowning detail of the harmonious arrangement of the round church plan. A fundamental, indeed, inescapable, consideration was that of the new possibilities offered by the major technical and conceptual feat that was the dome of Santa Maria del Fiore, built by Brunelleschi. The fourteenth-century tambour of the Florentine cathedral was still without a roof at the start of the fifteenth century, and its huge width made closure difficult because of the high cost and the difficulty of finding wooden beams of a sufficient size to bear the weight of the entire vault during the construction stage. The search for a solution

became almost an obsession for Brunelleschi. He went to Rome a number of times in order to study the techniques used in the vaulted ceilings of ancient buildings. In 1418, in response to the competition to provide solutions for the dome, he finally put forward a revolutionary design for a self-supporting dome that did not require props or shores. Brunelleschi's project was not received uncritically by everyone, and at the beginning he had to work with Ghiberti at the head of the construction workshop. Brunelleschi managed to oust his old rival from the competition for the bronze door of the Baptistery, and kept his secrets to himself. He was given sole responsibility for supervising the work, and into the bargain upset the traditional collegial way construction

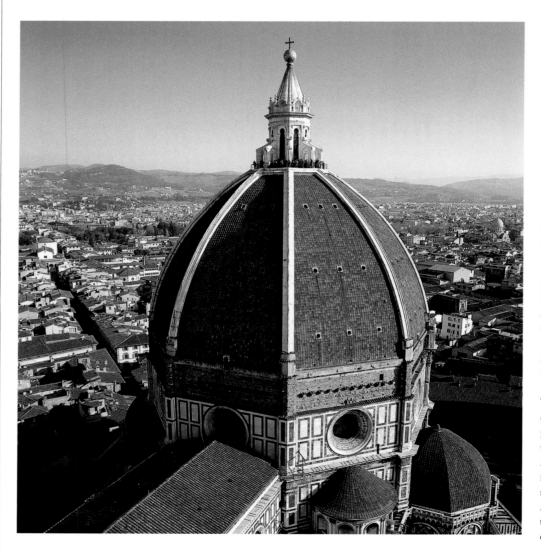

Filippo Brunelleschi
Cupola
1423–28. Florence, Cathedral.

"You could certainly say the ancients never went higher with their buildings, nor did they take the great risk of seeming to fight against the heavens as it truly seems to do, rising up to such heights it seems equal to the mountains around Florence." (Vasari)

Facing page:
Masaccio e **Masolino**
Madonna and Child with Saint Anne
c. 1424, tempera on wood panel. Florence, Uffizi Gallery.

The contrast between the composition of stratified planes by Masolino and the plastic volume of the *Madonna* by Masaccio is resolved by the fore-shortened hand of Saint Anne that brings together the two divergent spatial concepts.

sites were organized. While Brunelleschi managed to deduce how the ancients built things—a structure designed around joints, with powerful ties; bricks arranged in a herringbone pattern; and the higher up the structure, the lighter the materials used—he made use of this knowledge not to design a classical semispherical dome (which would not have been in keeping with the longitudinal layout of the basilica) but rather to create an innovative new ovoid cupola, using interconnected trapezoidal segments. The double shell allowed Brunelleschi to separate the smooth internal vault, which formed a continuation of the circular choir, and the external facing, the veins of which brought the cathedral's longitudinal lines, as though they were vanishing lines in perspective,

together around the central node of the lantern above the dome. The immense cupola, "raised above the skies, and wide enough to cast a shadow upon the peoples of Tuscany," links the cathedral with the surrounding urban space, and further ties the city's skyline to the horizon line running through the surrounding hills, becoming, in a sense, the very emblem of Florence's identity. The principle of the cupola as an element that creates and regulates space found another contemporary interpretation in the painting *Madonna and Child*, which Masaccio painted inside Masolino's Sant'Anna Metterza. The geometric fluidity of the figure of the Virgin, concentrated in the pure lines of her robe, confers a measure of three-dimensionality to the composition, which Masolino sought

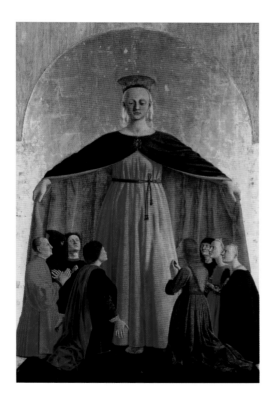

Piero della Francesca
Madonna of Mercy
1445–62, tempera on wood panel.
Sansepolcro, Pinacoteca Comunale.

The oval of the face of the Virgin, crowned by the perspectival projection of the halo, stands over the ecclesiastical body of the Madonna, who gathers the faithful, evoking the relationship between lantern and dome, and the symbolic relationship between the Church and the community of the faithful.

The Renaissance Configuring Space

otherwise to resolve with a series of layered surfaces. The slight rotation of the Virgin's body introduces an element of movement to the scene, not unlike the idea of movement suggested by the convergence of the veins of the cupola around the lantern. The effort to establish correspondences also has a certain symbolic value; it evokes the Virgin's role as mediator, as the *ecclesia* who welcomes and brings together God's faithful. This powerful use of space and the liturgical theme would be further developed by Piero della Francesco in *Our Lady of Mercy*. Focused on the central axis of the Virgin's standing form, the circumference of the opening in the Virgin's robe continues in the circular arrangement of the kneeling faithful, designing a circle within a square frame. In both

paintings, the use of the cupola form allows the artist to create a perfectly complete representation of space in a setting where any attempt at depth is voided by the golden background. As regards paintings opening onto a "natural" three-dimensional background, artists would make use of another solution developed by Brunelleschi in order to give the appearance of depth: the perspective device of the colonnade. Brunelleschi had already established the visual rhythm of the harmonious proportions of this device in the portico of the Spedale degli Innocenti ("Hospital of the Innocents"), and in the naves of the San Lorenzo and Santo Spirito churches. Donatello was the first to introduce the colonnade device, on the right of his bas-relief of *Saint George and the Dragon*, commissioned for the

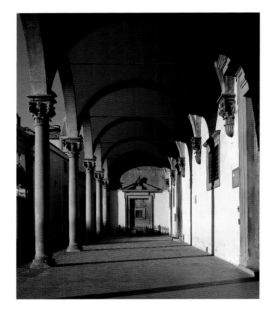

Filippo Brunelleschi
Longitudinal view of the open portico
1419–44.
Florence, Portico of the Spedale degli Innocenti.

Brunelleschi clearly did not "invent" the loggia with rounded arches. There are many celebrated precedents in Florence such as the Loggia dei Lanzi. But he defined the harmonic relationship in the rhythmic sequence of the framework in *pietra serena* (Firenzuola stone) and gave it a structural lightness through extreme reduction of thickness in the load-bearing elements.

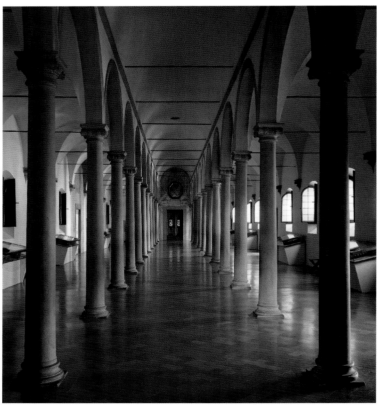

Michelozzo
Library
1444. Florence, Monastery of San Marco.

The clean, austere perspective of these slender arcades inspired the almost incorporeal architecture painted by Beato Angelico, working with Michelozzo, when he found himself painting frescoes in the areas built by the latter in the same monastery.

tabernacle of the Sword and Armor-makers' Guild in the church of Orsanmichele; here the colonnade is a spatial figure that determines the legend's positioning within the landscape. The same solution was used by Masaccio in his *Tribute*, painted for the Brancacci Chapel (see illustration on page 92). This correlation between the perspective device and the narrative became an effective part of the composition's structure. It would undergo a series of developments, some of them tied to the work's semantic value. For example, in the Nicolina Chapel in the Vatican, Beato Angelico placed the episodes of *Saint Laurence Consecrated Deacon* and *Alms to the Poor*, amid the crisp lines of basilica naves seen from the front. Their lightness evokes the airy colonnades of

Michelozzo's library in the convent of San Marco. Using perspective, the keypoint of the narration is correlated to the apse; that is, the high point of the story is linked to the focal point of the church's holiness. If the spatial figure is detached from any grounding in the *istoria*, or story, it becomes a demonstrative, almost ornamental element, such as the long, empty portico that Masaccio introduced into *Herod's Feast* in the Baptistery of Castiglione Olona; the portico expands depth in the comp-osition without satisfying any requirements of the narrative.

Masolino
Banquet of Herod
c. 1435, fresco.
Castiglione Olona,
Baptistery.

Masolino was not searching for universal scientific principles in his perspective construction. His interest aimed towards the pictorial potential of this new tool, which created unprecedented depth effects. One of the most skilled demonstrations of this is the impressive trompe l'oeil archway shown here.

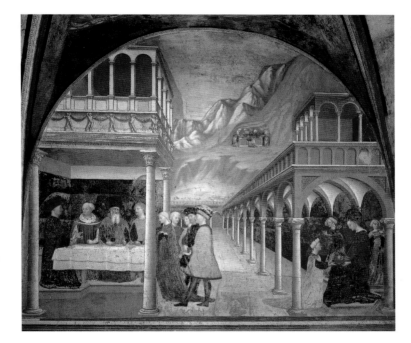

Below:
Donatello
Saint George and the Dragon
c. 1420, marble.
Florence, Bargello.

The trajectory lines drawn by the building with the walled arcade establish the depth of the ground, otherwise indefinite, where Saint George fights the dragon. The unexpected corner folds the final archway and, like a stage curtain, defines the setting of the drama and envelopes the figure of the princess.

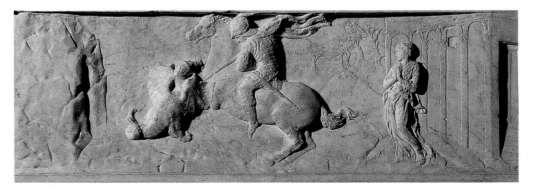

The Nude Figure

The theory of human proportions, based on geometric principles and mathematical measures, offered a universal, but somewhat impractical, conceptual model because, as Dürer had pointed out, "the line that delimits the human figure cannot be drawn with compass and ruler." Artists had to complete their studies of the human form by observing nudes, from both real life and classical statues, in order to study the representation of figures both dressed and unclad, as only anatomy established with precision would allow for correct definition of the fall of clothing. Thus, it was logical to draw the figures nude, and then to clothe them. Donatello followed in Brunelleschi's footsteps

and went to Rome to study the classics. According to Vasari, Donatello was among the first artists who "sought out the naked form of the figures;" he pursued his search to the point of carving a *Crucifix* (Santa Croce, Florence) and proudly asked his friend for his opinion. Brunelleschi is said to have scolded Donatello for putting a farmer on the cross rather than a body that was more like Jesus Christ, who "was very delicate and the most perfect man ever born." In order to back up his affirmation, Brunelleschi sculpted a *Crucifix* of his own (Santa Maria Novella, Florence), a more slender and longer figure, "laid out and united so closely" as to show the figure's perfect proportions. The anecdote underlines not only the necessary

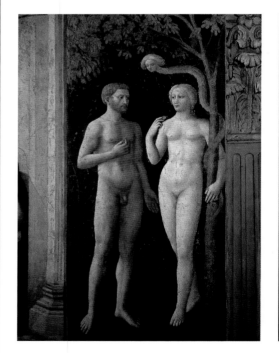

Masolino
Original Sin
c. 1425–26, fresco.
Florence, Santa Maria del Carmine, Brancacci Chapel.

Here Masolino shows he has adapted the models from late-fourteenth century painting to the new culture of antiquities, regularizing the relief and proportions but without adding any clear spatial arrangement; the figures of Adam and Eve seem to float on "tiptoes."

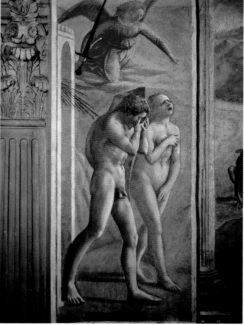

Masaccio
Adam and Eve Banished from Paradise
c. 1425–26, fresco.
Florence, Santa Maria del Carmine, Brancacci Chapel.

The weight of guilt crushes the bodies, now firmly anchored to ground level, giving place to contrasting movements: Adam hides his head in his hands in sorrow while Eve, her face turned heavenwards in a cry of grief, covers her genitalia with her arms.

Giovanni di Paolo
The Creation and Expulsion From Paradise
c. 1445, tempera on wood panel.
New York, Metropolitan Museum of Art.

Although aspiring to the severe, plastic relief of Jacopo della Quercia's *Fonte Gaia*, the Sienese Giovanni di Paolo interpreted the theme of *Adam and Eve Banished from Paradise* with no drama, setting it in his flowery, well-mannered world, animated by delicate, frolicking figures who skip lightly without touching the wonderful, multicolored meadow.

link between representation and the dignity of the figure shown, but also the fact that however skillful Nature may be, as Leon Battista Alberti said, perfection cannot be found in a single model because "total beauty will not be found in a single body, but scattered in several and rare bodies." In his *On Painting*, Alberti insisted on the intrinsic link between anatomy and movement: "each limb must perform its role," or, in other words, the limbs of the dead "as far as their dead nails" are bereft of the "offices of life, that is, the sentiment and movement" that are the hallmarks of the living. Anatomical exactitude serves to define positions relevant to the story, and Masaccio gave a very powerful interpretation of this dynamic concept of the nude seen as the bodily expression of physical reactions and the "movements of the soul." In the *Banishment From the Earthly Paradise*, painted in the Brancacci Chapel, the bodies of Adam and Eve, bowed by guilt, have lost all the serene lightness and graceful proportions that they had in the previous work, *Original Sin*, painted by Masolino. Now weighed down by harsher lines, original beauty has also dissolved with original purity, and the pain and grief of the fall distort bodies and faces in wild contractions. Other examples of contrasting bodily expression can be found in the fresco *Baptism of the Neophytes*. Here the well-built nude figure receiving baptism presents a serene sense of order, despite the

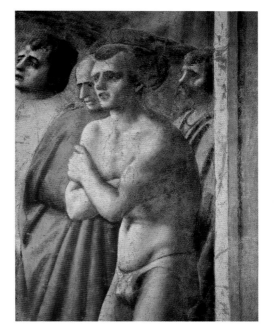

Masaccio
"Trembling" Nude, detail from the
Baptism of the Neophytes
c. 1425–26, fresco.
Florence, Santa Maria del Carmine, Brancacci Chapel.

"Great respect goes to a nude, among the others to be baptized, who trembles with cold. Executed in beautiful relief with a pleasant manner, this shows reverence and admiration for both the old and new arts for which this chapel has always been visited by master artists." (Vasari)

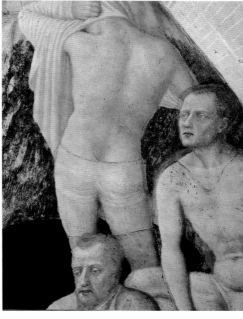

Masolino
Baptism of Christ, detail
c. 1435, fresco. Castiglione Olona, Baptistery.

In his search for variety to be found among disrobing figures, such as those Masolino portrayed in the margins of the fresco, Michelangelo later overturned the dynamic, portraying the physical effort of wet figures dressing themselves after hurriedly leaving a river, in the famous cartoon for *The Battle of Cascina* (cf. the figure on page 114).

Piero della Francesca
Baptism of Christ
c. 1459–60, tempera
on wood panel.
London, National
Gallery.

The figure of the undressing catechumen in "clear light" echoes the resplendent nudity of Christ and acts as a chromatic modulation between the figures in the foreground and the brown colors of the vegetation, while the pure curve outlining the bowed back formally links the strictly vertical solids of the standing bodies with the sinuous river and hills.

The Nude Figure

The Renaissance

water dripping down his head and the fact that he is standing knee-deep in the river. Behind him, an equally nude yet dry neophyte has wrapped his arms round his chest to ward off the cold (see page 37). The physical discomfort is used to mirror the spiritual agitation experienced before undergoing the saving ritual. Depictions of baptism allowed artists to explore and depict muscular tension. Masolino, for example, developed the theme in his *Baptism of Christ* (Castiglione Olona), adding variety with the different positions of the semi-nude initiates. Paying little heed to such notions of variety, Piero della Francesca included a single nude initiate in his *Baptism of Christ*. He is bent over, his shirt still wrapped around his head,

a splendid splash of white that stands out almost like a pause amid the brown hues and sinuous lines of the landscape, a transition in terms of shape and palette in relation to the luminous surrounding figures in the foreground. Della Francesca may have rationalized the human form by adopting the outline to a smoother, rounder geometric shape, but the more common trend was to search for contrasts in form that would highlight the rendition of muscle, something achieved through close study of anatomy. As Alberti wrote, in order to achieve the correct "commensuration" of forms and bodies, it was necessary first to "set each bone of the animal in its place, and then to add the muscles, and then to cover the whole in flesh."

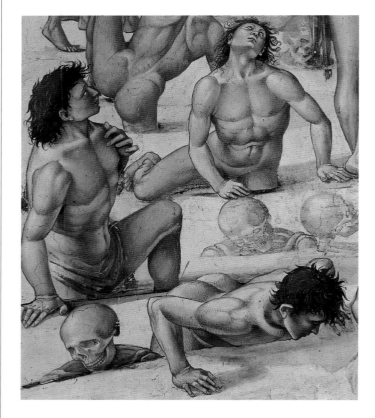

Left:
Luca Signorelli
The Damned Consigned to Hell, detail
1499–1503, fresco.
Orvieto Cathedral, San Brizio Chapel.

In the scene of the *Resurrection of the Dead* and *The Last Judgment* in the recently restored frescoes in the Chapel of the Orvieto Cathedral, Luca Signorelli places his nudes in a wide variety of positions, at times with a bold foreshortening, in the blessedness of eternal joy as well as in the torments of Hell. In the detail shown here, the juxtaposition of skeletons and bodies with precisely drawn musculature evokes the anatomical studies of flayed cadavers.

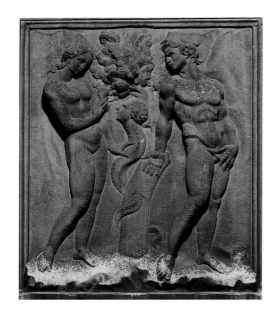

Jacopo della Quercia
Original Sin
1425–28, marble.
Bologna, San Petronio.

Despite a concise spatial definition, the relief shows remarkable plasticity, supported by the shapely musculature of the bodies and dramatic intensity of the faces.

Needless to say, this exacting operation required knowledge that could be obtained only by carrying out the same operation in reverse, namely, to remove all tissues from the body until the skeleton was revealed: In other words, dissection, a practice that several artists undertook, Da Vinci in particular. The interest in these "flayed corpses" could be seen in ever more powerful and physical representations of bodies, from the early, energetic nudes of Jacopo della Quercia, seen in the reliefs in the Fonte Gaia fountain in Siena and the portal of San Petronio in Bologna, to the well-turned, metallic musculature created by Luca Signorelli in the apocalyptic fresco cycle painted for the San Brizio Chapel in Orvieto. Moving away from religious subjects to worldly themes, nudity was explored further in terms of grace and beauty in themes from mythology, fables, and allegory. The secret interiors of wedding chests proved to be another area where nudity was explored. On the underside of the lids of these richly decorated chests, the artist painted the reclining, ideal nude forms of the spouses. These hidden couples would be brought into the public eye in the 1480s in mythological guise, in the oblong panels painted by Botticelli or Piero di Cosimo.

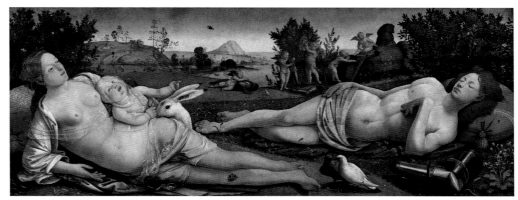

Piero di Cosimo
Venus and Mars
c. 1495, tempera and oil on wood panel.
Berlin, Gemäldegalerie.

Separated inside the chests, the bodies of the lovers were united on wood panels painted to give a space to Mars and Venus, as in this painting by Piero di Cosimo or in another previous one by Botticelli (London, National Gallery). The format would later be reserved solely for the extended female nude, destined for great success in Florentine and Venetian painting from the sixteenth century.

Right:
Giovanni di ser Giovanni, called **Lo Scheggia**
Wedding chest with male nude inside the lid
c. 1460, gilt and painted carved wood.
Copenhagen, Statens Museum for Kunst.

Always created in pairs, wedding chests contained the bride's trousseau and were brought in a procession to the groom's house the day of the wedding. A male nude and a female nude were frequently portrayed on the inside of each top.

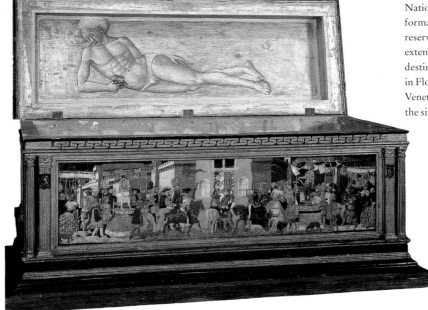

Movements of the Body and the Soul

According to Alberti, movements not only must suit the needs of the narrative (*istoria*), but should also be in keeping with the gender and age of the figures portrayed. Virgins should display "airy" movements, and their ethereal lightness may be mirrored in the equally airy flow of their hair in the breeze ("like flames"), as well as the flow of their vestments which, stirred by the wind against their bodies, would "reveal a great deal of the nude form beneath." This is the young girl who dances her way through Florentine paintings from the fifteenth century, such as the nymph in mythological scenes like the *Birth of Venus* (Uffizi Gallery, Florence; c. 1485; see page 54), or the handmaiden carrying a basket of votive offerings in religious scenes. She bursts onto the scene to carry fruit in Ghirlandaio's *Birth of the Baptist* (Santa Maria Novella, Florence; 1486–90). But the maiden's basket could just as easily contain the severed head of Holofernes, when she follows heroic *Judith* (Botticelli, c. 1470; Uffizi Gallery, Florence). Da Vinci would draw the young woman as an ethereal, graceful creature, in order to study the resonance between the turns and folds in her clothing and the vortices in the water, or the thickening spirals of the clouds, or the unifying principle of motion in water and air. The energy of the nymph's movement is provided by the disorderly arrangement of her accessories, while her face remains

Above:
Domenico Ghirlandaio
Birth of John the Baptist, detail
1486–90, fresco. Florence, Santa Maria Novella.

Mindful of the ancient nymphs, the maidservant with the swirling gown introduces a dynamic accent, in contrast to the static, composed atmosphere of the holy scene.

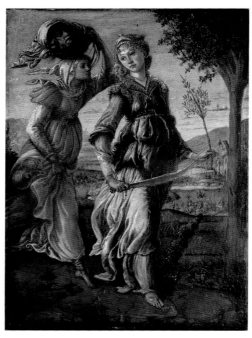

Sandro Botticelli
The Return of Judith
c. 1470, tempera
on wood panel.
Florence, Uffizi Gallery.

The light waves in Judith's gown turn into a dark vortex in the gown of the maidservant, a dramatic echo of the semicircular shadow created by the white cloth that wraps and reveals the head of Holofernes in the basket.

Leonardo da Vinci
Study of Three Dancers
c. 1515, pencil on paper.
Venice, Accademia, 26r.

In his early years of activity, Leonardo dedicated marvelous monochrome studies to the folds that make up drapes. He would reinterpret this motif at the end of his career in relation to his research into the unitary principle of motion, balancing the gowns of dancing nymphs in the air.

majestically serene. The origin of this particular motif can be traced to ancient statues. From these, as Aby Warburg explains, the artists of the Renaissance inferred not only the placid monumental balance and rules of proportion behind an Apollonian *ethos*, but also those "figures that intensify movement" (to use Warburg's expression), translating Dionysian *pathos* as well. Dance may take on frenetic rhythms, dragging *putti* and *efebi* into a vortex, giving the impression that they have left some kind of Bacchanal, like the cherubim Donatello sculpted on the pulpit of Prato Cathedral (1428–38), or the choir loft of Florence Cathedral (1433–39), or the dancers in the fresco by Pollaiolo in the Arcetri Villa (1464). The unstoppable

movement also involves angels with flowing, transparent robes, depicted in the bas-reliefs by Agostino di Duccio in the *Tempio Malatestiano*, Rimini's cathedral (c. 1453). This fevered breeze that blows through scenes of carefree and "innocent" *putti*, youths, and maidens, hides an unsettling shadow, because the line between frenzy and pure violence is very thin. The nymphs who carry fruit and severed heads with the same lightness may suddenly wield heavy sticks and transform themselves into harpies to butcher Orpheus, their clothing flowing in the breeze. This was shown in an engraving made in North Italy and from which Dürer would find the inspiration for a drawing (Kunsthalle, Hamburg; 1494). Antonio del Pollaiolo explored movement's

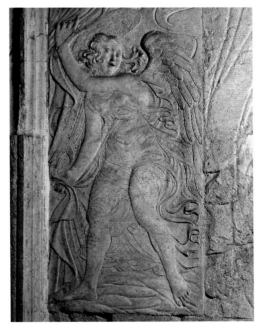

Agostino di Duccio
Angel drawing back a curtain
c. 1453, marble.
Rimini, Tempio Malatestiano, Cappella di San Sigismondo.

The sinuous, whirling design of the folds in the drape creates remarkable transparent effects and emphasizes the angel's excited movements.

Below:
Donatello
Dancing "putti" detail from the *Cantoria*, 1433–39, marble with mosaic. Florence, Museo dell' Opera del Duomo.

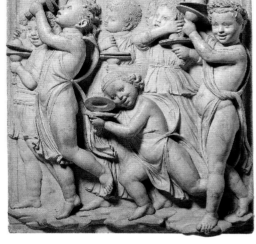

Above:
Luca della Robbia
Dancing musicians and children
detail from the *Cantoria*
1433–39, marble.
Florence, Museo dell'Opera del Duomo

In his choir loft created for the Cathedral of Florence, Luca della Robbia interprets the theme of dance with joyous composure and measured balance in a rigidly distinct series of bas-reliefs. In the opposite choir loft, Donatello conceived of the same motif in an unbridled dancing ring of unruly "putti" with disheveled clothes and hair.

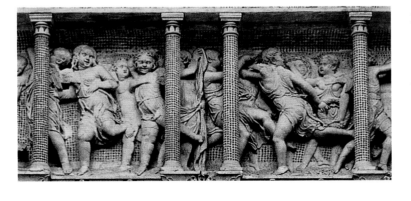

potential for cruelty in his own dynamic renditions. He emphasized the violence that was occurring with precise depiction of muscular tension in the bodies of his subjects, making use of excessive gestures of raised arms and legs that Alberti did not find at all pleasing. Pollaiolo produced an extraordinary series of scenes of abductions and fights, including the well-known engraving *Battle of the Nude Men*: enraged men, completely naked, mangling one another in a spasm of fury and violence equaled perhaps only by Mantegna's *The Battle of the Sea Gods* (c. 1494). The aggressive gestures of single individuals would be absorbed into the furious movement of the overall scrimmage, in the

bronze bas-relief of the *Battle* executed by Bertoldo (c. 1479), and produced after the model of the ancient statues that had also inspired young Michelangelo's *Battle of the Centaurs* (1490–92). In interpreting all the dramatic force of the battle, the intensification of movement, as a "formula for pathos" in Warburg's definition, also weighs upon the subjects' faces, masks contracted in a cry of aggression, or a scream of physical pain. Movement of the body thus becomes an extension of the facial expression, and artists developed this solution further to give expression to the soul's most profound sufferings. Alberti wrote that "these movements of the soul can be seen in the movements of the body." And Donatello chose

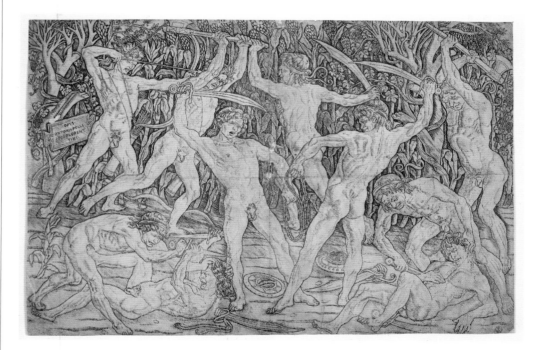

Antonio del Pollaiolo
Battle of the Nude Men
c. 1475, engraving.
Florence, GDSU,
124 st. sc.

The explosion of violence, supported by the graphic tension of Pollaiolo's incisive line, itself constitutes the subject of this engraving with no historic or mythological references. The *horror vacui* of the composition amplifies the destructive energy.

Donatello
Deposition in the Tomb
1446–50, stone.
Padua, Basilica of Saint Anthony, high altar.

In the restricted depth of *stiacciato* low relief, the progressive wave of pain proceeds from the inert body of Christ to the grief-stricken gestures of the male figures and culminates in the heart-rending movements of the devout women.

to use excessive gesture in his depiction of the most excruciating episode in Christian iconography, the mourning of the body of the dead Christ. In the bas-relief for the altar of the basilica in Padua (1446–50), behind the male figures who are laying the body of Christ to rest in the sepulcher, the pious women break into disorderly movements, they scream their grief and raise their arms to the heavens and pull at their hair. The airy nymphs have been transformed into wailing grievers whose gestures are wild and theatrical, following the exacerbated expressions of the ancient pagan *conclamationes*, or lamenters. Once again, the inspiration came from classical bas-reliefs, such as the sarcophagus depicting the *Death of* *Meleagrus* (Palazzo Montalvo, Florence), where in a crescendo of pathos the crying women pull at their hair with such fury that they bend back with their arms extended behind them. Paying careful attention to philological detail, Giuliano da Sangallo reproduced this composition in the frieze of the *Laments*, which he executed for the funeral memorial of Francesco Sassetti (Santa Trinita church, Florence; 1485); while showing a sensitivity closer to that of Donatello, Francesco di Giorgio developed the motif in a vertical composition in his *Mourning the Dead Christ* (Santa Maria del Carmine, Venice; c. 1477), interpreting Mary Magdalene as an uncontrollably suffering and frantic matron, almost as if she were possessed, her hair in

Niccolò dell'Arca
Lamentation Over the Dead Christ, detail
c. 1485, terracotta.
Bologna, Santa Maria della Vita.

With realistic effects, the terracotta renders the lament's expressive intensity, while the treatment of the gestures and clothing of Mary Magdalene illustrated here, as well as those of the Virgin and the other pious women, marks the progressive externalization of their pain. The original position of the statue remains uncertain.

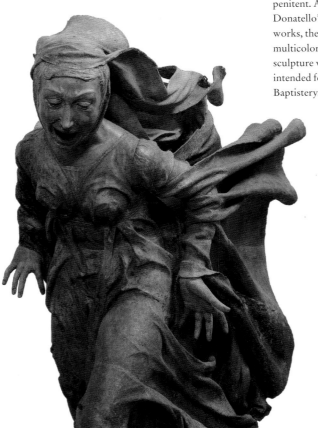

Right:
Donatello
The Penitent Magdalene
c. 1456, sculpted wood.
Florence, Museo dell'Opera del Duomo.

The vanity of the flesh is now consumed in the mystic intensity of the skeletal face of the penitent. Among Donatello's final works, the originally multicolored wooden sculpture was probably intended for the Florence Baptistery.

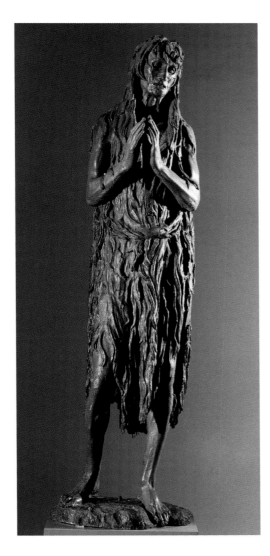

The Renaissance *Movements of the Body and the Soul*

disorder, her arms raised to the heavens, her face locked in terrible pain. Alongside its gracious and graceful ways, art in fifteenth-century Tuscany was also pervaded by this excruciating spirituality that focused on the figures of penitent saints, such as the extraordinary emaciated wooden *Magdalene* produced by Donatello (see page 43). The emotional intensity of the *Compianto* would be developed further in monumental works in Emilia; in the polychrome terracotta statues of Guido Mazzoni, who modeled faces marked by suffering with careful attention to descriptive force; or the work of Niccolò dell'Arca, who extended the shockwave of the soul's suffering into a crescendo of uncontrollable

movements and flowing clothing full of tormented folds. He did so in the sculptural group he executed for the church of Santa Maria della Vita in Bologna (see page 43). Another contemporary example from Bologna is the work of Ercole de' Roberti, who painted suffering figures with the same dynamic emphasis, such as his *Crucifixion* in the Garganelli Chapel in the church of San Pietro. The only remaining fragment depicts the face of Mary Magdalene torn by a scream and covered in tears. Ercole de' Roberti was from Ferrara, where Cosmè Tura had applied his disquieting linearity to different interpretations of the *Compianto*, making Christ thin and wiry, with nervous, taut muscles, and distorting the faces

Cosmè Tura
Pietà
1474, tempera
on wood panel.
Paris, Louvre.

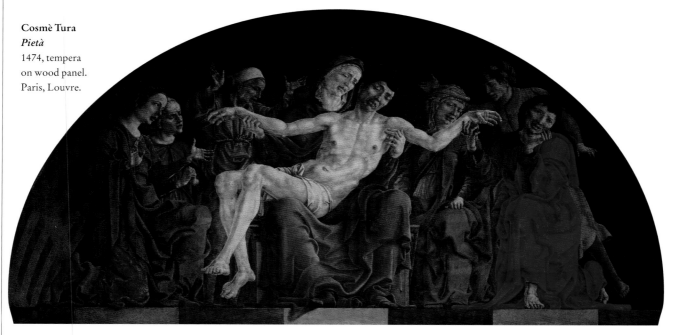

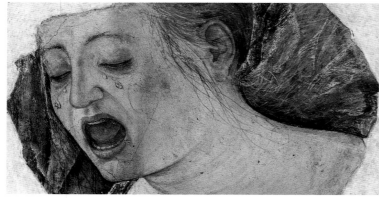

Left:
Ercole de' Roberti
Head of Mary Magdalene crying, fragment from the Crucifixion in the Garganelli Chapel pre-1486, fresco. Bologna, Pinacoteca Nazionale.

The only fragment from Ercole de' Roberti's activity in Bologna, this grief-stricken *Magdalene* confirms the productive exchanges between this painter from Ferrara and the sculptor Niccolò dell'Arca.

of the Virgin and the saints in grimaces of pain. This kind of pathos (albeit with more restrained gestures), based on the expressive intensity of the trait that overwhelms facial features and brings abundant tears to the eyes (an approach that was clearly inspired by models from the North), was also explored by Carlo Crivelli, a very atypical Venetian who worked mostly in the Marches region. Although excessive facial expression or gestures may well have offered support for intense devotion (as Alberti wrote, "we cry with those who cry, we laugh with those who laugh, and we feel pain with those who feel pain"), these excesses were not necessarily well received by Catholic theologians. Unrestrained pagan mourning was not suited to the norms of Christian funeral lamentation, sustained by faith in the Resurrection, which at the most made way for some mild crying. Alongside the intensification of exterior movements, artists developed a poetics of restrained pain, of inner profundity. The highest form of this approach, inspired by the Flemish analytic description of mourning, was achieved by Giovanni Bellini in Venice. In the Brera *Pietà* (c. 1460–65), as can be read on the scroll painted on the sarcophagus, pain is held back at the very edge of the eyes, the windows of the soul: "Just as these eyes swollen with tears could groan, so the work of Bellini could also weep."

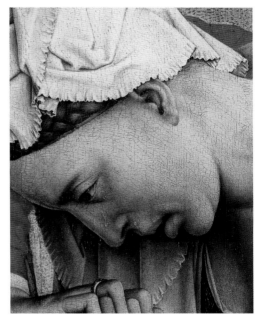

Rogier van der Weyden
*Deposition From the
Cross*, detail
c. 1435–37,
oil on wood panel.
Madrid, Prado.

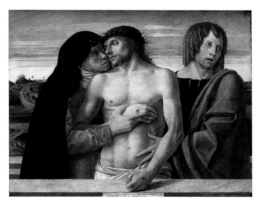

HAEC FERE QVVM GEMITVS TVRGENTIA LVMINA PROMANT
BELLINI POTERAT FLERE IOANNIS OPVS

Giovanni Bellini
Pietà, entire painting and detail
c. 1460–65, tempera on wood panel.
Milan, Brera.

Liberally taken from an elegy by Propertius, the inscription compares the lament in the figure with the lament of the miraculous image and praises the power of Giovanni Bellini's painting, with mimetic qualities that emotionally involve the devotion of the faithful.

Antonello da Messina
*The Dead Christ
Supported by an Angel*
c. 1475–76, oil on
wood panel.
Madrid, Prado.

Attentive to Flemish models and in contact with Giovanni Bellini in Venice, Antonello gave these figures mournful positions of resigned composure and expressions of inner depth. He describes with analytical precision the tears and drops of blood that run silently down the body.

Movements of the Body and the Soul

The Renaissance

The Polyptych and the Altarpiece

Changes in paintings for the altar that shifted from the multi-faceted system of the polyptych to the unified and syntactical system of the altarpiece bear witness to the quest for spatial and compositional unity that was such a feature of the fifteenth century. History is by no means linear, and may be put together piece by piece, like a mosaic, because many works have survived to our day in dismembered form, or without their original frames. Far from being merely decorative, frames were a fundamental element of the painting that also served as a way to organize space. From the early years of the fourteenth century, the Gothic frame, decorated with pinnacles and blossoms, formed a sumptuous compositional grid into which the artist could place, around the central image of the Virgin and Infant Jesus, the images of saints, prophets, angels, as well as a number of narrative scenes and *imago pietatis* (the image of the dead Christ sitting upright in his tomb). The organization of the scene was rationalized towards the end of the century, making use of a number of superimposed registers. At the center, the artist placed the Virgin and a number of saints depicted full length; below, in the part known as the predella, the artist placed episodes from the life of the Virgin or the lives of the saints; finally, in the upper part, there would be a devotional image. Towards the middle of the fourteenth century, Ambrogio

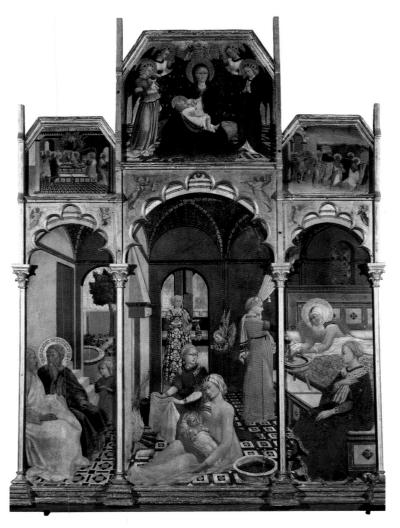

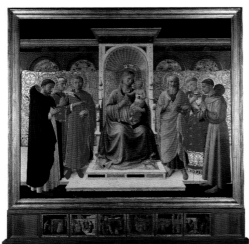

Left:
Maestro dell'Osservanza
Nativity of the Virgin
c. 1436, tempera on
wood panel.
Asciano, Museo Civico
Archeologico e d'Arte,
Sacra Palazzo Corboli.

The central section of
this painting is the noble
house, and birthplace
of the Virgin, the other
episodes of her life are
portrayed in the upper
sections and predella,
now detached.

Beato Angelico
Annalena altarpiece
c. 1430, tempera on
wood panel.
Florence, Museo di
San Marco.

One of the earliest examples
of a *tavola quadrata*, the
arrangement of the polyptych
in this so-called altarpiece
preserves the relation
between the saints in the
central section and the
narrative scene of the predella
with episodes from their
respective hagiographies.

and Pietro Lorenzetti from Siena interpreted this compartmentalized structure as though it were an architectural section opening onto a single, seamless three-dimensional space designed for a single narrative. They adopted this solution with faithful attention to detail, introducing mathematically rigorous perspective, starting with the Master of Observance in the polyptych known as the *Birth of the Virgin*. Florentine artists continued along these lines, although they disassociated the design of the frame from the spatial structure of the painted scene itself, achieving a contrast between the narration and its frame, such as in the *Deposition of Christ* started by Lorenzo Monaca and finished by Beato Angelico (Museo San Marco,

Florence; 1436–40). In Florence, the quest for compositional unity led above all to the invention of the *square panel*: a central panel where the Virgin and saints were reunited in a single perspective space, with a frame of evident geometric design, free of external ornament, which also featured a predella and occasionally a semicircular lunette. In the polyptych, the hierarchy of the picture was imposed from without by the divisions in the painting; in the square panel, such hierarchy is assimilated into the composition by means of the painted architecture. Angelico produced one of the early examples in his Annalena altarpiece (1430), using a rather simple principle: The Virgin's throne is detached from the wall in the background while

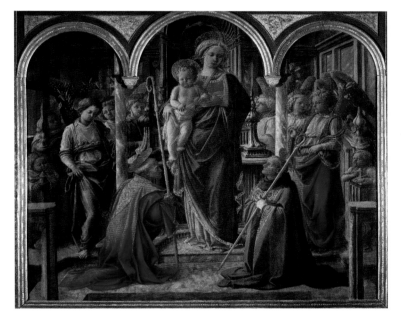

Filippo Lippi
Barbadori altarpiece
c. 1437–38, tempera on wood panel.
Paris, Louvre.

Lippi again uses a frame divided into three arches with corbels that are slightly staggered with respect to the columns framing the Virgin, but perfectly perpendicular to the position of the saints in the foreground. This staggering underlines the distinction between sacred place and place of veneration.

Domenico Veneziano
Saint Lucia altarpiece
c. 1445, tempera on wood panel.
Florence, Uffizi Gallery.

If the perspective construction of the altarpiece articulates in depth the plane of the saints, the composition gets its visual unity from the plane of the Madonna, the exedra in the background and the grove in the garden showing the tops of orange trees, and the arcade that corresponds in the upper section to the edge of the painting. The predella is now in pieces in various museums.

the saints are placed in positions corresponding to the arcades, on different levels of the steps. The compositional grid was at a later stage developed further, in particular by Domenico Veneziano, using more complex perspective principles, in order to join and at the same time separate the Virgin's impenetrable space from the space occupied by the saints, separating devotion from veneration. In the Santa Lucia dei Magnoli altarpiece (see page 47), the portico arcade determines at one and the same time the general layout of the composition, the vertical division of the different subjects, and their positioning in the depth of the composition; while the Virgin is seated on a throne under the loggia, the saints are located in front of columns in a separate area. These semantic and compositional explorations of how to structure the internal space of the painting would eventually produce the altarpiece, designed as a unified representation depicted on a single support, without predella or cusps. The screen was created outside Florence, however, by a pupil of Domenico Veneziano, one Piero della Francesca. In the Montefeltro altarpiece, painted in Urbino in all likelihood around 1472–74 (see page 94), della Francesca positions his subjects in a wide architectural space that is developed vertically and topped by an arcade that recalls the apse of a church. The hierarchy of the different figures is determined by their respective positions, although the group

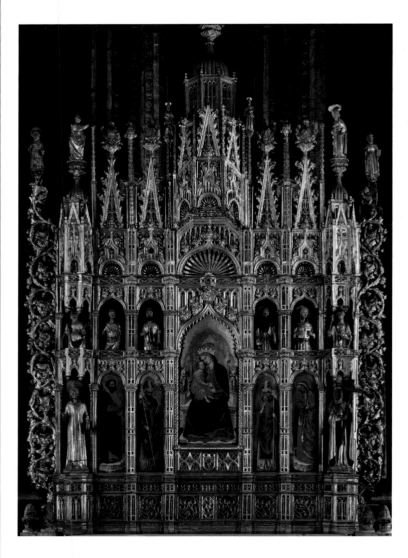

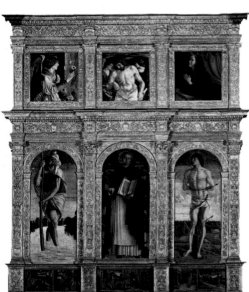

Antonio Vivarini and Giovanni d'Alemagna
Polyptych of Santa Sabina
1443–44, engraved wood, gilded and painted. Venice, San Zaccaria.

These polyptychs from the Murano studio of Antonio Vivarini, who worked alongside his brother-in-law Giovanni d'Alemagna, evoke the perspective of Gothic architecture.

Giovanni Bellini
Saint Vincent Ferrer polyptych
c. 1460–65, engraved wood, gilded and painted. Venice, Santi Giovanni e Paolo.

In his first great public work, Bellini adheres to the traditional design of polyptychs but orders the frames with forms from classic architecture.

does present a united front from which the slightly more prominent Virgin is detached. A few years later in Venice, in 1475, Giovanni Bellini and Antonello da Messina would arrive at a similar solution, placing the Virgin on a raised throne below the wide apse arcade, higher than the saints, and placing music-playing angels at her feet. Of the two fundamental works, Bellini's *Santa Caterina di Siena altarpiece* has been lost, while only a few fragments of Antonello da Messina's *San Cassiano altarpiece* have survived (Kunsthistorisches Museum, Vienna). Later works by Bellini, such as the *San Giobbe altarpiece* (c. 1480) clearly demonstrate how innovative this type of work was. The compartmental structure of the typical polyptych

served to bring external architectural perspective to the composition, and in Venice this approach could be seen in Gothic works by Antonio Vivarini and Giovanni d'Alemagna. Bellini had produced his own interpretation which had been rationalized by means of a classically regular frame in his *Saint Vincent Ferrer polyptych* (1460–65). Gradually the compartmentalized polyptych was unified into a pictorial composition and transformed into an inner architectural space. Subsequently, the altarpiece would go on to become the predominant, albeit not exclusive, form of altar painting, progressively freeing itself from its original ties to the architectural frame and opening itself up to explore landscape-related themes.

Giovanni Bellini
Saint Job altarpiece
c. 1480, oil on
wood panel.
Venice, Gallerie
dell'Accademia.

Inside the church, the unified altarpiece, with a monumental architectural design, offers an ideal spatial continuity, as if the immanence of the Divine had taken shape in the opening of the new chapel with the apparition of the Virgin and the saints. A clear reference to Saint Mark's Basilica, the golden mosaic gives a "Venetian" connotation to the place of worship.

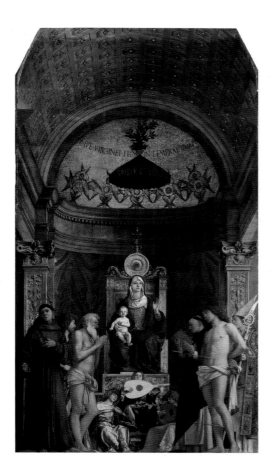

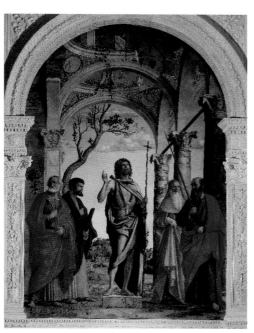

Cima da Conegliano
Saint John the Baptist altarpiece
c. 1490–93, oil on
wood panel. Venice, Santa Maria dell'Orto.

Cima developed the Bellini style, giving notable attention to the opening onto the landscape that would lead him to portray the figures of the Virgin and saints directly in the landscape (*Madonna with the Orange Tree*, 1496–7). In the painting shown here, the central role is instead assigned to the Baptist, who announces the coming of Christ by pointing his index finger heavenwards.

Istoria — The Story

In his treatise *On Painting* (1436), Alberti compared the surface of the painting to a transparent glass and the rectangular or square boundary of the picture to the frame of an open window. The new concept of what a painting was, based on the "legitimate construction" of perspective, allowed artists to develop a "cutting vision," as Dürer would later call it. What could be seen from the painting-window was not some illusory view of the world, however; rather, it was exactly "what would be painted there," or, in the words of the Latin version of Alberti's treatise (1435), the *historia*. From history comes story. This account is the "greatest work of the painter," from which he will obtain the highest recognition for his talent, and is the fulcrum of Alberti's reflections. While there may be a hint of the idea here that narrative painting is in some way superior (a notion later codified in the seventeenth century in the hierarchical system of genre paintings), Alberti's concept of *istoria* should not be considered a simple synonym of "story," in the sense of narrative subject, because in Alberti's view *istoria* also embraced how the subject was represented. In this dialectical relationship, the idea of *istoria* takes on a number of nuances which may refer to the composition of the painting itself, or to the action depicted, as can be seen when we compare the Latin and vernacular versions of Alberti's text.

Lorenzo Ghiberti
The Flagellation of Christ
1403–04, gilded bronze.
Florence, Baptistery, north doors.

Ghiberti used classic ancient forms in creating the architectural structure of the Gothic composition, which shows the place of the event with an impenetrable surface, while the pattern of the columns allows the arrangement of the figures in line with new principles of symmetry, made dynamic by the counter-movement of the torturers.

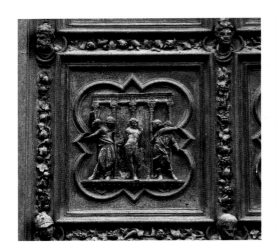

Above:
Donatello
The Feast of Herod
1427, gilded bronze.
Siena, panel from the cathedral baptistery.

Donatello completely encloses the story's setting in the architectural structure of this famous panel, with edges that reach the frame of the portrayal of this holy scene. This perspective construction allows the opening in depth of a series of environments that recount the drama up to the piteous climax, in the foreground, when the Baptist's head is presented to Herod.

Lorenzo Ghiberti
Joseph's Story
1425–52, gilded bronze.
Florence, Baptistery,
The Gates of Paradise.

At times the word *historia* is translated with the Italian word *pittura* ("painting"), while *istoria* ("story") could substitute for the Latin expression *res de qua agitur* ("the action in question"). In other words, *istoria* is the subject, the compositional principle applied, and the representation. In this context, perspective acts as a kind of syntactical tool to build up the narrative in keeping with criteria of intelligibility and convenience that are part of the tools of effective rhetoric, in order to establish a spatial setting directly linked with how the action is articulated. On the one hand, the rules of perspective allowed the artist to create a space where sizes are proportional to the figures depicted, a space in which the scene could conceivably take place, avoiding the error of representing a subject "closed within the building as though within a case, where having sat down, all the space is filled:" a hallmark of Gothic art. On the other hand, such proportional ratios allowed the artist to establish clearly the relationships among the different figures in the scene located at the same or different distances. Although the artist would seek "the copy and variety of things," the choice of compositional elements would in any case be conditioned by the needs of the narrative, in order to avoid the excesses produced by *horror vacui* ("fear of the void"). The latter led to the untenable and unjustifiable multiplication of figures and details that left no empty space but rather

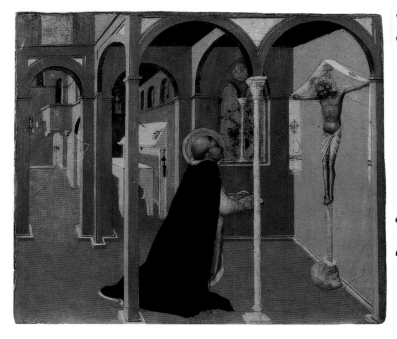

Sassetta
Vision of Saint Thomas Aquinas
c. 1426–27, tempera on wood panel.
Vatican City, Pinacoteca Vaticana.

From the fourteenth century, Sienese painting elaborated the concept of the pictorial surface as an architectural section of the portrayal's setting. In the new century, Sassetta further developed the idea with the principles of perspective, multiplying the divisions in the spatial structure with openings onto various environments that, instead of performing a narrative function, served to "decorate" the story.

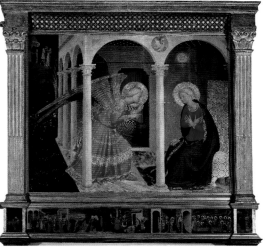

Beato Angelico
Annunciation
c. 1433–34, tempera on wood panel.
Cortona, Museo Diocesano.

The clear perspective construction of this painting defines the setting of the Virgin as much as it conceals the exact extension. The third frontal arch of the cubic niche is cut out of the frame, though exactly how the Madonna's chamber opens to the background is unclear. These ambiguities translate into images the immeasurable mystery of the divine that penetrates into the measure of the human world.

introduced only "dissolute confusion." Thus, "it seems that the story is doing nothing of worth, but seems rather piled up in a tumult." The principles of clarity and intelligibility that were applied to the *istoria* freed human action from the incomprehensible irrationality of disorder and elevated such action to the dignity of *exemplum*, the example to be transmitted to others, to be remembered and taught. Alberti advised artists to include a figure in their compositions "who admonishes and informs us of what is happening," a figure who turns to the viewer to point out, with a movement of the hand or facial expression, the significance of the episode depicted. The viewer's gaze is thus considered an integral part of the *istoria*, in order to transmit the meaning of the narrative more efficiently but also as a way of ensuring appreciation of the quintessentially pictorial qualities of the representation. Not only would the *istoria* clearly represent a worthy action, it would also be "ornate and graceful" enough to capture the attention "with pleasure and by moving the spirit, of any learned or unlearned person who looks upon it." According to Alberti, the artist who paints *istoria* is a "learned" man who first and foremost has a good knowledge of "geometry." By the time *On Painting* was being prepared for publication, the technique of perspective had already shown its potential for developing narrative order, in painting and in the composition of bas-reliefs. In designing the bronze figures for his first baptistery door (see page 50), Ghiberti may well have settled for the simple spatial

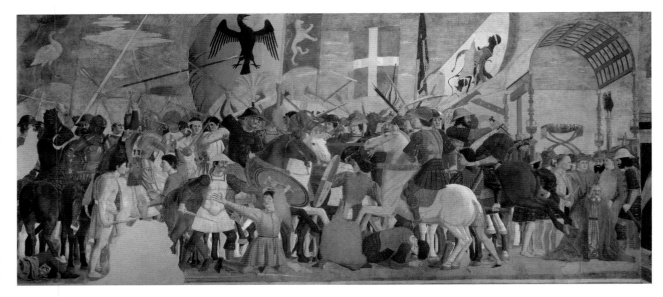

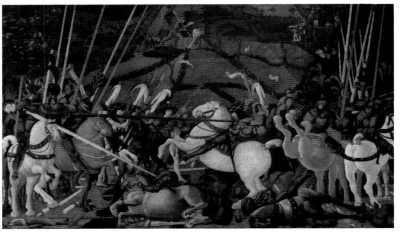

Above:

Piero della Francesca
Battle Between Heraclius and Chosroes
c. 1452–66, fresco. Arezzo, San Francesco.

Paolo Uccello
Battle of San Romano
c. 1438, tempera on wood panel.
Florence, Uffizi Gallery.

The Florentine victory over the Sienese at the battle of San Romano (1432), and the triumph of the Christian emperor Heraclius narrated in the *Legend of the True Cross,* are both interpreted according to geometric principles. Clear spatial arrangement of volumes suspend and organize the commotion of the action into intelligible proportions.

structure of Gothic tradition, arranging the scene in front of a closed architectural element, a surface framing the scene that defines the site of the action without containing it. Donatello, on the other hand, in executing the bas-relief for the baptismal fount in Siena Cathedral, decided to make use of the illusion of depth created by perspective in order to depict in a seamless succession of scenes the narrative sequence of *Herod's Feast* (1427). Ghiberti would seem to have learned from Donatello's experiment, because in the forms he created for his second baptistery door (1425–52), he made use of perspective to give a clear sense of organization. He did so over the different levels of distance in what appeared to be a single composition, to the various stages of the Old Testament episodes represented. In

painting, the traditional "box" was still widely used, although this spatial container had in a sense been adapted to accommodate the dimensions of the human body, and was now opening up to include a variety of settings. Sassetta from Siena still constructed the container in an empirical way, in the narrative scenes painted in the predella of his compositions, whereas the perspective employed by Beato Angelico in his *Annunciations* was based on rigorous mathematical principles; here, perspective had all the semantic force of a theological declaration. For example, in the Cortona *Annunciation* (p. 51), the vanishing point is located to the far left, on the edge of the Virgin's *hortus conclusus* ("walled garden"), below the threshold of Paradise. Another line, parallel with the horizon line and

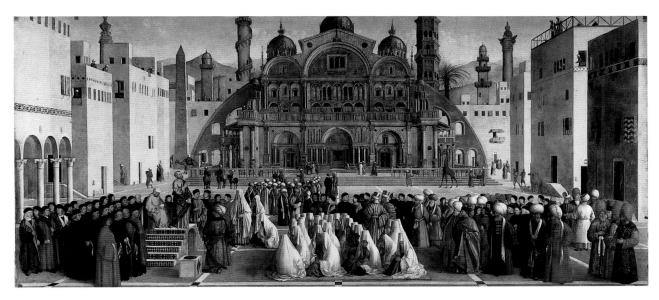

Above:
Gentile and **Giovanni Bellini**
Sermon of Saint Mark in Alexandria
1504–07, oil on canvas.
Milan, Brera.

In Venice, because of the humidity, narrative cycles were not done in frescoes but painted on a series of canvases, an ornament exclusive to the artistic fraternities. This immense canvas (347 x 770 cm), intended for the Scuola Grande di San Marco, was begun by Gentile Bellini, who specialized in this genre of painting, and finished after his death by his brother Giovanni.

Carpaccio
The Miracle of the Relic of the True Cross on the Rialto Bridge
1494–95, oil on canvas.
Venice, Accademia.

The narration of the miracle is isolated in a corner of the broad view of the Grand Canal, in the arcade to the left in the foreground, perhaps to underline the immanence of the divine in everyday Venetian life.

corresponding to the pull of the arcade, links the banishment of Adam and Eve to the Holy Spirit, tying original sin to the promise of redemption through the incarnation of Christ. A number of painters who were particularly attentive to the possibilities offered by perspective, such as Paolo Uccello and Piero della Francesca, showed that even the wild tumult of battle could be influenced by the geometric rationalization of the narrative. They defined with meticulous precision the exact location of each warrior, using contrasting movements and carefully executed scenes (see page 52). Alberti's learned painter had to be familiar not only with geometry, but also with the works of the poets and orators; he had to associate with men of letters, because not only did the latter "have many

qualities in common with the painter," but many also were "of good advantage in composing the *istoria*, every praise for which lies in its invention." Alberti was once again emphasizing the noble nature of painting, recalling Horace's well-known comparison between poetry and painting—*ut pictura poesis*—understood here to mean the poet's and painter's shared ability to illustrate complex subjects, as well as their similar rhetorical devices. This relationship could be seen in the painted representation of ancient textual sources, such as the well-known *ekphrasis* by the satirist and rhetorician Lucian on the painting the *Calumny* by Apelles, of which Botticelli later painted a version of his own. It was seen in the contemporary interpretation of classical subjects, such as Botticelli's

Right:
Sandro Botticelli
Spring
c. 1485, tempera on
wood panel.
Florence, Uffizi Gallery.

The allegory of the return of spring under the sign of Venus, who appears in a flowery garden with symbolic oranges and laurels, accompanied by Mercury, the Graces, Flora, Zephyr, and Clori, was painted for Lorenzo di Pierfrancesco de' Medici, with the iconographic program inspired by ancient classic sources set in his cultured circle frequented by humanists.

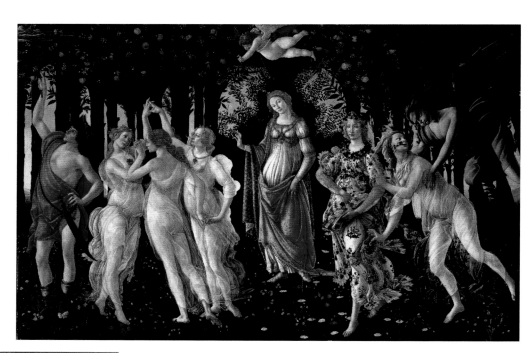

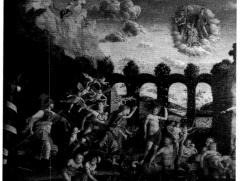

Andrea Mantegna
Minerva Chases the Vices from the Garden of Virtue
1497–1502, tempera on canvas.
Paris, Louvre.

This complex moral allegory, the result of Mantegna's humanistic consciousness and dialogue with literary figures from the court of Isabella d'Este, was intended for the small study of the Marquise of Mantua as part of a cycle of paintings that exalted the virtues and culture of the commissioning patron.

Primavera (*Spring*), which was freely adapted from different sources, including *De reurm natura* ("On the nature of things") by Titus Lucretius Caro (Lucretius), or again Mantegna's *Minerva Chases the Vices from the Garden of Virtue* (see page 54), a contemporary allegory (in a deliberate classical style) of the virtues of the patron who commissioned the painting, Isabella d'Este. The scene was in all likelihood painted on advice from Paride di Ceresara, a poet from Mantua. While Alberti's recommendations received wide acknowledgement in the fifteenth-century painting context, Leonardo da Vinci questioned the validity of Alberti's thinking, despite having learned his art in the tradition of that particular school. Not only would Da Vinci contest the "truth" of the legitimate

construction, he would also shake off the restriction imposed by the need for a transparent surface to the painting. Instead, he favored the idea of the outline, achieved through careful modulation of light and shadow, that would lead to the dissolution of the limits to the *istoria's* setting.

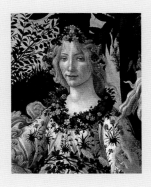

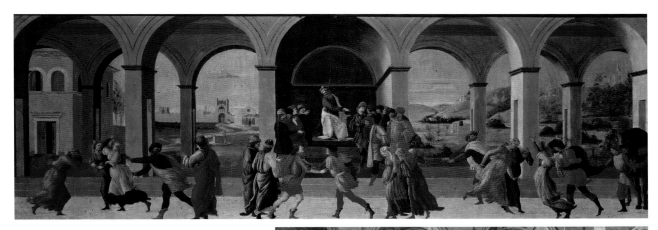

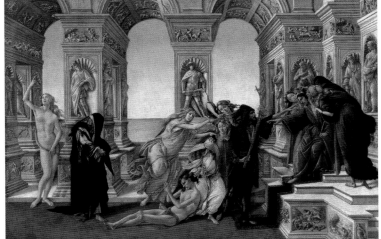

Filippino Lippi
Story of Virginia
1470–80, wood panel.
Paris, Louvre.

The edifying story of Virginia originally decorated the front of a chest. Filippino Lippi expressed the three episodes in the story — the arrest of Virginia, Virginia condemned to slavery, Virginia killed by Virginius — on a stage subdivided by the columns of the arcade, open onto a broad landscape.

Right:
Sandro Botticelli
The Calumny of Apelles
c. 1494, tempera on wood panel.
Florence, Uffizi Gallery.

The lost *Slander* by Apelles, known only by Lucian, is cited by Alberti as an example of the pleasure created in itself by a lovely "invention" and the ornament added by the talent of the artist. In retranslating the ancient text into image, Botticelli compares himself with the most famous painter from classical antiquity.

Lexicon of the Classical Age

Through their dialogue with antiquity, the arts were fully involved in the culture of the Renaissance. Artists sought to understand the essence of what they considered to be the peak of perfection; they sought the underlying structural, harmonic, and expressive principles that would allow them to found a "modern" conception of representation. The ruins and archeological findings from the Classical Age were also an inexhaustible source of new formal motifs, which came together to form not just a repertoire of ornamental devices, but a real lexicon that would allow architecture, sculpture, and painting to express themselves with a shared "ancient" language. The philological studies undertaken by artists in Florence, supported by trips to Rome, were the basis for this lexicon which, towards the middle of the century, began to spread in use across Italy, not only due to the efforts of artists who studied antiquity, such as Donatello in Padua, Alberti in Rimini, Ferrara and Mantua and later Bramante in Milan, but also due to the publication of collections of classical models. Spurred by this trend, around 1450 the greatest exponent of the Gothic style in Venice, Jacopo Bellini, began to compile collections of drawings in which the artist explored perspective backgrounds organized and framed by buildings of clearly classical influence (British Museum, London; Louvre, Paris).

Above:
Jacopo Bellini
Saint John the Baptist Preaching from the *Sketchbook*
c. 1450. Paris, Louvre.

The search for perspective models by Jacopo Bellini, inspired by the presence in the Veneto of Tuscan artists such as Donatello, Paolo Uccello, Andrea del Castagno, and Filippo Lippi, intentionally brings together structural elements taken from antiquity such as the rounded arch decorated in bas-relief that frames the *Baptist Preaching.*

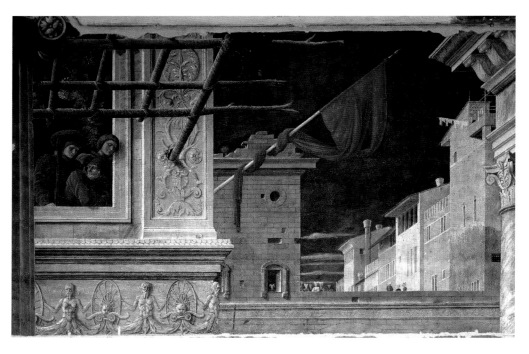

Left:
Giorgio Chiulinovich called Lo Schiavone
Madonna with Child
signed work
c. 1460, tempera on wood panel.
Turin, Galleria Sabauda.

Andrea Mantegna
Transport of the body of Saint Christopher, detail
1451, detached fresco.
Padua, Eremitani, Ovetari Chapel.

Heroic sentiment based on a monumental concept of classic antiquity already pervaded this first public work by Mantegna, produced in collaboration with Pizzolo, of which only this fresco remains after bombing during the Second World War.

The drawings were to be used in the artist's thriving workshop, where his sons, Gentile and Giovanni, served their apprenticeship. The workshop of Francesco Squarcione was active around the same time in Padua. Squarcione was a somewhat singular and controversial artist. He began his career as a tailor and embroiderer. Local sources praise his skill as an artist and scholar of antiquity, but modern historiography has called the extent of his talents into question. What is certain is that Squarcione had a number of young apprentices, such as Andrea Mantegna, Marco Zoppo, Giorgio Schiavone, and perhaps also Carlo Crivelli, whom he seems to have exploited rather than trained, as can be seen from the number of court

actions brought against him. In any case, the apprentices would have been able to study Squarcione's rich collection of ancient artifacts. The use of classical architectural motifs, festooned with fruit, to frame various works, such as the many examples of the *Virgin with Infant Jesus* (Carlo Crivelli, *Our Lady of the Passion*, Museo di Castelvecchio, Verona, c. 1460; Giorgio Schiavone, *Madonna and Child*, Galleria Sabauda, Turin, c. 1460), identified the works almost like a kind of factory hallmark. Mantegna soon turned away from this merely ornamental use of the classical repertoire. He re-created entire ancient settings to give a sense of monumentality to the *Histories of Saints James and Christopher* fresco cycles

Bramante
Man with a Broadsword
c. 1477–80,
detached fresco.
Milan, Brera.

In the frescoes in the Panigarola house in Milan, Bramante used powerful, classically inspired forms to express the humanistic theme of famous men, familiar to the artist from Urbino since he had decorated the small study of Federico da Montefeltro in Urbino's Palazzo Ducale.

Vincenzo Foppa
Martyrdom of Saint Sebastian
c. 1487–89, detached fresco.
Milan, Brera.

With softer tones in the fresco in the destroyed church of Santa Maria in Brera, Foppa examines the juxtaposition of the heroic anatomy of the Christian martyr and the monumental quality of classic architecture.

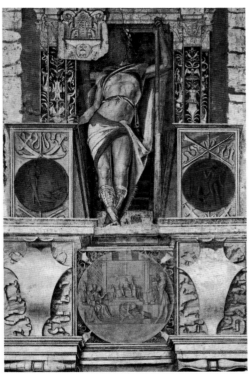

Bramantino
Argo
c. 1490–93, fresco.
Milan, Castello Sforzesco, Sala del Tesoro.

Possibly painted with the help of Bramante, the monumental *Argo*, set in trompe-l'oeil architecture with bas-reliefs influenced by classical antiquity, watches over the coffers of the duchy of Milan. In a reversal of the myth of Ovid, the giant of a thousand eyes has triumphed over Mercury, protector of thieves, over whom he brandishes the caduceus.

painted in the Ovetari degli Eremitani Chapel in Padua (1449-56). Mantegna found the key to his heroic compositions in the juxtaposition of ancient monuments and the human form, such as in his *Saint Sebastian* (Louvre, Paris, c. 1480; not shown in this collection). Here, the martyr's powerful physique competes, as it were, with the colossal ruined arch to which he is bound, underlining the triumph of the true faith over pagan idols and the grandeur of the new Christian humanity. This kind of heroic expression, which was achieved from the artists' under-standing of the principles of the monumentality of ancient models, was also a feature of the painting of Bramante when he arrived in Lombardy after his apprenticeship in Urbino, where

he had been in contact with Piero della Francesca and Merlozzi da Forlì. The subjects in his fresco cycle *Men of Arms and Philosophers*, for the Panigarola home in Milan (see page 57 for a detail), affirm their exemplary greatness in their imposing physiques, further emphasized by the proportional relationship with the sheer gigantic size of the classical-style invented architectural setting. This classical lexicon, which produced heroic human forms that looked like statues made flesh, would also bring a greater sense of monumentality to art in Lombardy (which until that time continued to favor a rather sumptuous ornamentation), as can be seen in the developments in the works by Bramantino and Vincenzo Foppa (page 57). The

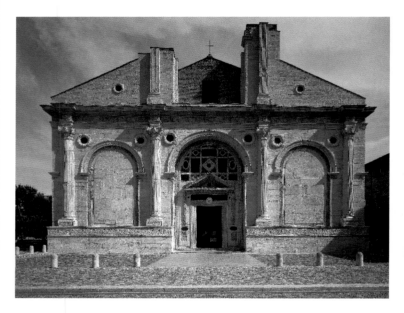

Leon Battista Alberti
Tempio Malatestiano
1447–50.
Rimini.

Originally the lateral arcades of this "triple-arched" triumphal arch in the incomplete façade of Sigismondo Malatesta's mausoleum were meant to be open to house the sarcophaguses of Sigismondo and his mistress Isotta, while the tombs of eminent men with their collection of classic epigraphs were placed in the arcades along the side walls in a series evoking ancient aqueducts.

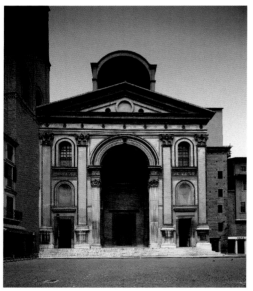

Leon Battista Alberti
Sant'Andrea
1470.
Mantua.

The façade of Sant'Andrea is unique in its deep, colossal central arcade, while the correlation of the triumphal arch and pediment underwent major changes, resolved in the organization of the flat wall surfaces, particularly in Bramante's projects in Milan, foreshadowing the future solutions of Palladio.

triumphal arch was the subject of numerous interpretations, and in architecture the motif was explored in philological terms by Leon Battista Alberti. Alberti used the arch in the *Tempio Malatestiano* to cover the façade and side walls of the old Gothic church of San Francesco (Rimini), and transform the building into a classical mausoleum in honor of the commissioning patron, Sigismondo Malatesta (1447–50). He did so with a sequence of classical-style arcades that was originally meant to correspond to the sarcophaguses of Malatesta and other illustrious figures. Throughout his career, Alberti elaborated with ever greater freedom combinations of different classical motifs, such as the single-barrel triumphal

arch and the pediment of a temple (a perfectly rational square module) that make up the façade of the church of Sant'Andrea in Mantua (1470). The result of archeological studies, the classical lexicon was gradually applied to a more modern syntax, which produced new solutions that appeared ancient. The motif of the triumphal arch with coffered vault, combined with the sarcophagus, classical epigram, lion heads, entwined acanthus leaves, and assembled *putti* bearing festoons, all constituted the ancient vocabulary of contemporary Florentine funereal monuments. Bernardo and Antonio Rossellino, Desiderio da Settignano, Mino da Fiesole, and Verrocchio all created numerous variations on these themes. The lexicon

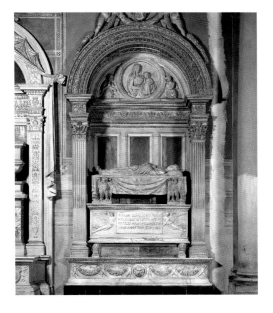

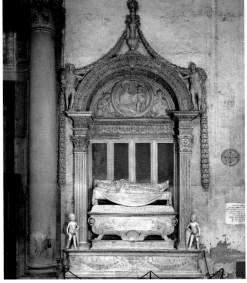

Andrea del Verrocchio
Tomb of Piero and Giovanni de' Medici
1469–72, marble, porphyry, and bronze.
Florence, San Lorenzo, Sacrestia Vecchia.

Bernardo Rossellino
Wall tomb of Leonardo Bruni
post-1444, marble.
Florence, Santa Croce.

Enclosed in the round arch, richly decorated with ancient classic motifs, the tomb of the humanist Leonardo Bruni ideally brings together the effigy of the deceased, shown above the sarcophagus, and the *Madonna with Child* in the lunette, in accordance with the composition of funeral monuments characteristic of Central Italy.

Desiderio da Settignano
Tomb of Carlo Marsuppini
1454, marble.
Florence, Santa Croce.

Although using the same motifs as the *Tomb of Leonardo Bruni* by Bernardo Rossellino, Desiderio da Settignano attempted to go beyond the architectural frame and has *putti* holding coats of arms, and angels holding luxurious festoons outside the limits of the arch.

In this nonfigurative interpretation of the Florentine tomb, Verrocchio substitutes the funereal effigies and images of the Virgin with the transitional transparency of a beautiful bronze grate.

would be developed further in Venice by Antonio and Tullio Lombardo or Antonio Rizzo. The fifteenth century produced its own version of the triumphal arch in the portal of the "Castel Nuovo" in Naples (1453–8), a collective work that may have been supervised by Pietro di Martino from Milan, with contributions from Domenico Gagini, the Dalmatian Francesco Laurana, and students of Donatello and other sculptors who had studied Roman archeology. The monument was commissioned in honor of the new ruler, Alfonso of Aragon, and was meant to ratify the ruler's power in solid stone (when in fact Alfonso's authority derived from a dynastic change wrested by force from the House of Anjou). Alfonso's triumphal entry into

Naples is depicted in the bas-relief in the middle of the portal, while the huge empty arch above may have been designed to house an equestrian statue of the ruler, as suggested by an examination of a drawing attributed to Pisanello's school (see below). There had been a precedent in Naples for the use of an equestrian statue; the funeral monument of King Ladislao features one (1428). In northern Italy, the equestrian statue, considered a heroic image, was gradually being disassociated from traditional funerary art, and was leaving the church to appear in public squares. This shift was a direct consequence of study of the ancient giant statues of Marcus Aurelius in Rome, and the so-called Regisole in Padua, not only because

Arch of Alfonso of Aragon
1453–58 and 1465–75, marble.
Naples, Castelnuovo.

The central bas-relief portrays Alfonso of Aragon's triumphal arrival in Naples, celebrated on February 26, 1443, the day the Royal Parliament ratified the new ruler's arrival on the throne. Completed by Alfonso's son, Ferrante, the arch was inserted in the reconstructions of the ancient fortress façade and clearly expressed the Aragonese conquest of what had been the capital of the Angevin dynasty.

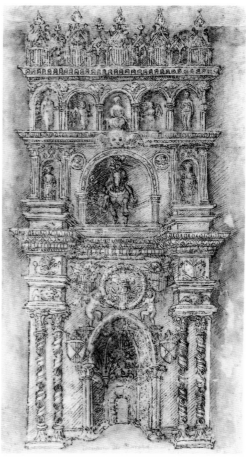

Cerchia di Pisanello
Portal with equestrian statue
c. 1452, sketch on paper. Rotterdam, Museum Boymans-van Beuningen, I. 527.

This design for a monumental portal brings together classic forms with Gothic rounded arches and shows remarkable similarity to the arch in Castelnuovo (illustrated here opposite). Perhaps it should be considered in relation to a lost painted decoration commissioned by Alfonso of Aragon for Capuano Castle. Sources testify that this showed an equestrian figure of the sovereign.

of the form of the work, but also because of the use of a noble material like bronze. It was perhaps hardly surprising that the three giant equestrian statues executed in the fifteenth century were all by Florentine artists, given the technical skill and immersion in classical cultural that were so much a feature of Florence's artistic circles. The statue of Niccolò III d'Este (now lost) was executed by Niccolò Baroncelli and Antonio di Cristoforo; it was meant to be placed on a pedestal designed by Leon Battista Alberti and sited against the façade of Ferrara cathedral (1444–51). The famous statue of Gattamelata was executed by Donatello and placed in front of Padua Basilica (1447–53). The statue of Bartolomeo Colleoni was executed by Verrocchio and placed in front of the Church of Santi Giovanni and Paolo in Venice (1486–95). The last two statues were reinterpretations of ancient figures and celebrated the military qualities of captains of the Most Serene Republic of Venice in their role as defenders of the republic's dominion and independence. Their imposing scale, set within an urban space, was soon used to celebrate not only heroism but also the political power of rulers. To this end, the Duke of Milan, Ludovico Sforza (known as the "Moro"), commissioned an equestrian statue of his father Francesco from Leonardo da Vinci, but it was never finished (1485–99).

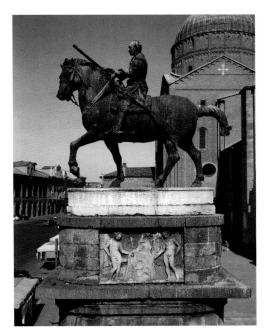

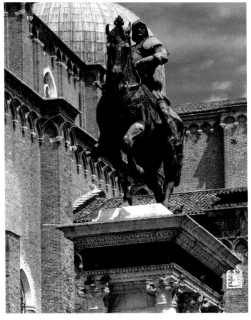

Filarete
Marcus Aurelius
c. 1450, bronze.
Dresden,
Skulpturensammlung.

The model of classic statuary profoundly influenced the imagination of the Renaissance and gave rise to a series of classic reinterpretations in a smaller bronze format by artists such as Filarete or Il Riccio. Jacopo Bonacolsi achieved such a level of classicism in his works that he earned the nickname "Antico."

Donatello
Equestrian Monument of Gattamelata
1447–53, bronze.
Padua, Piazza del Santo.

This famous monument was erected in front of the Basilica of Saint Anthony, where the leader was entombed. Cyriacus of Ancona states that this was commissioned by the Venetian Senate to honor Gattamelata for his loyalty and courage. The armor, as well as the breed of horse, marks this sculpture as a modern interpretation of ancient models with a classic appearance.

Andrea del Verrocchio
Equestrian Monument of Colleoni
1486–95, bronze.
Venice, Campo San Zanipolo.

Colleoni left a large inheritance to the Republic of Venice on that condition an equestrian statue of him be erected in Piazza San Marco. For this early monument with a set burial place, the Senate preferred a central location in front of San Zanipolo, and after a competition assigned Verrocchio the construction, completed after his death by Alessandro Leopardi.

The Portrait

The contemporary interpretation of classical models in the Renaissance yielded new forms of portraiture other than the equestrian statue, including the much smaller medallion. Inspiration came from ancient coins, many of which had been conserved and collected since the fourteenth century. The metal coins had resisted the passage of time and had proved to be vectors of immortality. The coins could be reproduced and distributed easily, and the fact that the image could be associated with an inscription guaranteed identification. The Renaissance medallion differed from its classical antecedents in that it had no monetary value and was not coined but smelted,

using the lost-wax technique, which ensured greater finesse. One side of the medallion presented the endeavors of the person depicted, a kind of emblematic portrait of the person's virtues and qualities. In this sense, the medallion was similar to the literary portrait and its description of the person in question. It was probably no coincidence that the new form of the medallion was created in the 1430s in the humanist court of Leonello d'Este in Ferrara (where Guarino from Verona taught) by the painter and acclaimed portraitist Pisanello. Pisanello became so successful that he was sought after by the most powerful rulers of his time. The medallion would go on to become an essential element in the representation not only of

Pisanello
Medal with Leonello d'Este (recto) and *Blindfolded lynx* (verso)
1441–44, bronze.
London, British Museum, inv. Hill no. 28.

The stylized profile of the thin face is given movement by a lion-like mane that evokes the name of the Marquis of Ferrara. Pisanello portrayed Leonello d'Este several times in a painting and numerous medals with different reverse sides, a symbolic gallery of the prince's virtues.

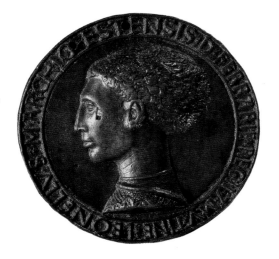

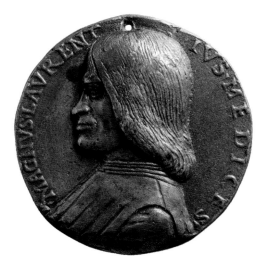

Niccolò Fiorentino (Niccolò di Forzore Spinelli)
Medal of Lorenzo the Magnificent
c. 1490, bronze.
Florence, Bargello, I 5999.

rulers, but also of illustrious men of letters or arms. It attracted the interest of a number of artists, such as Matteo de' Pasti, Cristoforo di Geremia, Sperandio da Mantova, and Niccolò Fiorentino. With a few rare exceptions, and unlike the more noble forms of coins in the sixteenth century, the persons depicted on medallions were usually in contemporary dress shown in half-length profile (cut off linearly), a tactic similar to the technique adopted for sculpted busts which were also receiving considerable attention from artists of the time, especially in Florence. The example offered by statues from antiquity also played an important role in the development of statue busts, especially in association with classical sources

such as texts by Pliny or Polybius, which explained how Rome's patrician families used to keep wax images of the departed in the atriums of their homes. Florence had a long-established tradition of wax art, represented by generations of craftsmen who "made images." These include the Benintendi family, who used casts taken directly from the faces of their subjects to model wax masks of the departed and the living, the masks being used in particular for votive effigies. Due to the extreme characterization of the physiognomy depicted, the marble busts of Antonio Rossellino, Benedetto da Maiano, or Mino da Fiesole condensed the lifelike qualities of the mask with the characteristic features of classical statues. This contemporary

Below:

Donatello
Portrait of Niccolò da Uzzano (assumed)
c. 1432, polychrome terracotta.
Florence, Bargello.

The prominence of the bone structure and attention to detail show the use of a wax model, a "handcrafted" technique that has led some critics to reject the attribution to Donatello. Nonetheless, the plastic refinement and skillful effect of movement obtained in the marvelous twisting of the neck make this bust a great work of art.

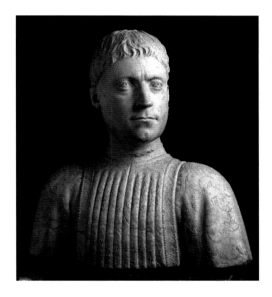

Mino da Fiesole
Piero de' Medici (The Gouty)
1463, marble.
Florence, Bargello.

Florentine busts from the fifteenth century showed constant attention to physical resemblance and rendering the expression, while the bust could be dressed in a classic toga or modern clothing, as in this case.

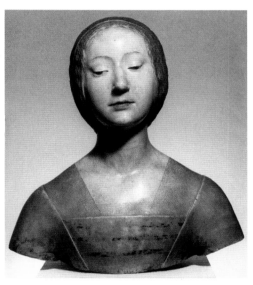

Francesco Laurana
Bust of Isabel, daughter of Alfonso of Aragon
c. 1488, partially painted marble.
Vienna, Kunsthistorisches Museum.

The Dalmatian artist Francesco Laurana, active in the court of Alfonso of Aragon in Naples, and later at Federico da Montefeltro's Urbino court, created female busts with abstract, geometric forms and refined elegance.

reading truncated the bust with a straight line, unlike the rounded cutoff at shoulder height that was typical of Roman busts. The attention paid to achieving versimilitude was further developed by the addition of a sense of movement, obtained by turning the head with respect to the bust, which was viewed from the front. This particular approach reached the height of dynamism in the piece by Donatello known as *Niccolò da Uzzano*. The quest for capturing individual facial details and "lifelike similarity," with the intention of transmitting one's own image to posterity. It was also a feature of the development of the painted portrait in Italy, which was spurred, however, not by ancient models, lost to the passage of time, but by the impetus of Flemish art. In 1436 Alberti praised the "divine force" of painting, because it made "absent men present, and the dead, even after centuries, seem as though they [were] alive." At the time, portraits in Italy typically followed a very rigid arrangement half-length busts: in profile against neutral backgrounds, which bore witness to their origins in the figures of donors included in religious works. It was against this background that the now lost portrait of Pope Eugene IV and two family members—painted in Rome in 1445 by Jean Fouquet—caused something of a scandal because of its three-quarter depiction of the subjects' faces and the generous space given to the busts, including the subjects' hands. Filarete wrote that the subjects

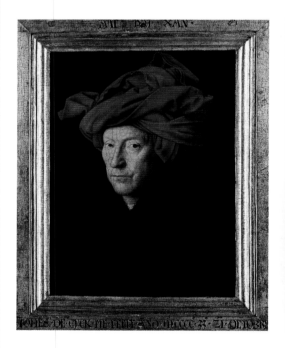

Jan van Eyck
Man with a Red Turban
signed and dated 1433, oil on wood panel.
London, National Gallery.

The first Renaissance portrait to aim the gaze directly towards the spectator, this painting may be a self-portrait. This seems confirmed by the frame, as always integrated into the work by Van Eyck, who signed it with a precise date, "Johannes de Eyck made me October 21, 1433," and the motto of the artist, "As I know how."

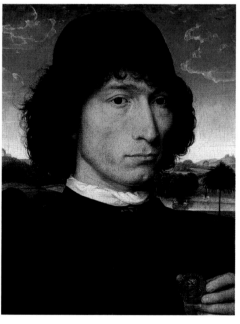

Hans Memling
Man with an Emperor Nero Coin
c. 1470–75, oil on wood panel.
Antwerp, Koninklijk Museum voor Shone Kunsten.

Memling was among the favorite painters in the Florentine community resident in Bruges. Not coincidentally, Italian nationality is assumed for this subject holding an imperial coin, probably referring to his collection of ancient artifacts and humanistic culture.

Antonello da Messina
Portrait of a Man
1475, oil on wood panel.
Paris, Louvre.

The neutral background, restricted framing, and analytical description show remarkable similarity to Flemish models, among which Antonello stands out in his attention to expression. The work is signed and dated on the cartouche at the bottom.

"appeared truly alive." Fouquet had trained in the Franco-Flemish school, and he had selected a type of portrait that was well-established in Flanders where, in the 1430s, painters such as Jan van Eyck (*Timotheos*, 1432, National Gallery, London), and Robert Campin (*Portraits of a Couple*, c. 1430, National Gallery, London), and later Rogier van der Weyden (*Francesco d'Este*, c. 1450, Metropolitan Museum, New York), gave a three-quarter turn to the profiles of their subjects, pushing the gaze towards the viewer, a link they intensified using fake marble frames similar to those of a window. Flemish portraits were much sought after by collectors in Italy, although more for an appreciation of their artistic properties than for any real interest in the subjects. Collectors particularly appreciated the excellent degree of closely observed detail and the physical nuances of the painting achieved by the use of oils. It took time for Italian art to absorb this new way of painting, and it was not until 1470 that the process was complete. At that time Antonello da Messina painted a series of stunning portraits with the subject looking at the viewer, similar to a number of compositions by Van Eyck or Petrus Christus. Antonello da Messina used the reduced form of the half-bust to explore intense facial expressions. In Florence, the portraits of Hans Memling, with their architectural or landscape-themed frames, were the most current reference models available to the likes of

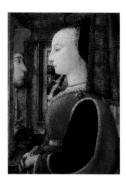

Filippo Lippi
*Woman With a
Man at a Window*
c. 1440, tempera
on wood panel.
New York,
Metropolitan Museum.

Filippo Lippi's portraits
show an early absorption
of Flemish models in
details and framing, at
times open onto
landscapes, motifs again
adapted to the tradition
of profile portraits.

Left:
Domenico Ghirlandaio
Giovanna Tornabuoni
c. 1488, mixed media
on wood panel.
Madrid, Museo
Thyssen-Bornemisza.

This posthumous portrait
of Giovanna Tornabuoni,
despite the profile rep-
resentation, commun-
icates with the spectator
via the epigram on the
cartouche, taken from
Martial, praising the
excellence of this painting
while lamenting the limits
of painting in general:
"Art, if only you could
portray characters and
souls! Then there would
be no more beautiful
painting on earth."

Sandro Botticelli
*Portrait of a Man with
a Medal of Cosimo
the Elder*
c. 1475, tempera on
wood panel.
Florence, Uffizi Gallery.

From the Flemish model
comes the placement of
a broad view and frontal
gaze that calls the atten-
tion of the spectator to the
medal in relief, no longer
a collectable object as in
Memling, but memorial
to Cosimo de' Medici,
pater patriae.

Botticelli (*Man with Medallion*, see page 65), Ghirlandaio (*Old Man with Child*, c. 1490, Louvre, Paris), Perugino (*Francis of the Good Works*, c. 1490, Uffizi Gallery, Florence) and the young Da Vinci (*Ginevra de' Benci*, c. 1475, National Gallery, Washington), who would later greatly extend the use of the three-quarter bust with considerable success. The move away from the rigid imposition of the profile shifted the portrait away from mere facial description and introduced a dialogue with the viewer, with the subject looking to the front, as was more fitting for an object that was meant to substitute someone who was absent. Like contemporary poetry following the example of Petrarch's sonnets in praise of Laura's portrait, ancient epigrams praised the consoling powers of the portrait, which in a sense made the absent person seem present, thanks to the likeness of the subject shown, while bemoaning the disappointment caused by the inanimate image and criticizing the portrait's failure to represent fully the virtues of the subject's soul, the prerogative of literature. Da Vinci's answer to this controversy was to sustain the superiority of painting's evocative power over that of poetry. According to Da Vinci, painting "put before the lover the very image of the person loved, and the lover would kiss the image and talk to it, things he could not do with the same beauty presented to him by the writer." The portrait was not to be considered a faithful reproduction of the subject, as much

Jean Fouquet
Portrait of the Ferrara Court Jester Gonnella
c. 1440–45, oil on wood panel. Vienna, Kunsthistorisches Museum.

Inventories from the seventeenth century identify this person as the famous Ferrara court jester. The attribution to Jean Fouquet, because of the analytical description of the grotesque face accented by the restricted framing inspired by the Flemish style, has suggested the artist most likely stayed in Ferrara during his trip to Rome, where he lived around 1444–46.

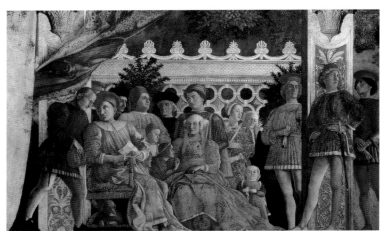

Above:
Andrea Mantegna
The Court of Mantua
1465–74, fresco.
Mantua, Palazzo Ducale, Camera degli Sposi.

Left:
Francesco Cossa
Borso d'Este gives a Coin to his Jester Scoccola
detail from *The Month of April*
c. 1470, fresco. Ferrara, Palazzo Schifanoia.

The portrait played a central role during the fifteenth century and was no longer a marginal element in telling the Christ story. Painted under the direction of Francesco Cossa in Ferrara, the rhythm of the months creates the scenes showing the activities of Borso d'Este's good government. In Mantua, the court of Ludovico Gonzaga dominated in the Camera degli Sposi frescoes by Mantegna.

as a construct crafted by the painter in response to the prevailing artistic criteria of his age, and in the fifteenth century that meant the search for beauty. Alberti referred to the classical example of blind Antigone, shown in profile, and commented that "the ancient painters, when painting kings, if they possessed some defect, not wanting to have it noticed, as far as they could, making use of the similarity of the image, corrected the defect." Renaissance Italy had its own Antigone in Federico da Montefeltro, Duke of Urbino, who had lost an eye when he was young and had broken his nose during a joust. He was always shown in profile. The well-known portrait by Piero della Francesca may at first seem cruelly unflattering in its depiction of the duke's ungracious features, but a comparison with the closely observed portraits by Pedro Berruguete and Joost van Wassenhove (Justus van Ghent) show to what extent Della Francesca sought to rationalize the Duke's irregular profile with geometric clarity. The idea that the dignity and rank of the subject should be evident in his facial features (even if this compromised the exact rendering of the subject's likeness) would play a significant role in portraiture in the next century.

Francesco di Antonio del Chierico (attr.)
Federico da Montefeltro and Cristoforo Landino
c. 1475, miniature from *Disputationes Camaldulenses* by Cristoforo Landino. Vatican City, Biblioteca Apostolica Vaticana, Urb. lat. 508.

The profile was the Duke of Urbino's hallmark, and here the artist, who painted the miniature in Florence from previous models, did not invert the painting from the side with the damaged eye, probably for compositional reasons.

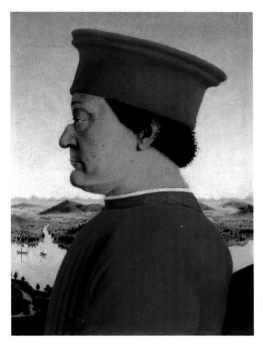

Piero della Francesca
Federico da Montefeltro
c. 1472, tempera on wood panel. Florence, Uffizi Gallery.

Together with the portrait of Battista Sforza, this painting forms a diptych whose opposite side shows the married couple on allegorical triumphal carriages. The head of the Duke stands out against the sky, while the shirt collar is aligned with the horizon of the deep Flemish-style landscape, evoking the vigilance of good government over the princes in the Duke's territory.

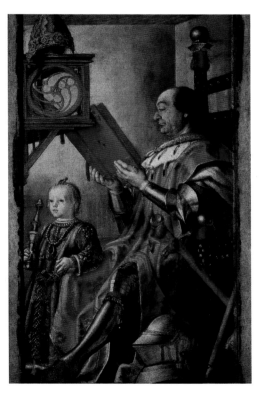

Pedro Berruguete (attr.)
Portrait of Duke Federico da Montefeltro and His Son Guidobaldo
c. 1476–77, oil on wood panel. Urbino, Galleria Nazionale.

The Duke's profile, rendered with careful precision, shows flabby cheeks, a sunken chin, and a snub nose, unlike the enhancement attempted by Piero della Francesca.

The Pomp of Court

Whereas the ascetic quest for structural and formal rationality that began in Florence led to a view of art that dominated the sixteenth century to the exclusion of other visions (especially in Vasari's historiographic reconstruction), the fifteenth century was receptive to a multitude of artistic idioms. In 1423 in Florence, Gentile da Fabriano put the finishing touches to one of the greatest works in the "International Gothic" style. Using a very refined technique and a wealth of gold and silver leaf and plaster molding, Gentile produced a work of great formal elegance, teeming with figures, animals, and natural details: the *Adoration of the Magi* altarpiece for the sacristy of the Santa Trinita church. The commissioning patron was Palla Strozzi, the richest man in Florence according to 1427 property records, and with this display of magnificence he intended to demonstrate the extent of his wealth. Strozzi identified his devotion with that of the Three Kings from the Orient, and it is hardly a coincidence that both he and his son Lorenzo Onofrio are included in the group of people following the Magi. In a sense diametrically opposed to the rigorous compositions of his contemporary Masaccio, and to the codified rules that Alberti compiled ten years later, the art of Gentile da Fabriano was far from being old-fashioned. Along with his spiritual heir Pisanello, he was the only Italian painter to be honored with the inclusion of a biography in the *Vite di Uomini Illustri* (*Lives of Illustrious Men*) written by Bartolomeo Fazio at the Aragonese court in

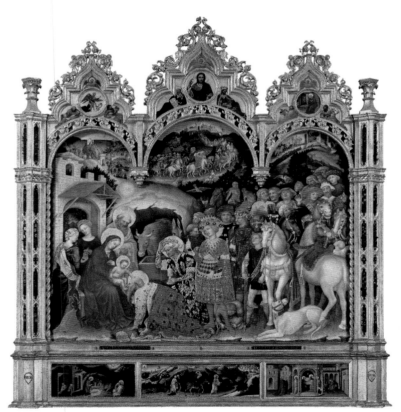

Above right:
Gentile da Fabriano
Gentile da Fabriano, Strozzi Altarpiece, entire painting and detail
1420–23, tempera on wood panel. Florence, Uffizi Gallery.

The formal refinement and use of gold stands in contrast with the analytical precision of several naturalistic sections, such as the fighting hawk and jay, the leopard attacking a deer, or the thirty-six species of flowers portrayed in the engraved frames. However, the attention paid to Nature remains episodic, used for ornamental purposes, and does not involve the whole composition.

Pisanello
Cheetah
c. 1430–40, parchment.
Paris, Louvre, Dépt. des Arts Graphiques, 2426.

A great painter of animals, Pisanello did many life studies, among them this cheetah, a favorite exotic animal in princely menageries and in the portrayal of splendid courts. Pisanello, who trained in Verona, was the last great exponent of art from the courts of Lombardy and Veneto, which also included Giovannino de' Grassi and Michelino da Besozzo. Gentile da Fabriano was also inspired by the botanical and naturalistic repertoire from this court culture.

Naples (1456); Da Fabriano's reputation was also based on important commissions received in Venice and Rome. A taste for the refined splendor of ornaments and clothing, which was such a feature of life at court, was not uncommon in Florence, where it was displayed with great pomp during public celebrations. Such events are recorded in the sinuous processions that decorate wedding chests. When he returned from exile in 1434, Cosimo de' Medici chose a rather sober and rigorous artistic style for his public commissions, but he also acknowledged the role of pomp and ceremony, taking part in the processions organized for the Epiphany (January 6) by the Company of the Magi, of which he was patron. Not only did Cosimo de' Medici appropriate for his own political ends the model of devotional identification used by Palla Strozzi, he also commissioned Benozzo Gozzoli to cover his private chapel in frescoes. The chapel was a place to represent Medici power, and the monumental procession of the Magi that covered the walls also included images of family members. With a more distinct compositional style than the previous work by Gentile da Fabriano, the fresco cycle contains a similar wealth of details and natural episodes which recalls the *horror vacui* ("fear of the void") that was a feature of the Flemish tapestries and painted drapes the Medici favored.

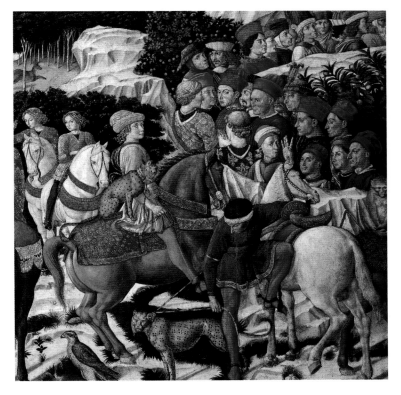

Above and right:
Three Wise Men, details
1459–63, fresco. Florence, Palazzo Medici, Magi Chapel.

King Gaspar is followed by Cosimo and Piero de' Medici (detail on the right) and the young brothers Lorenzo and Giuliano as well as Galeazzo Maria Sforza and Sigismondo Malatesta, who came to Florence to meet Pope Pius II in 1459. Painted soon after the political event, this fresco extols the power of the Medici and preserves the memory of the magnificent pomp of the period.

Flemish production
Lady With Unicorn
late fifteenth–early sixteenth centuries, tapestry,
silk and wool.
Paris, Musée de Cluny.

The taste for accumulating refined descriptive details is shown by the great number of Flemish tapestries and painted drapes listed in the inventories of the Medicis. Purchasing agents in Flanders were advised to choose a "pleasant subject," and people in Flemish clothing were accepted even in stories from classic antiquity.

The Renaissance | The Pomp of Court

Details

An appreciation for detailed refinement, a legacy of the "International Gothic" style, paved the way for the favorable reception in Italy of new-style Flemish art. In the 1420s and 1430s, the issue of the exact representation of the natural model was being explored as much in Florence as in Flanders. In Florence, the answer was a rationalization of structural principles based on perspective, while in the Netherlands, artists chose an illusionistic "realism" achieved through the development of painting in oils on thin canvases. Unlike painting with tempera, the new technique brought considerable transparency to the painted surface, giving the appearance of depth and boundaries through gradual and unified *chiaroscuro* gradients. The technique defined not only the external light source (the *lume*), but also the way light might fall on different surfaces, either absorbed or reflected, depending on the material in question (the *lustro*, as Da Vinci defined it). Flemish superiority in painting fascinated Italian artists, who tried to make the new technique their own. As Vasari wrote in his *Lives*, it produced some rather improbable anecdotes, such as Antonello da Messina's trip to Flanders in order to "steal" the oil painting technique from its "inventor," Jan van Eyck. Antonello da Messina never made such a trip, but he did study in the Aragonese court in Naples where the humanist

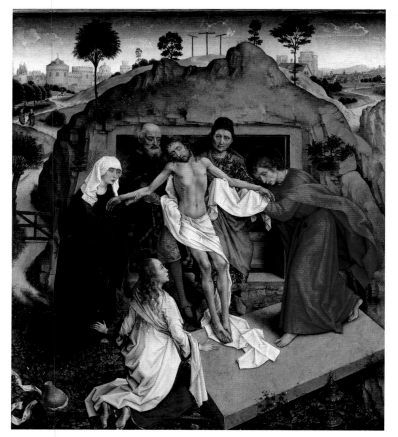

Rogier van der Weyden
Lamentation Before The Tomb
c. 1450, oil on wood panel. Florence, Uffizi Gallery.

This artist interprets a composition by Angelico, already in the predella (Berlin) of the *Saint Mark's altarpiece* in Florence, with the suffering intensity that contributed to his fame. Fazio and Ciriaco d'Ancona praised the expressive qualities of pain and the tears, "so real you would not believe they were not."

Rogier van der Weyden
Medici Madonna
c. 1450, oil on wood panel.
Frankfurt, Städelsches Kunstinstitut.

This painting alludes to a Medici commission with the lilies, the Medici saints (protectors of the family), and the "name saints" of Piero (Peter) and Giovanni (John) de' Medici.

Facing page:
Colantonio
Saint Jerome in His Study
1444–45, oil on wood panel. Naples, Capodimonte.

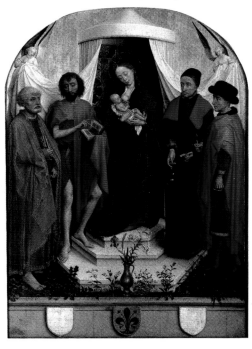

Bartolomeo Fazio wrote his *De Viris Illustribus* ("Of Illustrious Men") in 1456, including the first biography of Van Eyck, who was defined as *nostri saeculi pictorum princeps*, "the prince of painters in our time." Fazio was historiographer and secretary to Alfonso of Aragon, who possessed the richest collection of Flemish paintings at the time in Italy. Alfonso's interest in Flemish art pre-dated his coronation in Naples in 1442, and in 1432 he had already sent the artist Luis Dalmau from Valencia to study and develop his art in Flanders. In his new capital, Alfonso found an artistic environment that was amenable to the Flemish way of doing things, thanks to the relationship with the Provencal court of his predecessor as ruler, René d'Anjou. The

connection can be seen in the astounding similarities in works from the 1440s by the Neapolitan artist Colantonio and the so-called Master of the Annunciation of Aix. Compared with Colantonio, Antonello da Messina tried to achieve greater fidelity to the original models, developing a pictorial style that was very similar to Van Eyck's, as could be seen in the fine detail of his landscapes, the impressive rendering of chiaroscuro effects and the serene harmony of his composition; his *Saint Jerome in His Study* is one of the finest examples of this art. In all likelihood, Antonello da Messina took the painting to Venice to present the style. Here his deep understanding of Flemish art had a strong influence on Giovanni Bellini, who was

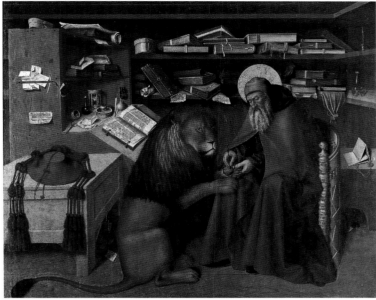

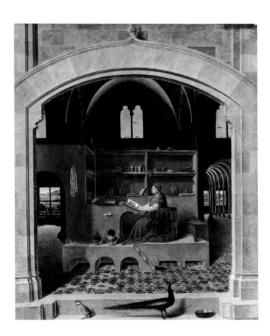

Left:

Jan van Eyck

Saint Jerome in His Study

1435, oil on paper mounted on wood panel.
Detroit, The Detroit Institute of Arts.

Van Eyck developed a very successful model of *Saint Jerome in His Study*. A version of this subject made up a panel of the Lomellini Triptych in the collection of Alfonso of Aragon; another is cited in the collection of Lorenzo the Magnificent. The painting now in Detroit was probably similar.

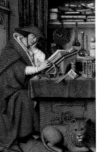

Antonello da Messina

Saint Jerome in His Study

c. 1475, oil on wood panel. London, National Gallery.

With analytical description, based on Flemish models, Antonello re-creates the trompe-l'oeil frame and luminous arrangement of the interiors and openings to the landscape to create an unprecedented composition. The Saint's study, situated in an ecclesiastical architecture of elusive dimensions, evokes the human limits in comprehending the immeasurable divine mystery enclosed in the sacred texts.

already an attentive student of the many Flemish works in local collections. Bartolomeo Fazio dedicated a biography to Rogier van der Weyden, who was considered, after the death of Van Eyck, the greatest living Flemish painter. Filarete also described him in 1460, in *Sforzinda*, written in Milan at the time Blanche of Savoy sent Zanetto Bugatto to train in Van der Weyden's workshop. Van der Weyden's fame in Italy was consolidated during his trip to Rome for the 1450 Jubilee. In 1449, Ciriaco d'Ancona praised the "miraculous art" of a lost triptych, a *Deposition of Christ From the Cross*, which he had seen at the d'Este court in Ferrara, describing the excellence of the details and the intensity of emotion portrayed. Two works that have

been preserved, the *Deposition of Christ in the Tomb*, inspired by a model from the school of Beato Angelico and the *Madonna Medici* (see page 70), have suggested to some scholars that Van der Weyden stayed in Florence, although it is quite possible that he executed the paintings in the Netherlands based on Italian models, as was often the case for tapestries. While the courts were influential in introducing Flemish style to Italy (Federico da Montefeltro's invitation to Joost van Wassenhove [Justus van Ghent] to come to Urbino was a telling example), contact between Italy and Flanders was essentially commercial, with trading agents being dispatched to both countries and with strong support from the Italian

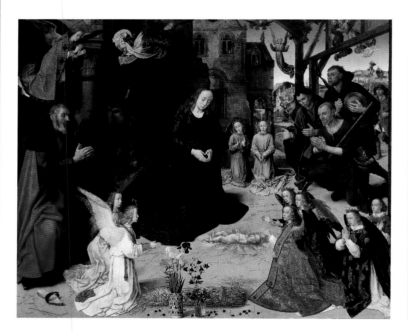

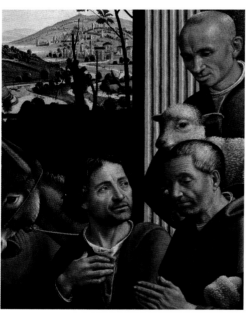

Hugo van der Goes
Portinari triptych, detail of the central panel
c. 1473–78, oil on wood panel.
Florence, Uffizi Gallery.

Domenico Ghirlandaio
Adoration of the shepherds, detail
1485, oil on wood panel.
Florence, Santa Trinita, Sassetti Chapel.

Intended for the great altar of the church of Sant'Egidio annexed to the Spedale di Santa Maria Nuova—founded by an ancestor of Tommaso Portinari—this majestic triptych carries on its side panels (not illustrated here) portraits of the sponsor, and his wife and children, kneeling in an act of devotion. In a monumental concept, the Flemish artist has brought together precise detail and expressive rendering, while paying little attention to "realistic" proportional relationships between the figures.

Ghirlandaio took up the motif of the three shepherds from the triptych by Van der Goes, regularizing the features and choosing more composed gestures, but canceled the hurried rush and amazed expressions to render the humble figures full participants in the divine mystery.

communities established in the Netherlands, especially in Bruges, the European textile capital. Van Eyck was to count merchants from Genoa and Lucca among his clients, such as Giovanni Arnolfini, for whom he painted some very memorable portraits. The Florentines became major clients only from the 1460s onwards, although they did commission very ambitious projects. In 1469, Angelo Tani commissioned Hans Memling to execute a large-scale triptych on the theme of the *Last Judgment* for his chapel in the Badia Fiesolana. The painting was shipped by sea in 1473, but after a pirate raid it ended up in Danzig. In the same year, Tommaso Portinari, rival and successor to Tani as head of the Bruges branch of the Medici

Bank, returned to the idea and commissioned Hugo van der Goes to produce a triptych of *Adoration of the Shepherds* which in 1483 did make it to its destination, namely the high altar of the church of Sant'Egidio in Florence. At the time, due to the presence of many Flemish works in Florentine collections, including a *Saint Jerome* by Van Eyck and the portrait of a woman by Petrus Christus in the collections of Lorenzo the Magnificent, a particularly warm reception was given to works from north of the Alps. This openness could be seen in greater attention to rendering details and greater depth in bird's-eye views of landscapes, features first seen in the works of Filippo Lippi, and then more extensively in paintings

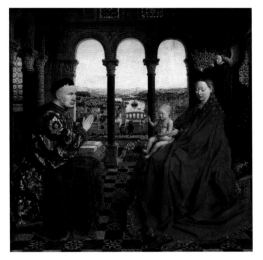

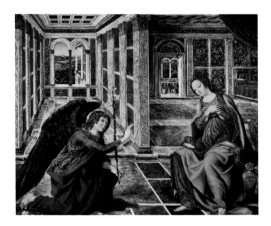

Left:

Jan van Eyck
Madonna of Chancellor Rolin, entire painting and detail
c. 1437, oil on wood panel. Paris, Louvre.

Right:

Antonio and Piero del Pollaiolo
The Annunciation,
entire painting and detail
c. 1470, tempera on wood panel.
Berlin, Gemäldegalerie.

Van Eyck's depth of view amazed the Italians. "Horses, small human figures, mountains, woods, towns, and castles rendered with such skill you would think them fifty miles distant from one another" (Fazio). The Flemish model led the Florentines to abandon the traditional landscape closed in by vertical mountains and to adopt clear bird's-eye views that pushed the horizon into extreme distance.

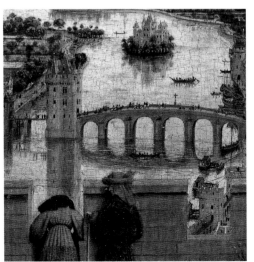

73

The Renaissance *Details*

by Pollaiolo, Verrocchio, Botticelli, Ghirlandaio, Perugino, and the young Da Vinci. The *Portinari Triptych* was the first work in the new Flemish style destined for public display in Florence (see page 72) and was an essential contribution to the development of the technique, leading to explicit references by other artists, such as the shepherds in the altarpiece Ghirlandaio executed for the Sassetti Chapel in the Santa Trinita church. An emblematic example of the strong attraction exercised by the richness of detail in Flemish painting was the reflection motif. In a tiny space, a reflection could condense the whole of the work, or reveal its hidden parts. A lost painting of bathing women by Van Eyck amazed Bartolomeo Fazio, who was astounded by a mirror that allowed the viewer to see both the "breast and the back" of one of the bathing beauties. Van Eyck pushed the potential of the reflection much further in his celebrated painting of the Arnolfini couple, where the mirror shows not only the reverse image of the scene, namely the spouses seen from behind, but also gives an expanded view of the scene that goes beyond the surface of the painting, as two other persons can also be made out in the mirror. The painting is thus the frame for a part of a much bigger situation, which in theory extends into the viewer's space.

Right and Below:
Jan van Eyck
The Arnolfini Marriage
entire painting and detail
1434, oil on wood panel.
London, National
Gallery.

A merchant from Lucca who settled in Bruges, Giovanni Arnolfini is portrayed with his wife Giovanna Cenami. The signature above the mirror reads "*Johannes de Eyck fuit hic*" instead of the traditional "fecit" and makes it likely one of the two people who appear in the frame of the door revealed in the reflection is the painter in a position corresponding to that of a spectator.

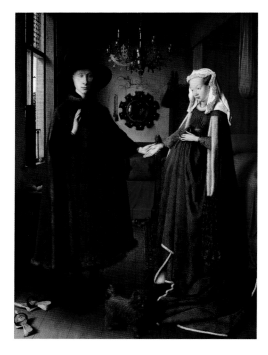

Giovanni Bellini
Allegory of Vanity
c. 1490, oil on wood panel. Venice, Accademia.

Part of a cycle of four allegorical panels with complex interpretation, the carnal female statue on a high pedestal probably represents vanity. Instead of admiring herself in the mirror, in accordance with the usual iconography (taken up, for example, by Memling), the beauty indicates, with an admonishing gesture, the reflection of the beholder.

The shiny surface of armor was also ideal for the play of reflections, and Memling used the chest armor of Saint Michael in the *Tani Triptych* to reflect the vast apocalyptic landscape in which the position of the viewer is also, symbolically, included. The symbolic message of the painting could at times outweigh the verisimilitude of the composition, as was the case with some Spanish depictions of Saint Michael executed by Bartolomé Bermejo or Juan de Flandres, in which the armor reflected the image of a city in flames: conquered Babylon. Back in Venice, Giovanni Bellini combined the two ideas in his *Vanitas*, which features the outline of a man (the viewer or the artist), a fleeting image of human life. Italian painters preferred to demonstrate their skill with lighting effects, by exposing the reverse image of elements that were already part of the composition, such as the helmet in Piero della Francesca's *Montefeltro altarpiece*, or the well-polished armor of the archangel in Ghirlandaio's *San Giusto altarpiece* (Uffizi Gallery, Florence). The secret behind the quality of Flemish paintings was gradually made a part of the structure of Italian compositions.

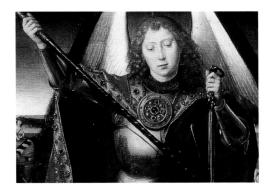

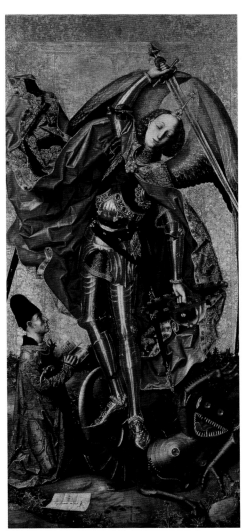

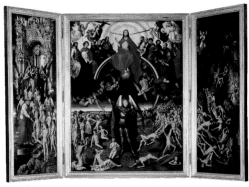

Hans Memling
The Last Judgment
entire painting and detail
c. 1469–73, oil on wood panel.
Danzig, Narodowe Museum.

The reflection on the armor includes not only the landscape at the feet of the archangel but also the door to Paradise and the mouth of Hell in the lateral panels of the triptych, underlining the space beyond the frame.

Piero della Francesca
The Montefeltro altarpiece detail
1472–74, (entire painting on page 94), oil on wood panel.
Milan, Brera.

Bartolomé Bermejo
Saint Michael Triumphant over the Devil with the Donor Antonio Juan
oil on wood panel,
c. 1475–80.
London, National Gallery.

Instead of the demon at the foot of the saint or the figure of the donor kneeling to his left, the armor of Saint Michael shows the reflection of a city in flames, a symbolic overturning of the iconographic subject that underlines Christian victory over evil.

Details

The Renaissance

Softness of Outline and Nuance of Tone

In the introduction to the third part of the *Lives*, Vasari lists the progress made in art in the "second age," or the fifteenth century: "rule, order, measure, drawing and manner, if not entirely perfect, at least almost real." The search for rationalization in painting based on science had produced an exact representation of the natural model, to which was added a further goal, beauty, because "the aim was to imitate the most beautiful part of nature" which in turn would lead to the *bella maniera* or "fine manner." According to Vasari, the fifteenth century, the Quattrocento, had laid the foundations for "modern" art, but it was left to the sixteenth century to render the outcome perfect. Among the defects of the artists of the second age, Vasari listed the excessive concentration on the definition of outlines, the linearity that produced "a certain dry, crude and cutting style." Vasari placed a number of painters in this category, including Andrea del Castagno, Piero della Francesca, Pollaiolo, Verrocchio, Botticelli, Ghirlandaio, Luca Signorelli, Ercole de' Roberti, Mantegna, and Giovanni Bellini. The somewhat labored diligence that "dries up the style" had to be replaced by a "graceful and gentle ease" of manner; those harsh outlines, absent in nature, had to be replaced by a softness and delicacy of line that would make things seem "alive." A crucial element in this gradual shift towards the impression of "being alive" was that "sweetness made one with color," or the gradients of chiaroscuro

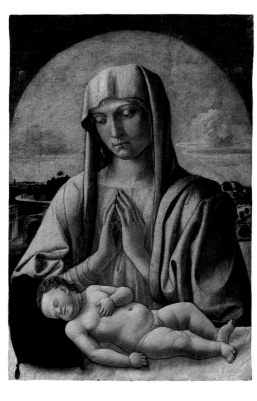

Right:
Giovanni Bellini
*Madonna with Child
(Davis Madonna)*
tempera on wood panel
c. 1460.
New York,
Metropolitan Museum.

Far right:
Giovanni Bellini
Madonna degli alberetti
1487, oil on wood panel.
Venice, Accademia.

Below right:
Giovanni Bellini
*The Madonna of
the Meadow*
c. 1505, oil on wood panel
transferred to canvas.
London,
National Gallery.

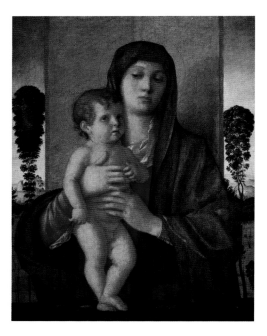

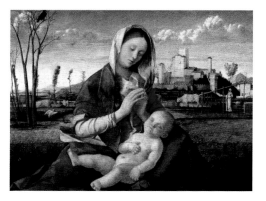

Because of its frequency throughout Bellini's entire body of work, the devotional theme of the *Madonna with Child* is an excellent indicator of the artist's stylistic development from a "dry style," in other words a linear outline of the figures, to the chiaroscuro softness of relief. The formal relationship between the Madonna and the landscape changed from a clearly distinct background to an enveloping environment, thanks to soft shadings of light. The position of the Child on a marble sheet, evoking the altar and tomb, and his sleep contemplated by the Virgin with a gesture of prayer, foreshadow the sacrifice of the Passion.

absorbed by color which erased the angular opposition between shadow and light. The first painters to develop this technique were Francesco Francia and Pietro Perugino. Giovanni Bellini also deserves to be added to the list, and Vasari probably excluded him on the grounds he was Venetian. Bellini's early works showed a still immature preference for linearity while in the last decades of the century his compositions demonstrated a considerable softness of color which he had gained from studying Flemish paintings. The technical and formal impact of Flemish painting played a fundamental role in the changeover to the new technique. In Florence, Perugino was one of the most receptive interpreters of the example set by Hans Memling, developing more sober and serenely balanced compositions with a more restrained expression, set in vast bright landscapes. Francesco Francia pursued a similar kind of exploration in Bologna, although with less accomplished results, and in striking contrast to the vigorous linear approach preferred in Ferrara. Still in the early stages of the "fine manner," the success achieved by Francia and Perugino with this "new and more lively beauty" would not withstand the wave of innovation triggered by the second generation which, in Vasari's opinion, brought an end to their ascent. In 1500, Perugino was the most respected painter in Italy; five years later Michelangelo judged him "clumsy," and Perugino left Florence and withdrew to Perugia. After he saw Raphael's *Saint Cecilia*, Francia became aware of his own

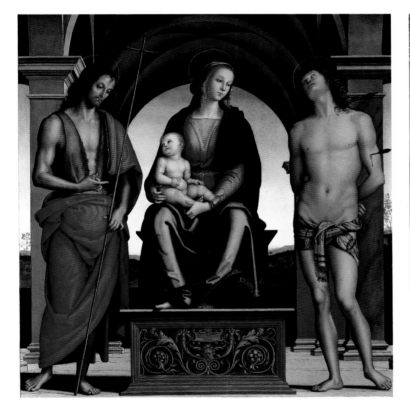

Pietro Perugino
Madonna and Child with Saints John the Baptist and Sebastian
1493, oil on wood panel. Florence, Uffizi Gallery.

In his paintings over the course of the 1480s, Pietro Perugino reached a perfect fusion of composition, color, and chiaroscuro in rendering figures, landscapes, and architectural structure, following a successful formula of classic balance he would later diligently develop in diverse variations.

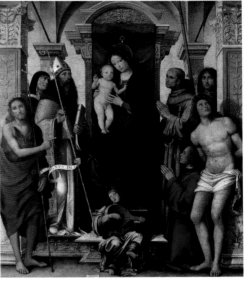

Francesco Raibolini, called **Il Francia**
Felicini Madonna
1494, oil on wood panel.
Bologna, Pinacoteca Nazionale.

Although similar to Pietro Perugino in his serene compositions of bright colors arranged with symmetrical order and no surprises in a broad environment with architecture and landscape, Francia still maintains a rather harder plasticism than that found in the Ferrara style. Another artist in Bologna, Lorenzo Costa, also participated in this formal change in terms of softness and balance.

limits, and in 1514 went to Bologna where, "heartbroken, he died shortly thereafter." There is little historical truth in the anecdote (Francia died in 1517), but Vasari tells a very eloquent version of it in his *Lives*; the most accomplished exponents of the "modern manner," Michelangelo and Raphael, buried, as it were, the leading figures of the previous generation, and with them, the last imperfections in art. The transition took place smoothly; the young Raphael had already adopted Perugino's compositional approach and use of color, and Bellini maintained his reputation in Venice right up to the end of his career, while still taking on board the innovations of the younger generation of emerging artists, such as Giorgione, Sebastiano Luciani, and Titian. In any case,

towards the end of the fifteenth century the parameters of the ongoing artistic debate quickly shifted, due in great part to the impact of Leonardo da Vinci who, according to Vasari, "started the third manner, which it pleases us to call modern"; Leonardo really "gave his subjects a sense of moving and breathing." In the field of painting technique, Da Vinci introduced a fundamental innovation: his acclaimed and much-discussed *sfumato*, the blurred nuance of tone that not only abolished rigid lines in general, but also dissolved outlines in a luminescent atmosphere. This technique was the result of a new and scientific approach to painting which no longer sought truth in precise geometric measurements but in the lifelike rendering of what was actually seen. In Da Vinci's view, color

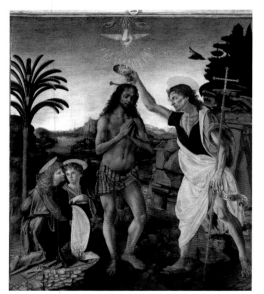

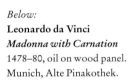

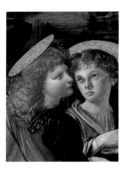

Below:
Leonardo da Vinci
Madonna with Carnation
1478–80, oil on wood panel.
Munich, Alte Pinakothek.

Although the attention to the atmospheric rendering of faraway landscapes was already present in Florentine painting during the 1460s, Leonardo applied this systematically to the entire composition, using soft chiaroscuro variations to tie together the movement of the figures, evoking the movements of the soul, with the luminous vibrations of the humid air, or the more general movement of the elements.

Andrea del Verrocchio and Leonardo da Vinci
Baptism of Christ, entire painting (above) and detail (above right)
1473 or 1478, tempera and oil on wood panel.
Florence, Uffizi Gallery.

In contrast to the emphatic linearity of the work, the hand of the young Leonardo, apprenticed to the studio of Verrocchio, can be seen in the shaded angel on the left and the atmospheric effects in the background landscape. The differences in quality reflect the work of various apprentices in keeping with the practice in Verrocchio's studio. The rigid palm is the result of a modest talent, while Botticelli's name has also been suggested for the angel on the right.

Leonardo da Vinci
Female Head
("La scapigliata")
c. 1490, oil on wood panel.
Parma, Galleria Nazionale.

This monochrome, completed in the face and unfinished in the ruffled hair, is a demonstration of the shaded relief achieved by the soft passage between the emphasis of light and the veil of shade that envelopes the face.

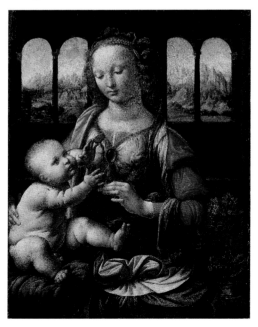

was a variable property that depended on distance and light. While he may well have added variations in shade and light to the outlines of his figures with the addition of black and white in keeping with Alberti's recommendations, Da Vinci also wrapped his compositions in a shadowy veil, softening the figures' outlines and placing them in contact with that atmospheric vibration, the unifying principle of motion that stirs the whole world. The surface of the painting was no longer seen as a crisply transparent space out of which the figures were drawn with precision. Instead, the surface became dense physical space created by the shadows from which the various figures emerged, their outlines blurred by the gentle nuances of *sfumato* that rendered the softness of

the flesh and the changing nature of their exteriors in relation to the flow of life itself. Vasari acknowledged that Giorgione conducted similar experiments in tone in Venice ("he added nuance of tone to his paintings and gave terrible movement to the things he painted, by means of a certain obscurity of well-formed shadows"), but criticized Giorgione's underlying approach which was based on the use of color, something Vasari considered inferior to Da Vinci's scientific approach, based on drawing, the fundamental technical and intellectual tool of the "fine manner."

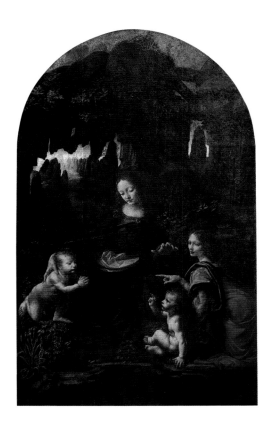

Leonardo
Virgin of the Rocks
1483–86, oil on wood transferred to canvas.
Paris, Louvre.

Leonardo makes his figures an integral part of the landscape, unlike we see in *The Last Supper*, where each figure is set in relation to an overall architectural sceheme determined by perspective.

Giorgione
The Tempest
c. 1503–07, oil on canvas. Venice, Accademia.

In this enigmatic work, the characters meld into the atmosphere, enveloped by the humid shadows that shade the contours, while the contrasting luminosity of the storm lights up the relief. In contrast to the painting by Leonardo, here the landscape dominates, includes the figures, without being structured by them, to such an extent it makes up the chosen subject of the painting.

The Renaissance Softness of Outline and Nuance of Tone

Portrait of Beato Angelico,
from Giorgio Vasari's *Lives,*
Edizione Giuntina, Florence,
1568.

Fra Giovanni Angelico
(Vicchio di Mugello 1385/1400–1455 Rome)

This Dominican friar was called *Beato Angelico* ("blessed angel") in 1469, because of his refined and luminous painting style, full of detail, which owed much to Masaccio. He took holy orders in 1420–22 and entered Fiesole monastery, where he painted a number of works, including a *Coronation of the Virgin* (Louvre, Paris; 1434–35). He went on to paint frescoes in the monastery of San Marco, rebuilt by Michelozzo on the initiative of Cosimo de' Medici. He made a significant contribution to the type of altarpiece known as *sacra conversazione* ("holy conversation"), like the *Pala di Annalena* (c. 1430) and *Pala di San Marco* (1438–43). He showed a strong grasp of narrative in the predella scenes he painted. Between 1446 and 1449 he worked on a number of prestigious commissions in Rome (decorations, now lost, for the apse of Saint Peter's, and for the study and private chapel of Pope Nicholas V). All that remain are the decorations of the Pope's chapel. With his apprentice Benozzo, he started the fresco cycle in the San Brizio Chapel in Orvieto Cathedral (1447), which would later be completed by Luca Signorelli.

Right:
Fra Angelico
Saint Peter Consecrates Saint Laurence
as Deacon, detail
1448–49, fresco.
Vatican City, Niccolina Chapel.

Below:
Fra Angelico
Angel of the Annunciation, detail from
paintings for the Armadio degli Argenti
1450–52, tempera on wood panel.
Florence, Museo di San Marco.

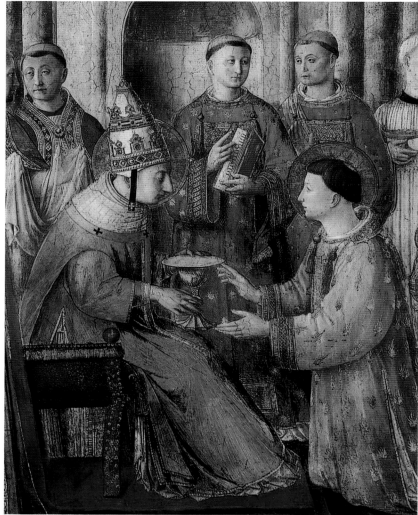

Antonello da Messina

(Messina c. 1430–1479)

The "mystery" behind the painting of Antonello da Messina stems from the combination of his early mastery of painting in oils, worthy of the finest Flemish master, and his profound grasp of perspective, the equal of any Tuscan artist. Vasari provided an explanation to the question with a somewhat misleading anecdote that told the story of how Antonello da Messina went first to Rome to study drawing and then to Flanders, where he was supposed to "steal" the secret of oil painting from the aging Van Eyck. The truth of the matter is that Antonello da Messina learned these techniques as an apprentice to Niccolò Colantonio in the Aragonese court in Naples, where Flemish examples were well-known through original works and the many contacts the court had with artistic circles in Catalonia and Provence. Some scholars have put forward the idea, based on the arrangement of landscapes and viewpoints and complex organization of space in his compositions (the Palermo *Annunciation*, and a *Saint Jerome*, c. 1475), that he also journeyed through Central Italy on his way to Venice where he was recorded as staying, in 1475–76, leaving major works that show evidence of his rewarding association with Giovanni Bellini (*Saint Sebastian; the San Cassiano altarpiece*).

Portrait of Antonello da Messina, from Giorgio Vasari's *Lives*, Edizione Giuntina, Florence 1568.

Right:

Antonello da Messina
Virgin Annunciate
1474 or 1476/77,
oil on wood panel.
Palermo, Galleria Regionale della Sicilia.

Below:

Antonello da Messina
Portrait of a Man
c. 1475, oil on wood panel.
London, National Gallery.

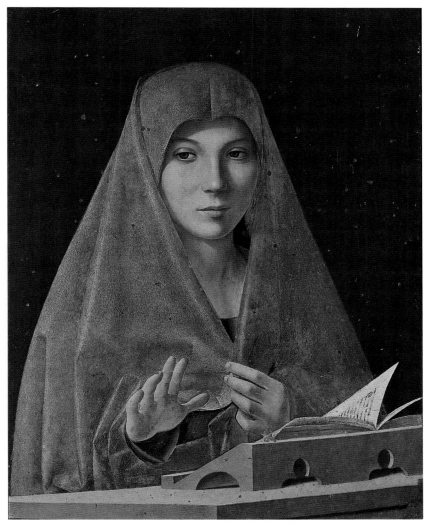

Portrait of Giovanni Bellini,
from Giorgio Vasari's *Lives*,
Edizione Giuntina, Florence
1568.

Giovanni Bellini
(Venice c.1430–1516)

After serving his apprenticeship with his older brother Gentile in the workshop of their father, Jacopo Bellini, in the 1450s Giovanni adopted the powerful figurative solutions of his brother-in-law Andrea Mantegna, which he later softened with the use of mellower lighting and a sculptural approach to composition, inspired in part by Flemish examples and in part by the work of Antonello da Messina. He was a portrait artist of considerable skill, and executed a large number of devotional paintings that were distinctive for their restrained but intense emotional expression (the Brera *Pietà*, and *Madonna degli alberetti*). In the field of works meant for public display, Giovanni Bellini played a major role in the transition from the polyptych (*San Vincenzo Ferrer polyptych*, 1460–65) to the new single narrative altarpiece (*Pala di san Giobbe*, c. 1480, and *Pala di san Zaccaria*, 1505). In 1506 Dürer referred to Bellini as the greatest living Venetian painter and he maintained his dominant position until his death, while successfully adopting the new forms introduced by the younger generation of Venetian artists (*Drunkenness of Noah*; 1514–15).

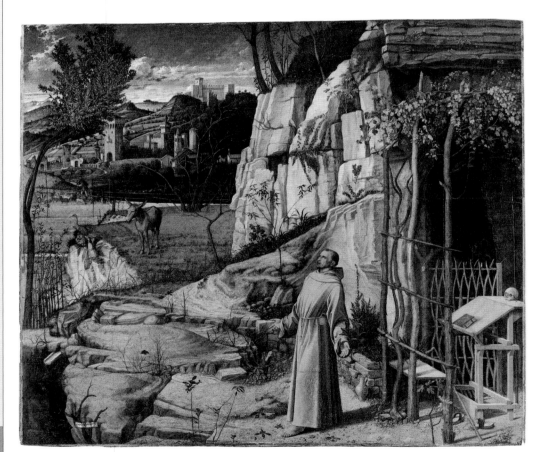

Left:
Giovanni Bellini
Saint Francis
1477–78,
oil on wood panel.
New York, Frick
Collection.

Facing page:
Sandro Botticelli
Adoration of the Magi
1475, oil on wood panel.
Florence, Uffizi Gallery.

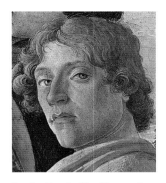

Sandro Botticelli, self portrait,
detail from *Adoration of the Magi*, c. 1475, oil on wood panel. Florence, Uffizi Gallery.

Sandro Botticelli
(Florence 1445–1510)

An apprentice of Filippo Lippi, Botticelli made a name for himself with the lightness of his dynamic style, which he used to confer grace and softness on his female subjects. Apart from a stay in Rome in 1481–82, when he worked on the decoration of the Sistine Chapel, he spent his whole career at the court of Lorenzo the Magnificent, depicting the leading members of the Medici circle in his *Adoration of the Magi*, commissioned by Giovanni Zanobi del Lama (currently in the Uffizi Gallery). He interpreted the humanist and Neoplatonic ideals of that fervid cultural environment in mythological works influenced by the principle of *ekphrasis* (*Pallas and Centaur*, c. 1482 and *Spring*, c. 1485, painted for Lorenzo di Pierfrancesco de' Medici; *Birth of Venus*, c. 1483; *Mars and Venus*, c. 1486; *Calumny of Apelles*, c. 1494). He was influenced by the sermons of Savonarola and, from the 1490s onwards, adopting a harsher and emotionally more intense style, he worked on a number of moral and spiritual themes (*Histories of Virginia and Lucrezia*, c. 1498–1500; *Mystic Nativity*, 1501) as well as illustrations for the *Divine Comedy*.

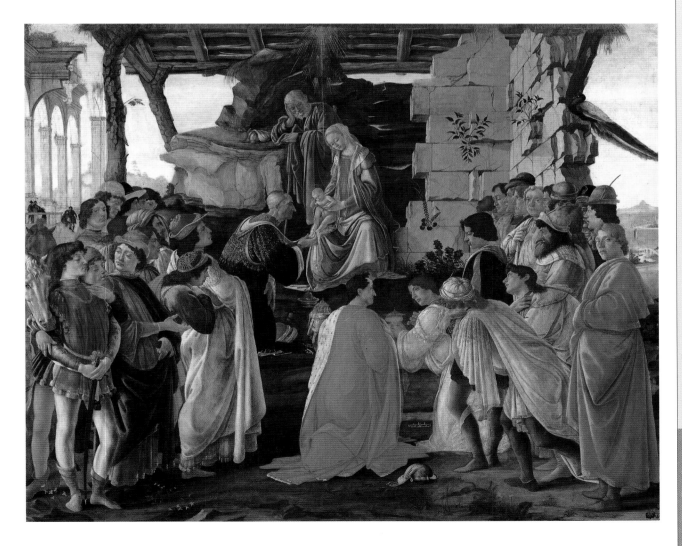

Portrait of Donato Bramante, from Giorgio Vasari's *Lives*, Edizione Giuntina, Florence 1568.

Donato Bramante
(Monte Asdruvaldo, Pesaro 1444–1514 Rome)

After his apprenticeship at the court of Urbino, where he had been in contact with Piero della Francesca and Melozzo da Forlì, Bramante worked as a painter in Lombardy from 1477 onwards (*Men of Arms*, for the Panigarola home), attracting attention for the monumental nature of the classical forms he depicted. At the court of Ludovico il Moro, Bramante worked as an architect (the choir of the church of Santa Maria delle Grazie), using the ornamentation and clearly defined structures of classical examples, while not hesitating to apply the illusionistic effects of perspective. He worked in Rome from 1499, where he opted for a more austere classical approach (the cloister of Santa Maria della Pace, 1500–04). He achieved a perfect synthesis of classical and modern conceptions of art in the church of San Pietro in Montorio, the first concrete example of the ideal church with a circular layout, which he would go on to develop in his plans for Saint Peter's Basilica, a project commissioned by Pope Julius II (1506). He also worked on the courtyard of the Belvedere (from 1503) and on the Vatican Loggias (from 1512).

Donato Bramante
Temple in Ruins
1481, engraving by
Bernardo Prevedari.
Milan, Castello Sforzesco,
Civica raccolta delle stampe
Achille Bertarelli (the
Bertarelli Collection).

Donato Bramante
*View of the interior of the
church toward the false apse*
1482–86.
Milan, Santa Maria
presso San Satiro.

Filippo Brunelleschi
(Florence 1337–1446)

He trained as a goldsmith and sculptor (the competition for the north door of the Baptistery in Florence, 1401) before going to Rome to study the construction secrets and principles of the effortless form, symmetry, and proportion of Classical Age buildings. He is credited with "inventing" linear perspective as a means of rationalizing space. In 1418, spurred by his deep theoretical and technical knowledge, Brunelleschi presented an ambitious project for a self-supporting, ribbed dome composed of interconnected segments for the Florence cathedral, and he gradually asserted himself as sole "inventor and supervisor" of the construction site, at the expense of his old rival, Ghiberti. Brunelleschi was in a sense the first modern architect, planner, engineer and sole construction supervisor: the professional figure Alberti had praised so highly. Indeed, Alberti dedicated the vernacular edition of *On Painting* (1436) to Brunelleschi. Similar praise came from the mathematician Antonio Manetti, in a posthumous biography. Brunelleschi also designed other central or long-plan buildings in Florence that featured rhythmically harmonious sequences of solids and empty spaces.

Andrea di Lazzaro Cavalcanti
Portrait of Filippo Brunelleschi,
detail, marble, 1446. Florence,
cathedral.

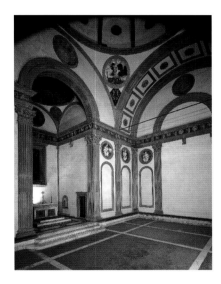

Filippo Brunelleschi
Interior and exterior of the Pazzi Chapel
c. 1430–61.
Florence, first cloister of the Franciscan
Monastery of Santa Croce.

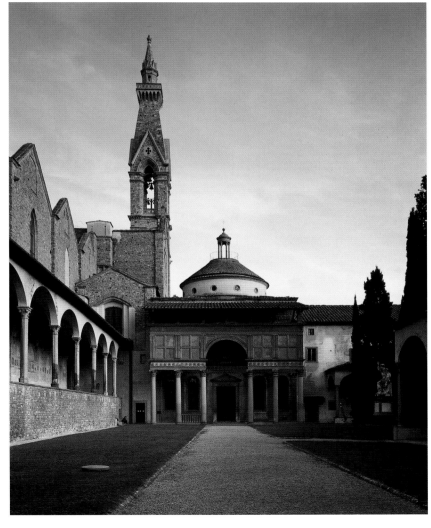

Paolo Uccello (attr.), *Donatello*,
detail of the *Portrait of five
Illustrious Men*, c. 1450.
Paris, Louvre.

Donatello
(Florence 1386–1466)

A sculptor of supreme talent, Donatello's early years were spent working on major construction projects in Florence, and later he asserted his talent as the sole executor of commissions for the church of Orsanmichele (*Saint George*, 1416–20). He rejected the late Gothic tradition bundled up in the classical forms preferred by Ghiberti and embraced instead Brunelleschi's more philological approach to antiquity. Donatello may have followed Brunelleschi to Rome in 1402. He is recorded as staying in Rome in 1432–33, with his working partner Michelozzo. From his studies, Donatello developed a powerful, plastic style and an intensity of expression, while he showed his firm understanding of perspective in the vigorous lines of his *stiacciato*, or low-relief forms (*Herod's Feast*, 1427). His skill with bronze led to some monumental works executed during his long stay in Padua (*Altare del Santo*, for the high altar in the Basilica of Sant'Antonio, 1444–50; his equestrian statue of *Gattamelata*, 1447–53). His last works in Florence are pervaded by a profound sense of pathos (his wooden *Mary Magdalene*, c. 1456; *Judith and Holofernes*, after 1461).

Donatello
Cantoria
1433–39
marble.
Florence,
Museo dell'Opera
del Duomo.

Facing page:
Albrecht Dürer
Christ Among the Doctors
1506, oil on wood panel.
Madrid, Museo
Thyssen-Bornemisza.

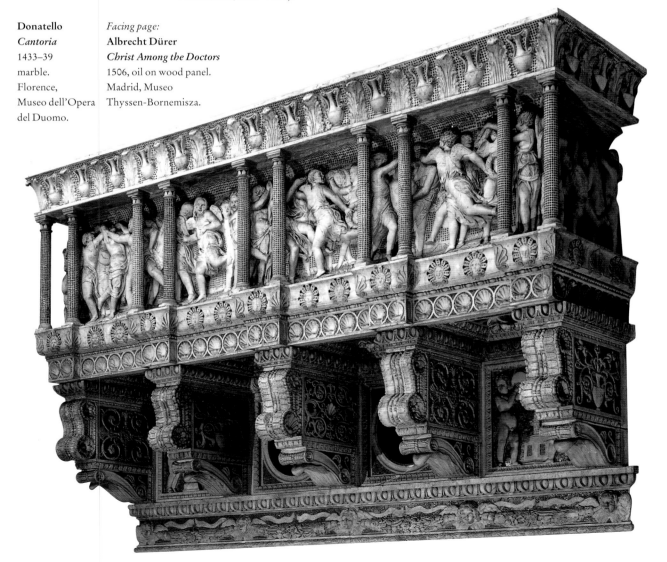

The Renaissance | Donatello

Albrecht Dürer
(Nuremberg 1471–1528)

Dürer's talent was evident from an early age. He trained in the family business (they were goldsmiths) and then with the artist Michael Wolgemut. He completed his training by traveling through Germany (1490–94) and to Venice (1494–95). He would later return to Venice (1505–07), his fame as a painter and engraver well-established (the *Feast of the Rosary/Feast of the Rose Garlands*). Dürer was a friend of the humanist Pirckheimer and worked mostly in his home town of Nuremberg (the *Paumgartner Altar*, 1502–04; *Adoration of the Trinity*, 1511; the *Four Apostles*, 1526). He also served Emperor Maximilian I (woodcuts for the *Triumphal Arch*, 1515). He made a last journey to Flanders (1520–21). Dürer's trail blazing art, and his treatises on geometry and proportions (1525 and 1528 respectively), were fundamental vehicles for the introduction of Italian artistic and theoretical models to Germany, while Dürer's own exceptional graphic work had a profound impact on Italian artists (*Apocalypse*, 1499; the *Small Passion* and *Great Passion* series, 1511; *Melancholia* I, 1514). An extraordinary series of self-portraits bears witness to his high regard as an artist.

Albrecht Dürer, *Self-portrait*
detail, oil on wood panel, 1500.
Munich, Alte Pinakothek.

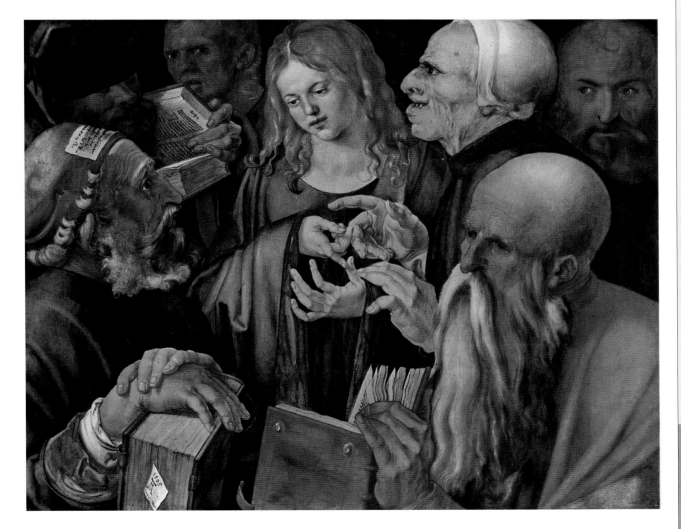

Hubert and Jan van Eyck
Saint John the Evangelist, 1432,
detail of Ghent polyptych, outer
panel, oil on wood panel. Ghent,
Sint-Baafskathedraal.

Jan van Eyck
(? 1390/1400–41 Bruges)

Van Eyck may have trained originally as an illuminator (*Turin-Milan Hours*). He served Duke John of Bavaria (1422–24) and from 1425 worked at the court of Philip the Good of Burgundy. In 1431 he settled in Bruges. The first dated work is the monumental polyptych, *Adoration of the Lamb*, or *Ghent Altarpiece* (1432), which also raised the issue of whether Jan van Eyck collaborated with his older brother Hubert, who is otherwise a lesser known figure. Jan's production is confirmed by an extraordinary series of panels, many of which are signed and dated, such as *Madonna with Chancellor Rolin* (c. 1430), *Portrait of a Man in a Red Turban* (1433), the *Arnolfini Portrait* (1434), *Madonna with Canon van der Paele* (1436), and numerous others. While he was not the actual "inventor" of painting in oils, Van Eyck took the technique to new heights, to depict an analytical vision of man and the world in the most meticulous detail, through outstanding, and remarkably innovative, rendering of light and the sheer physical nature of different materials, as well as imparting an expert understanding of spatial depth. Van Eyck's reputation reached Italy, where the humanist Bartolomeo Fazio defined him as "the first painter of our time" (1456).

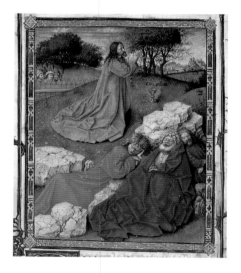

Jan van Eyck (?)
Christ in the Garden of Olives
c. 1437–40, illuminated page
from the *Turin-Milan Hours*
c. 30v. Turin, Museo Civico
d'Arte Antica.

Jan van Eyck
Madonna of Lucca
1436, oil on wood panel.
Frankfurt, Städelsches
Kunstinstitut.

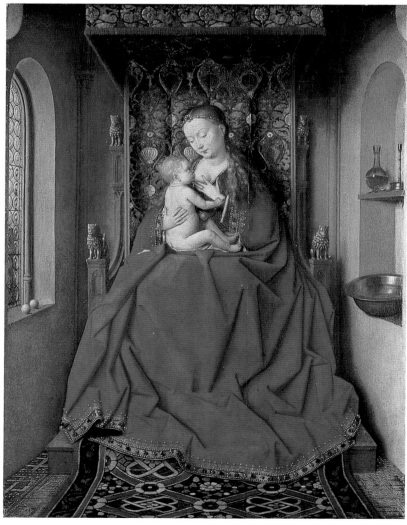

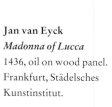

Jean Fouquet, *Self-portrait*,
c. 1451, gold and black enamel
cameo on copper, Paris, Louvre.

Jean Fouquet
(Tours c. 1420–77/1481)

Very little is known about Jean Fouquet, the painter and illuminator from Tours who was in the service of Charles VII and then Louis XI. Filarete recorded a stay in Rome, when Fouquet worked on a now lost portrait of Pope Eugene IV and two family members (1444–46). This new form of representing the pontiff would encounter lasting success. Fouquet's skill in bringing new life to traditional approaches can also be seen in his three-quarter length portrait of Charles VII, while his earlier portrait of *Court Jester Gonnella* still shows signs of approaching Van Eyck's analytical approach. A journey to Italy provided him with a repertory of classical ornament and an insight into the workings of perspective as well as a sense of monumentality in the composition of his figures that would be distinctive features of his paintings after his return to France (the *Melun Diptych*, c. 1450; the portrait of *Guillaume Jouvenel des Ursins*, c. 1460). He showed exceptional talent in his illuminated miniatures, in the quality of his crowd scenes, the depth of his landscapes and the lighting effects he employed (*The Book of Hours* by Etienne Chevalier, before 1461; *Judaic Antiquities*, before 1475).

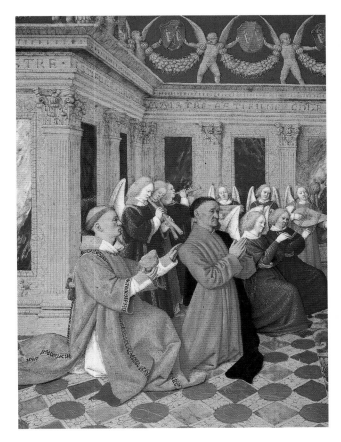

Jean Fouquet
Étienne Chevalier in Adoration of the Virgin
1452–60, miniature from *The Book of Hours*
by Étienne Chevalier Chantilly.
Musée Condé, MS 71.

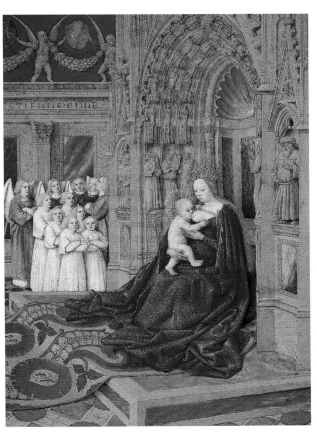

Jean Fouquet
Virgin and Child
1452–60, miniature from *The Book of Hours*
by Étienne Chevalier Chantilly.
Musée Condé, MS 71.

Leonardo da Vinci, *Sanguine self-portrait,* after 1515, on yellowed white paper. Turin, Biblioteca Reale.

Leonardo da Vinci
(Vinci 1452–1519 Amboise)

After training as an assistant to Verroccchio, Da Vinci's reputation as a painter, engineer, and man of science earned him long stays far from Florence, in Milan (1482–99; 1506–13), Rome (1513–16) and even at the court of François I of France (1516–19). The few works executed (including the *Adoration of the Magi*, 1481; the *Virgin of the Rocks*, 1483–86; *The Last Supper*, 1495–98; the *Battle of Anghiari*, 1503–05; the *Mona Lisa*, 1506–10; *Virgin and Child with Saint Anne*, c. 1510–13) are in stark contrast to the huge number of extant sketches and notes, the fruit of Da Vinci's indefatigable exploration. In his view, painting was a way of exploring the wider world and its finer details, in order, ultimately, to understand the driving force behind everything. He gave his paintings an all-embracing sense of unity through the meticulous evocation of movement and expression, and by his use of atmospheric effects achieved by means of his "trademark" *sfumato,* the blurring of colors and outlines, and aerial perspective.

Leonardo da Vinci
The Last Supper
1495–98,
mixed media on plaster.
Milan, Santa Maria delle
Grazie, refectory.

Facing page:

Andrea Mantegna
Dead Christ
1480–90, oil on canvas.
Milan, Brera.

Giovanni Cavalli, *Portrait of*
Andrea Mantegna, detail
c. 1480, bronze.
Mantua, Sant'Andrea.

Andrea Mantegna
(Isola di Carturo, Padua 1431–1506 Mantua)

Mantegna began his career in the thick of classical culture in Padua, as an assistant in Squarcione's workshop. He also stayed in Venice and Ferrara, and adopted the perspective and compositional approaches he could see locally in works by Tuscan masters such as Donatello. His monumental figurative style, his incisive hand and daring foreshortening came together clearly in the fresco cycle he painted for the Ovetari Chapel (Padua, 1449–56) and the *San Zeno altarpiece* (Verona, 1456–60). In 1453, Mantegna married Nicolosia, the daughter of Jacopo Bellini, but he chose not to stay in Venice and instead went to the Gonzaga court in Mantua, where he settled in 1459. He pursued his exploration of optical illusion and the reconstruction of classical forms and painted the *Wedding Chamber* (1465–74) for Ludovico Gonzaga, and the *Triumphs of Caesar* (c. 1485–95) for Federico. He painted the *Virgin of Victory* (1496) for Francesco Gonzaga, and for Isabella d'Este he painted *Parnassus and the Fight between Vices and Virtues*, both meant for Isabella's private study (1497–1502). He also produced a number of engravings.

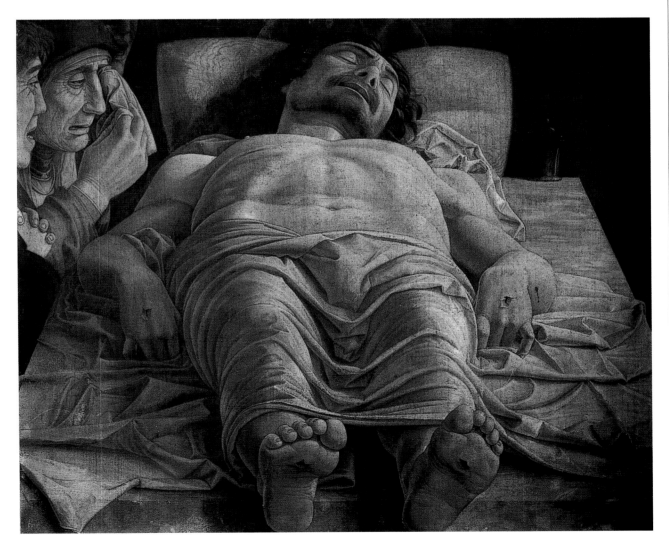

Masaccio, *Self-portrait*, detail
of *Saint Peter enthroned*
c. 1424–25. Florence,
Santa Maria del Carmine.

Masaccio

(San Giovanni Valdarno 1401–1428 Rome)

There are few credible details known of the short-lived, meteoric, and profoundly influential career of Masaccio, who was registered in the Florentine Guild of Physicians and Apothecaries in 1422, and died six years later. He was active essentially between 1424 and 1428, and the only sure date is for the polyptych for the church of Santa Maria del Carmine in Pisa (1426). It was during that period that he worked with his much older colleague Masolino da Panicale on the fresco cycles for the Brancacci Chapel, the *Sant'Anna Metterza* and perhaps the *Triptych of the Snows*, for Santa Maria Maggiore in Rome. Masaccio's figurative approach, the restrained monumentality and firm hand evident in his compositions, and his meticulous use of perspective all placed him in sharp contrast to the late Gothic tradition of contemporary Florentine painting; he found inspiration instead in the works of Donatello and Brunelleschi (Santa Maria Novella *Trinity*, 1427–28). According to the *Libro del Billi* (c. 1506–30), Brunelleschi, who "taught [Masaccio] many things," is supposed to have said on Masaccio's death, "We have experienced a great loss."

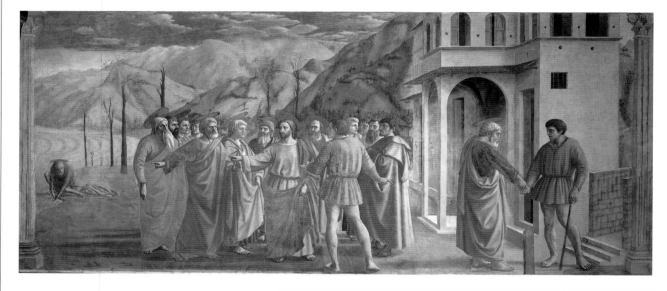

Above:
Masaccio
Tribute
c. 1424–25, fresco.
Florence, Santa Maria del
Carmine, Brancacci
Chapel.

Right:
Masaccio
*Saint Peter Healing
Cripples*, detail
c. 1424–25, fresco.
Florence, Santa Maria
del Carmine,
Brancacci Chapel.

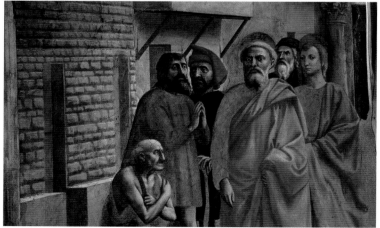

Portrait of Pietro Perugino, from Giorgio Vasari's *Lives*, Edizione Giuntina, Florence 1568.

Pietro Perugino
(Città della Pieve c. 1450–1523 Perugia)

After serving his apprenticeship under Verrocchio, Perugino began to work on his own in 1472, dividing his time between Florence and Perugia (*Nicchia di san Bernardino*, 1473). His research into pictorial technique produced straightforward spatial structures, well-balanced symmetry, and serene visual rhythms, while he absorbed the typical line of the Florentine style into a "delicacy blended with color" which, in Vasari's opinion, was the forerunner of a new way of painting. He took part in decorating the Sistine Chapel (1480–82), before carving out a significant role for himself in Florentine circles with his classical-style compositions placed against sweeping landscapes that recalled the example of Flemish art (*Vision of Saint Bernard*, c. 1490). He reached the height of his fame at the turn of the century (the commission to paint the Perugia Bankers Guild, 1496–1500), and Agostino Chigi referred to him as "the finest master [painter] in Italy." However, as early as 1505, Florentine artistic circles, the same arena in which Da Vinci and Michelangelo were also engaged, began to consider Perugino's solutions as dated (his *Deposition* for the Annunziata church), and the artist withdrew to Perugia.

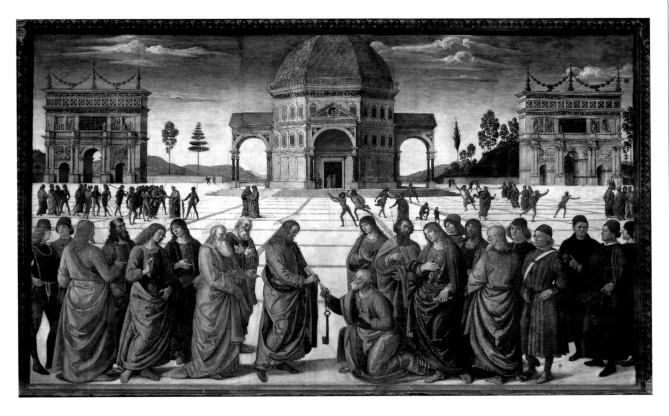

Pietro Perugino
The Delivery of the Keys
1481–82, fresco.
Vatican, Sistine Chapel.

Portrait of Piero della Francesca, from Giorgio Vasari's *Lives*, Edizione Giuntina, Florence 1568.

Piero della Francesca
(Borgo San Sepolcro c. 1416/20–92)

There are records of della Francesca having served as an assistant to Domenico Veneziano in 1439. He worked in his home town of Borgo San Sepolcro (the *Misericordia polyptych*, 1445–62; *Baptism of Christ*, c. 1459–60; the *Resurrection*, 1468) and in Arezzo where he painted the fresco cycle *The Legend of the True Cross* (Basilica of San Francesco, c. 1452–66), although while working on those commissions, he also moved around extensively. He executed works for Lionello d'Este in Ferrara (1449), Sigismundo Malatesta in Rimini (1451), Pope Nicholas V and Pope Pius II in Rome (1454 and 1459, respectively), and for Federico da Montefeltro in Urbino (the *Flagellation*, after 1459; the *Montefeltro diptych* and *altarpiece*). He was as much a mathematician as a painter, and wrote a study on perspective (*De prospective pigendi*, "On perspective in painting"). He applied a rigorously geometric approach to the composition of space and volume in his paintings, developing an austere, monumental style (that he would later soften after entering into contact with Flemish artists working in Urbino), as well as paying keen attention to detail.

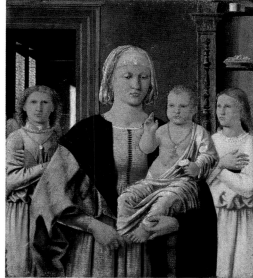

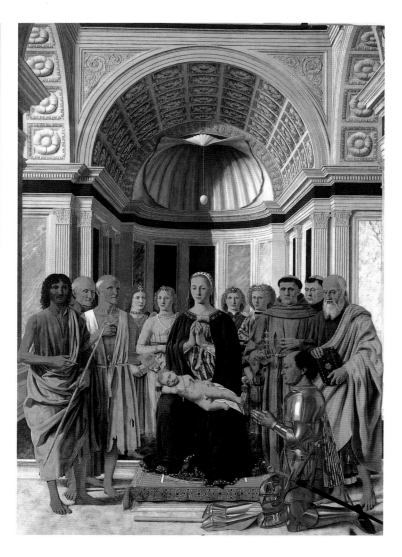

Above:
Piero della Francesca
Madonna of Senigallia
c. 1474, oil on
wood panel.
Urbino, Galleria
Nazionale delle Marche.

Right:
Piero della Francesca
Pala Montefeltro
altarpiece (detail on page 75)
1472–74,
oil on wood panel.
Milan, Brera.

Portrait of Antonio del Pollaiolo, from Giorgio Vasari's *Lives,* Edizione Giuntina, Florence 1568.

Antonio del Pollaiolo
(Florence c. 1435–Rome 1498)

The head of a flourishing workshop, Antonio del Pollaiolo first made a name for himself in Florence as a goldsmith (his silver *Crucifix* for the Baptistery, 1457–59), and then turned to painting and sculpture alongside his younger brother Piero. The two painted an altarpiece for the chapel of the Portuguese Cardinal in San Miniato. Antonio del Pollaiolo was receptive to the taut, expressive style of Donatello and Andrea del Castagno; he was a keen student of anatomy and developed a powerfully dynamic figurative style of his own, which reached its height in battles between naked figures, such as in the paintings *Hercules and Antaeus*, *Hercules and the Hydra*, *Hercules and Deianira* (c. 1475–80), a bronze statue of *Hercules* and *Antaeus*, 1475, and an engraving of the *Battle of the Nude Men*, c. 1470. In his paintings he favored sweeping landscapes teeming with figures and a high horizon line, inspired by Flemish examples (*Martyrdom of Saint Sebastian*, c. 1474). In 1484 he went to Rome with his brother Piero to work on the funeral monuments for Pope Sixtus IV (1484–93) and Pope Innocent VIII (1492–98).

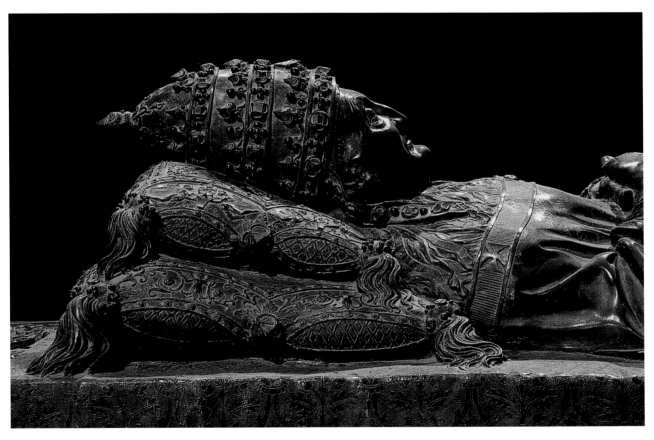

Antonio del Pollaiolo
Tomb of Sixtus IV
detail, 1484–93, bronze.
Vatican, Museo storico
del Tesoro di San Pietro.

Portrait of Verrocchio, from Giorgio Vasari's *Lives*, Edizione Giuntina, Florence 1568.

Andrea del Verrocchio
(Florence 1435–88 Venice)

Goldsmith, painter, and sculptor, Verrocchio was the head of one of the major artistic workshops in Florence, where his assistants included Perugino, Leonardo da Vinci, and Lorenzo di Credi (c. 1470–80). His assistants played a leading role in completing paintings, such as the *Baptism of Christ*, c. 1473, where it is possible to distinguish the work of at least three different artists. Verrocchio displayed the peak of his skill and talent in sculpture. He had a good knowledge of classical principles, which he had also acquired from his restoration work on classical statues (the *Tomb of Piero and Giovanni Medici*, San Lorenzo). Making skillful use of the fall of natural light, he managed to lend considerable delicacy to both bronze and marble (*Christ and Saint Thomas*, 1467–83; *Lady With Posy*, 1475), while borrowing from Donatello and producing a more restrained style (*David*, c. 1476; *Cherub With Dolphin*, c. 1476). Following Donatello's example, he also engaged in the production of an equestrian statue of Bartolomeo Colleoni, in Venice (1479–88).

Andrea del Verrocchio
Cherub With Dolphin
c. 1476, bronze.
Florence, Palazzo
Vecchio, Terrazzo
di Giunone.

Andrea del Verrocchio
tabernacle with the
Doubt of Saint Thomas
bronze.
Florence, Orsanmichele
(the sculpted group is
a copy of the original,
found in the Museo
di Orsanmichele).

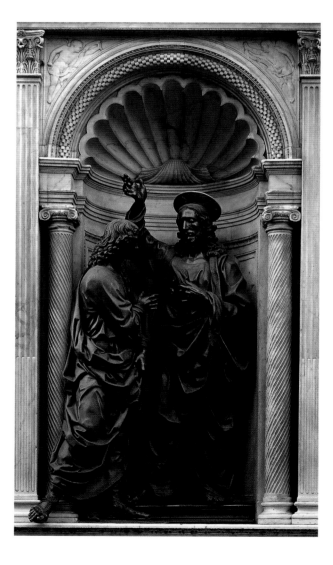

Rogier van der Weyden

(Tournai 1399/1400–64 Brussels)

"In Brussels, after the celebrated Jan of Bruges, painting's greatest pride, Rogier is considered a great painter of our time." This was the description given by Ciriaco d'Ancona in praise of a work by Van der Weyden that he had seen in Ferrara in 1449. The artist was in Italy at the time, on his way to Rome for the Jubilee, and he may have stayed in Florence. Van der Weyden came from Tournai, where he was in contact with the workshop of Robert Campin (1427). Although he showed he was receptive to the example of Jan van Eyck (*Saint Lucia and the Virgin*, c. 1435–37), his works featured a certain highly emotional expression compounded by an increasingly austere linearity. The vexed question of the chronology of his works is based essentially on stylistic evidence; *Deposition of Christ, Triptych of the Virgin* (c. 1437), *Polyptych of the Last Judgment* (c. 1445–50), *Bladelin Triptych* (c. 1450–60), *Triptych of John the Baptist* (c. 1450–60), *Columba altarpiece* (c. 1455–60).

Hieronymus Cock, *Portrait of Rogier van der Weyden,* from Dominicus Lampoonius' *Pictorum aliquot celebrium Germania e inferioris effigies,* 1572.

Rogier van der Weyden
Deposition From the Cross
c. 1435–37,
oil on wood panel.
Madrid, Prado.

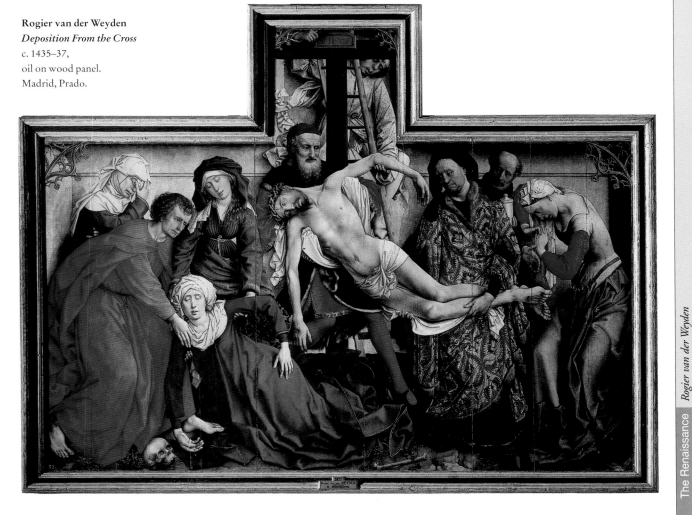

Mannerism

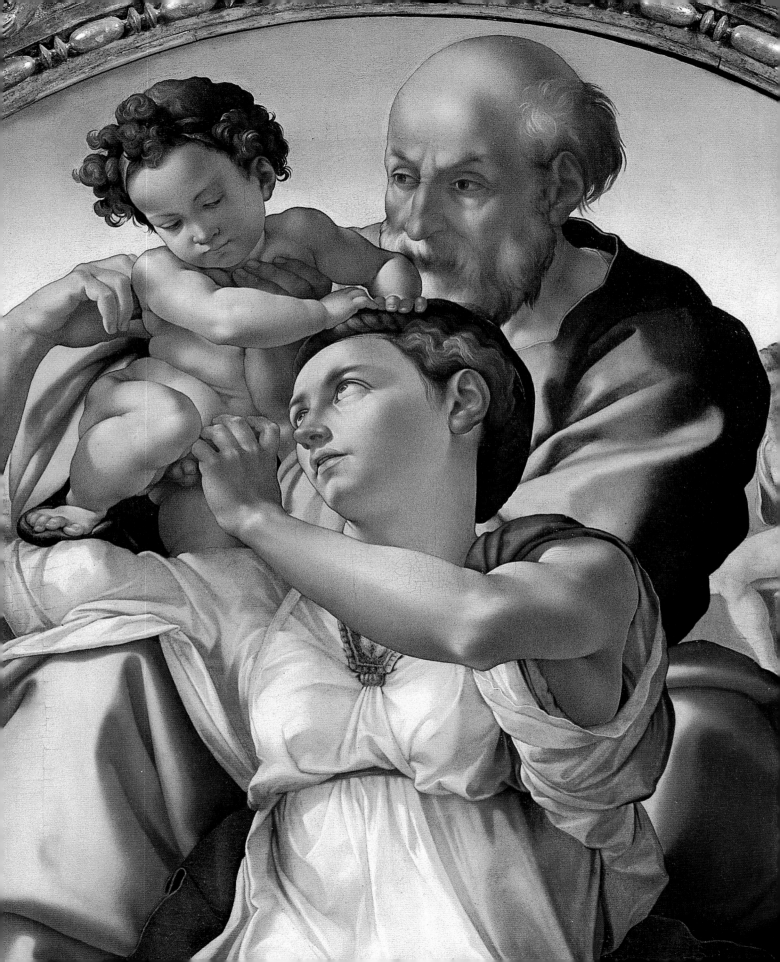

Previous page:
Michelangelo
Doni Tondo, detail
(in full on page 115)
1505–06, tempera on
panel.
Florence, Uffizi Gallery.

Left:
El Greco
*Poison transforming into
a Dragon in Saint John's
Chalice*, detail from the
painting of *Saint John
the Evangelist and
Saint Francis*
c. 1600, oil on canvas.
Florence, Uffizi Gallery.

Right:
Jacques Bellange
The Raising of Lazarus
1630–35, burin etching.
Paris, Bibliothèque
National.

Mannerism: Between Decline and Progress

As an artistic phenomenon, Mannerism was given a far from auspicious start, at a time associated with decline. Luigi Lanzi coined the term in 1792, writing in his *Storia pittorica d'Italia* ("Pictorial History of Italy"), to define what he saw as the regression from the classical ideal of the Renaissance during the course of the sixteenth century before the innovative changes brought about by the Carracci family. Lanzi was in fact echoing criticism by Giovanni Pietro Bellori, who had commented in 1672 in his *Vite de' pittori, scultori ed architetti* ("Lives of Painters, Sculptors and Architects") that "the artists, having abandoned the study of nature, spoiled their art with the vice of manner, or, we could say, their creative idea, based on practice and not imitation."

The term *Mannerism* has its origins in this negative view of "maniera," manner or style, as a practice that was increasingly remote from nature, and which was repeated mechanically with artificial affectation. It was of course this very "vice" which, when compared with the model of nature and classical precepts, would lead to a reassessment of the style in the early years of the twentieth century, when the period's anti-classicism (particularly evident in the work of Pontormo, El Greco, and Jacques Bellange) was interpreted in keeping with modern sensibility as an expression of artistic freedom and spirituality that in some works heralded contemporary movements such as expressionism or abstraction.

During the second half of the twentieth century, following upon a more extensive under-standing of the works and artistic theories of the sixteenth century, this assessment of Mannerism was refined even further. As a result, scholars compiled not only a detailed analysis of the for-mal evolution of the style in relation to the complex contexts that existed in the various cultural centers where Mannerism was produced, but also a redefinition of its relationship with the classical ideals of the Renaissance, seen now in terms of not rupture but of continuity. Indeed, the seeds of Mannerism, as it were, can already be seen in the works of Raphael and Michelangelo, while the so-called "Mannerist" artists saw their work as intrinsically connected with the model of perfection represented by the two great masters, without, however, rejecting their links with nature. The dialectical tension between the natural model and the ancient model, so fundamental to the

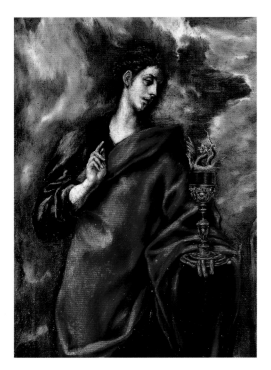

Pontormo (attr.)
Emblem of the Della Casa and Tornaquinci families, with frame imitating porphyry
back of the Lisabetta Tornaquinci della Casa birthing table, with *Nativity of Saint John* c. 1526–27, tempera on wood panel. Florence, Uffizi Gallery.

Renaissance concept of art, remained a central theme in the writings on Mannerism. In these texts, the classical example, in which category the works of Michelangelo and Raphael were now also placed, acted as a corrective to the imperfections of nature, so that artists could achieve the idea of beauty they had already formed in their imagination. Nature was not to be merely *portrayed*; it had to be *imitated*, shown as it should be (and not necessarily as it actually was). Furthermore, during the sixteenth century, "manner" was not an artistic practice but a style, a characteristic of a historical period (the Greek, or Byzantine, manner) or of a particular artist (the dry manner of Pollaiolo), and in absolute terms it was *the* style, the one required to achieve perfection in art. When the word *manner* is used in relation to one's own age, it takes on, except for some very rare exceptions, a highly positive tone. In Vasari's opinion, the *modern manner* reached its peak in his own time in the *fine manner*. The underlying principles of the fine manner sought to go beyond the rational harmonic measurements of the Renaissance, without, however, denying them. To the idea of the *rule* had to be added the notion of *license*, which "being not of the rule, had to be ordered within the rule;" to the idea of measurement had to be added the notion of *grace,* which "would exceed the measure," and to composition had to be included *facility*, or ease, "so soft and sweet, which is seen and yet not seen," while the manner itself had to incorporate *leggiadria*, "so as to render all figures slender and graceful."

It was on this fine balance of excess restrained within the parameters of order that the manner based its creative principle, pushing its models to the very limits in a continuous whirl of renewed

Abraham Jamnitzer
Daphne
c. 1550, gilt silver, coral and precious stones.
Ecouen, Musée national de la Renaissance.

Facing page, top:
Milanese production
Burgundy decanter for Alessandro or Ottavio Farnese
c. 1560–65, steel, gold and silver.
Naples, Capodimonte.

Below left:
Leonardo
Grotesque figure
early sixteenth century, red pencil.
Windsor Castle, Royal Library, © Her Majesty Queen Elisabeth II.

Below right:
Quentin Metsys
Old Woman
(*The Queen of Tunis*)
c. 1513, oil on wood panel.
London, National Gallery.

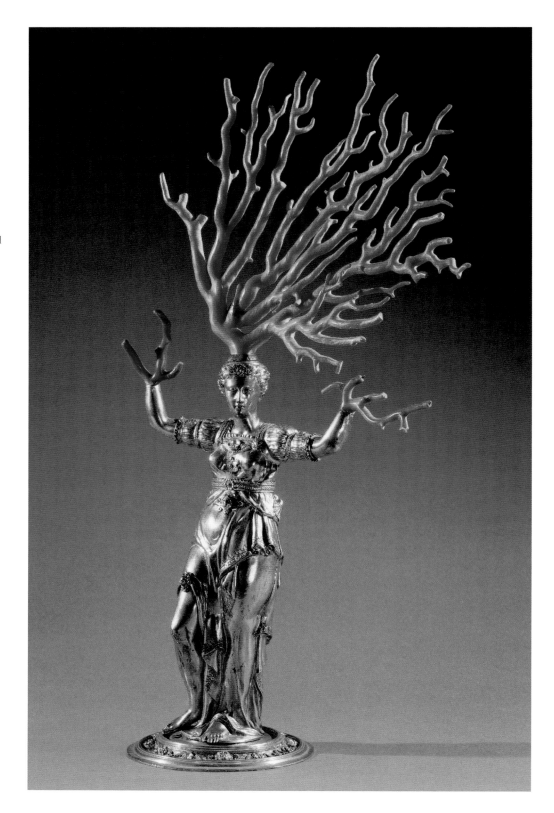

compositional forms and solutions. In this sense, the elements of *artifice*, *caprice*, or the *bizarre* (words that would be used in later generations' criticisms) were understood to be positive qualities. They showed the artists' inventive scope in pushing the idiomatic structure of their reference models into unexpected configurations, intended to arouse awe in a public capable of recognizing and understanding the paintings' cultural framework.

The fine manner was a cultured art form meant for a learned public; it praised studied difficulty rendered with apparent facility or ease, just as the good manners required for life at court showed how to display a certain natural *grace* that was, however, acquired through diligent application. According to Baldassare Castiglione in his *Book of the Courtier*, such nonchalance "conceals the art and shows that what one says or does is said and done without effort, almost without thinking about it."

Art concealing art, or the technical complexity of its own procedure, has Mannerism showing art in the persistent ostentation of its self-references. Rightly defined as an "art of art," or a stylish style, the understanding of its underlying principle of referential inventiveness has allowed scholars to identify its extension beyond the figurative arts (painting, sculpture, and architecture) to the decorative arts, garden design, spectacle, and performance art, literature, and music, as the highest, most wide-ranging expression of sixteenth-century artistic culture—not only in Italy but across the whole of Europe.

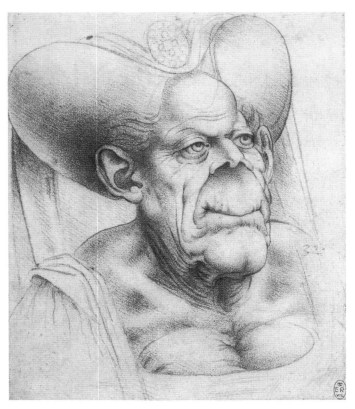

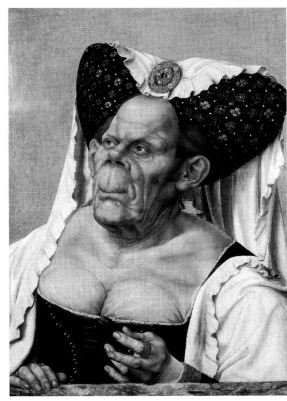

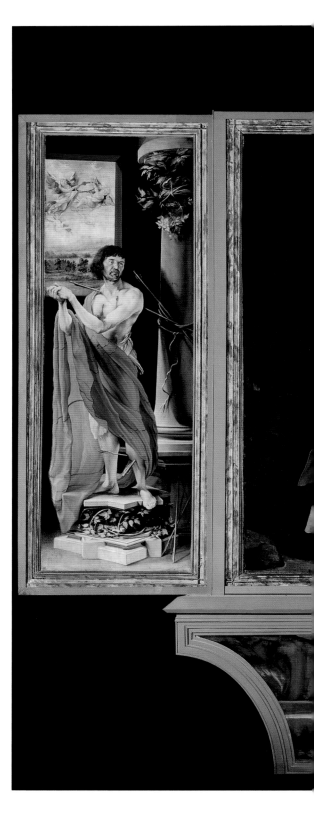

Top:
Perin del Vaga
Tarquinius Priscus Founding the Temple of Jupiter, detail, c. 1521, fresco. Florence, Uffizi Gallery.

Pontormo
Deposition, detail of painting shown on page 124 1527, oil on wood panel. Florence, Santa Felicita.

Right:
Matthias Grünewald
Isenheim Polyptych
1515, oil on wood panel. Colmar, Musée d'Unterlinden.

Below:
Hans Baldung Grien
The Three Ages of Woman and Death
1509–11, oil on wood panel. Vienna, Kunsthistorisches Museum.

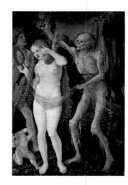

Genres and the Evolution of the *Bella Maniera* in Italy

The recontextualization of Mannerism has also underscored the role played by the "first generation" of Mannerist painters, the generation of Pontormo, Rosso Fiorentino, and Beccafumi. Their anti-classicism, formulated in the period 1515–1520, was not in fact a reaction to the classicism of Roman archeological culture embodied in Michelangelo and Raphael, but rather a reaction to Florentine classicism, those serene, well-balanced, and finely expressive compositions that were introduced by the generation of Perugino and pursued with particular emphasis by Fra Bartolomeo and Andrea del Sarto. This first wave of Mannerism, which was very receptive to the anti-classical elements in Germanic painting, as formulated by Grünewald, Altdorfer, Baldung Grien, and Dürer, and made known to the public through prints, remained detached from the main thrust of Mannerism, although it did herald some of the formal characteristics of later Mannerism. There were parallels to the first wave of Mannerism elsewhere in Italy, in the provocative figures of Amico Aspertini in Bologna, or the work of Dosso Dossi in Ferrara, or Lorenzo Lotto and Pordenone in the Veneto region. Mannerism, understood in its relation to the classical form, and sustained by the examples of Michelangelo and Raphael, developed around the same time in Rome, in Raphael's circle, including his pupils Giulio Romano, Perin del Vaga, and Polidoro da Caravaggio, who, after the master's death in 1520, contributed to the elaboration of an elegantly refined style that was further enhanced by the contribution of new arrivals in the Eternal City, Rosso Fiorentino and Parmigianino, who brought with him the sensual grace he had absorbed from Correggio. The lively cultural circle that was centered on the court of the Medici Pope Clement VII was abruptly and brutally dispersed by the Sack of Rome in 1527. The subsequent migration of artists who fled to other cities in Italy furthered the spread of Mannerism. When the Medici returned to power in Rome and Florence in the 1530s, exchanges between artists were concentrated around the major collective projects, while the last works of Michelangelo (and in particular the *Last Judgment*) were held up as models for the generation of Bronzino, Vasari,

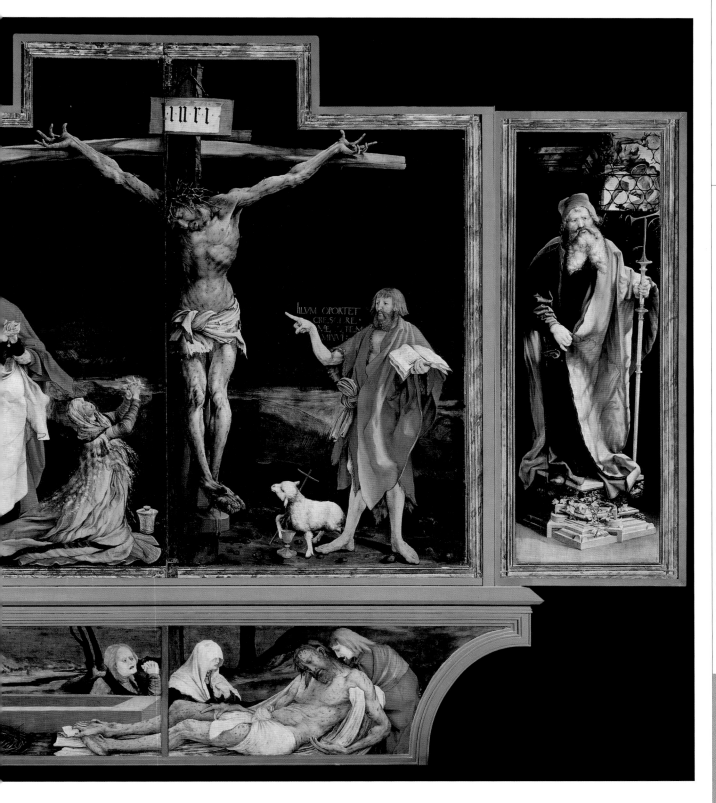

independently around such figures as Pellegrino Tibaldi and Bartolomeo Passerotti. Venice resisted this stylistic expansion, and in the view of commentators from Tuscany, the city was a hub of contradiction because of its stubborn faith in the use of color, so bound up with the natural model, the dominion of composition and its classical foundations; in other words, because of the city's preference for Titian as opposed to Michelangelo. Regardless of its entrenched theoretical standpoint, which was so central to sixteenth- century artistic debate, Venice did open up to Mannerist ideas in the 1540s (while never losing its own distinct and deeply rooted identity in terms of painting), thanks to the presence of Tuscan artists Francesco Salviati, Giuseppe Porta, and Vasari, and also because of the prox-imity of Parma and Mantua. These influences, which also surfaced briefly in the work of Titian and which were adapted by Paolo Veronese, had a significant impact on the formal explorations of Schiavone, Jacopo Bassano, and above all Tintoretto. The latter, in his quest to blend the compositional forms of Michelangelo with Titian's use of color, forged what might be called a Venetian style of Mannerism (the subject of harsh criticism from the Tuscan artists). Federico Barocci was little appreciated in his native Urbino, but achieved recognition across Europe. Around 1580, Barocci developed what might be called a transitional style, combining a highly emotive, indeed, powerfully pathetic, gracefulness with the typical style of Raphael and Correggio. He did so in order to imbue the still highly Mannerist figurative approach with sweeping naturalism that found favor well into the seventeenth century. During that period, artists had to deal with, and react to, the figurative and comp-ositional demands of the Counter-Reformation, imposed as a result of the 1563 decree from the Council of Trent on images. In the name of truth and the proper handling of the divine story, its dictates included clarity of intent and "readability" of representations of the same. This already carried a latent condemnation of the formal and conceptual license that was such a hallmark of Mannerism, and would trigger the gradual sapping and undermining of the style's creative scope.

and Francesco Salviati, who all contributed to establishing some form of regulation for the *bella maniera*, through both the writing of various treatises and the foundation of the *Accademia delle arti del disegno* in Florence in 1563. While Mannerism asserted its influence on a wide scale, it also spurred the founding of local schools in a number of Italian cities, but only to the extent that Mannerism was absorbed into the preexisting artistic tradition. For example, neither Genoa nor Mantua continued as centers for Mannerism after, respectively, Perin del Vaga left Genoa and Giulio Romano died in 1540. Mannerism in the Emilia region, and in particular in Bologna, developed

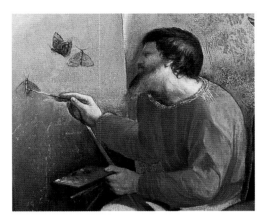

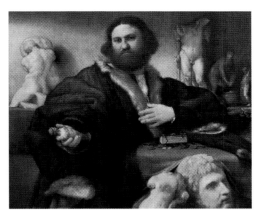

Far left:
Dosso Dossi
*Jupiter Painting
Butterflies,* detail of
*Jupiter, Mercury,
and Virtue*
1529, oil on canvas.
Vienna,
Kunsthistorisches
Museum.

Lorenzo Lotto
Portrait of Andrea Odoni
1527, oil on canvas.
Hampton Court,
Royal Collection.

Jacopo Tintoretto
*Cat staring threateningly
at a duck,* detail of
Leda and the Swan
c. 1560, oil on canvas.
Florence, Uffizi Gallery.

Facing page, top:
Paolo Veronese
The Battle of Lepanto
1573, oil on canvas.
Venice, Accademia.

Facing page, bottom:
Albrecht Altdorfer
The Battle of Issus
1529, oil on wood panel.
Munich, Alte Pinakothek.

Genres and the Evolution of the Bella Maniera in Italy

Mannerism

Hendrik Goltzius
*Without Ceres and
Her Offspring,
Venus Weakens*
1599–1602, pen and oil
on linen.
Philadelphia,
Philadelphia Museum
of Art.

François Clouet
A Lady in Her Bath
c. 1571, oil on
wood panel.
Washington,
National Gallery.

Below:
Parmigianino
*Portrait of a
Young Woman
(The Turkish slave)*
c. 1530, oil on
wood panel.
Parma, Galleria
nazionale.

Political Art and European Style

The eccentricity and spiritual restlessness of
Mannerism were no longer interpreted in a
generic fashion, but were limited to a few isolated
cases, such as Pontormo, Rosso Fiorentino,
Parmigianino, and El Greco. Nevertheless, in its
tensely inventive thrust, caught between balance
and instability, and in its quest to push the limits of
well-measured classical harmony to the point of
actually overwhelming them, Mannerism
developed a figurative register of refined and
somewhat remote elegance. This register, while it
may not have visibly interpreted the profound
political and religious upheavals of its age, did
in a sense sublimate its torments through
Mannerism's supreme command of the art of
imbalance. And this art form, which was con-
stantly victorious over its own inherent difficulty,
was art used in the representation of triumphant
power. After the Sack of Rome, Mannerism was
used to flaunt the reassertion of the papacy's
sovereignty and the unswerving stability of the
Holy See in the face of the Protestant threat. In
Florence, Mannerism was used to confirm the
legitimacy of continued Medici power, while the

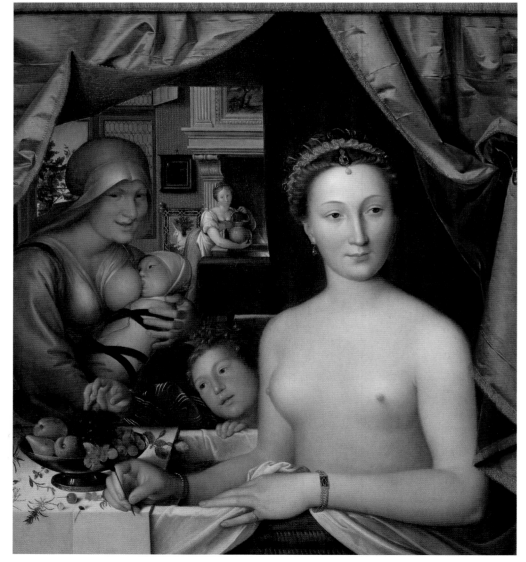

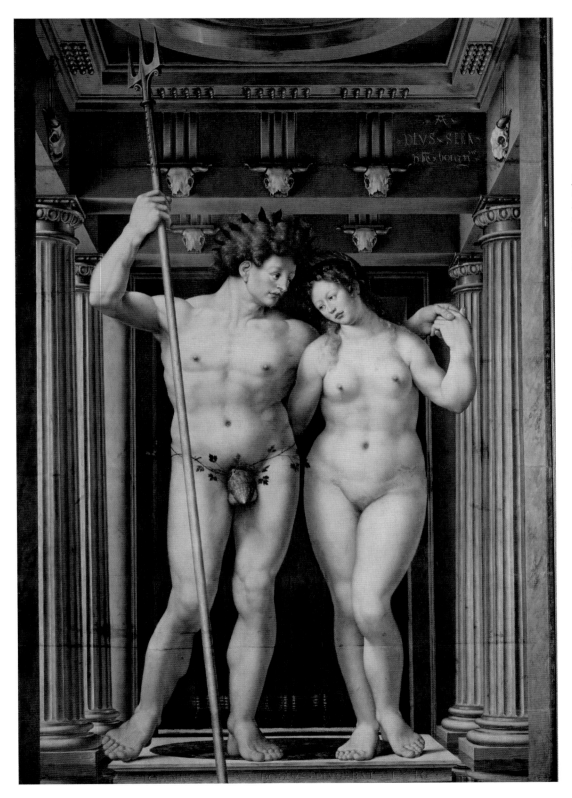

Jan Gossaert
called **Mabuse**
Neptune and
Amphitrite
1516, oil
on canvas.
Berlin,
Gemäldegalerie.

Lucas Cranach the Elder
Nymph of the Fountain
1518, oil on wood panel.
Leipzig, Museum der
Bildenden Künste.

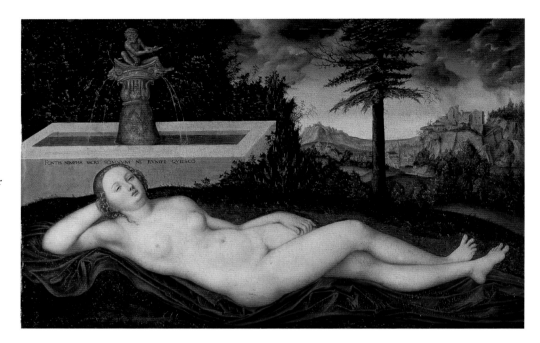

style's spread through Europe was largely a result of the political will of rulers. Emperor Charles V was one of the first to spread Mannerism, when he decided to substitute the traditional imperial Germanic model with the classical Italian style, and while the emperor's itinerant court meant that no one center for Mannerism took root, it did contribute to spreading its repertoire of ancient templates along the routes the court took through Italy and the whole of Europe; this repertoire was used to design temporary sets and other artistic creations to be used in celebrations of triumphal entries in different cities.

It fell to Charles's arch rival, Francis I of France, to create an outpost of Mannerism north of Italy. When the French king returned to France after his years of imprisonment in Madrid, he decided to demonstrate the restoration of his authority by leaving his castles along the Loire (decorated in a superficial ornamental Italian style) to focus on the founding of the entirely modern palace at Fontainebleau. To this end, Francis summoned masters such as Rosso Fiorentino (1530) and Primaticcio (1531). This vast project met with lasting success, and was sustained by the contribution of other Italian artists such as Benvenuto Cellini, Sebastiano Serlio, Jacopo Vignola, and Niccolò dell'Abate. The project was also pursued by Francis's successors, and led to the founding

of a number of local schools. Copies of the work at Fontainebleau were made known across Europe in prints. For the Netherlands, Fontainebleau would become the closest example of Italian modernity, a compulsory stop on the road to Rome. Openness to Italian concepts of art began in the second decade of the century with Bernard van Orley, who made a careful study of the cartoons for Raphael's tapestries in Antwerp in 1517, and Jan Gossaert (known as Mabuse), who was one of the first Dutch artists to visit Italy (1508–09). The journey to Italy would become an essential ritual for the next generations of artists, such as Jan van Scorel, Marten van Heemskerck, Frans Floris, and Martin de Vos (some of whose works are seen in this collection). Coming into contact with the Mannerist circles in Rome or Florence, these artists would then introduce the style in their own country. While Mannerism may have been developed independently in Flanders, it did not really have an impact on artistic production as a whole, which, due to the well-established and highly acclaimed local tradition, followed independent lines of development that led in particular to the emergence of successful genres, such as landscape painting and still life. A very telling example is the work of Pieter Brueghel the Elder who, regardless of his journey to Italy, developed a quintessentially modern style

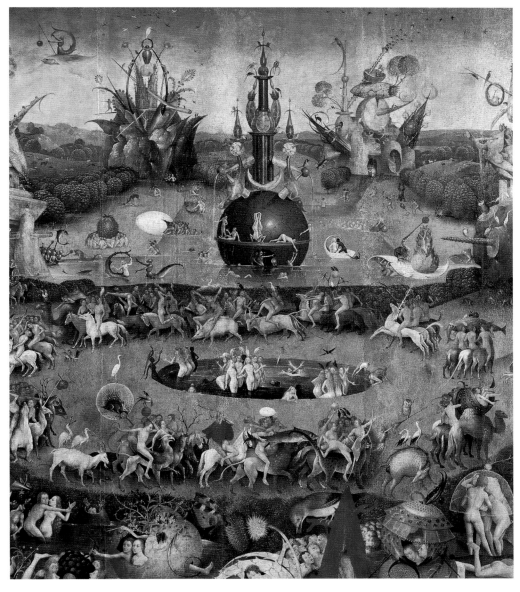

Hieronymus Bosch,
The Garden of Earthly
Delights triptych, detail
of central panel
c. 1505–10, oil on
wood panel.
Madrid, Prado.

Peter Brueghel the Elder
The Harvesters
1565, oil on wood panel.
New York,
Metropolitan Museum.

of representation founded on Flemish pictorial tradition. This style can be seen in the stories set in cosmic landscapes or in his apocalyptic visions inspired by the grotesque and hallucinatory world of Hieronymus Bosch. The separation of the Protestant provinces in the north of the Netherlands from the Catholic lands in the south (made effective in 1581) contributed to further development of Mannerism. This style was pushed to formal and technical extremes by the virtuoso talent of the Calvinist north, where artistic production, released from the demands of church

Gaspar Becerra
Perseus with Medusa's Shield, ceiling detail of *Perseus and the Golden Fleece* c. 1565, fresco. Madrid, Palacio El Pardo.

Right:
Philibert de l'Orme
Cupola Vault 1549–52. Anet (Eure-et-Loir), castle chapel.

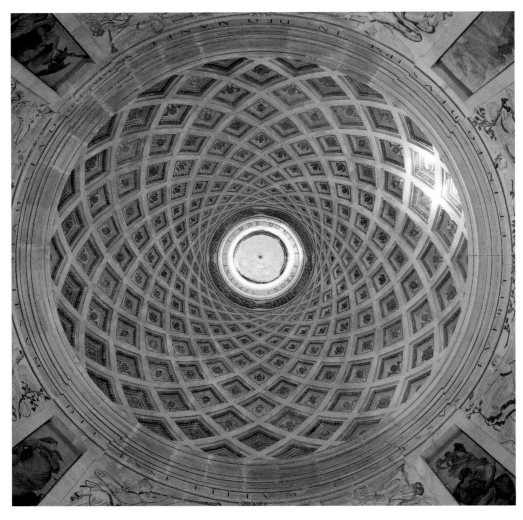

commissions, was now supported by the market and private collectors. It was to the cities of Haarlem (and the work of Karel van Mander, Hendrik Goltzius, and Cornelis Cornelisz) and Utrecht (Abraham Bloemaert and Joachim Wtewael) that the Emperor Rudolf II turned when he created collections in his new capital established in Prague in 1583. This last truly Mannerist court, which continued to dazzle as late as 1612, was dominated by such figures as Bartholomaeus Spranger, Hans von Aachen, and Adriaen de Vries. Rudolf's cultural choices followed in the family tradition of his father Maximilian II, his uncle the archduke Ferdinand, and his cousins, the dukes of Bavaria. In their respective residences in Vienna, Innsbruck, and Munich, they had imported antiques dealers and

scholars, as well as pieces from antiquity, Mannerist works and artists, and models for palaces and decorations, all with the aim of giving a more courtly and elegant appearance to the representation of their power. Protestant principles inclined collectors, except in very rare cases, to prefer the more Germanic register of painters such as Lucas Cranach (shown on p. 110). But in Rudolf's Prague, art was not employed in the ostentatious demonstration of power (which, in any case, was increasingly weakened and contested); rather, it sought to re-create a highly cultured microcosm of extreme refinement, designed for the sovereign and his circle. The Mannerist choices of Rudolf's relative, Philip II of Spain, who had also founded a new capital in Madrid in 1561, and who shared

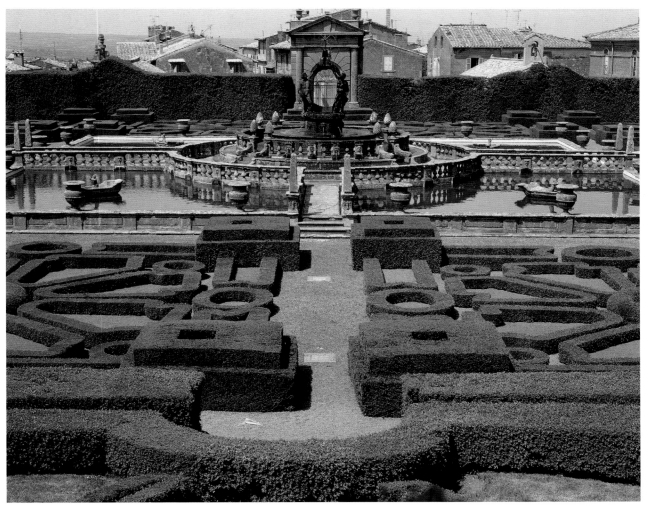

Giambologna
Fontana dei Mori
last quarter of the
sixteenth century.
Bagnaia, Villa Lante
gardens, designer by
Jacopo Vignola.

Rudolf's passion for collecting, produced diametrically different results; Philip's choices were tied to the representation of a political and religious program.

In the 1560s, Philip commissioned the decoration of the Pardo palace from Gaspar Becerra, a Spanish artist who was familiar with the approach of Roman Mannerism. However, in the 1580s, when it came to the grand project to decorate the Escorial, the royal convent and family mausoleum, the sovereign turned directly to Italian artists: Luca Cambiaso, Federico Zuccari, and Pellegrino Tibaldi. In the execution of this commission for enormous religious paintings, the king's demands for clarity and decorum, in keeping with the Council of Trent's impositions, clashed with the creative zeal of the Mannerist painters to such an extent that their inventiveness suffered, while more accomplished and more coherent results were achieved with the architecture of the huge building, inspired by the sober principles of Counter-Reformation architecture as seen in the Roman church of Gesù, designed by Vignola and Giacomo della Porta. The Escorial (which is illustrated here in a separate section) is the most flagrant example of the intrinsic impossibility of reconciling Mannerism and Counter-Reformation. It marked the end of the last stylistic expression of the Renaissance and opened the way to the Baroque.

Competitions, Comparisons, and Rivalries

In the first two decades of the sixteenth century, Rome and Florence produced artistic works of such importance that they influenced the development of art throughout the whole century. The authors of these works were the leading exponents of what Vasari would call the "modern manner," namely Leonardo da Vinci, Michelangelo, and Raphael, who confronted it other, as it were, in the arena of major public commissions. The first round took place in Florence, where the new century, like the previous one, began with a public competition that was meant not to identify the finest talent available, but rather to stimulate competitive zeal between two leading artistic figures. In 1504, the magistrate Pier Paolo Soderini entrusted the decoration of the Grand Council chamber in the Palazzo Vecchio to the 52-year-old Leonardo da Vinci, a highly acclaimed painter with a well-established reputation, and the much younger Michelangelo, a sculptor of recent and much discussed success. Both painters were required to paint a historic Florentine military victory on the chamber's two long walls. Despite the infelicitous outcome of the project (Da Vinci abandoned the commission in 1506 for technical reasons, while Michelangelo responded to Pope Julius II's summons to Rome in 1505), the unfinished works served as a lesson to the next generation of artists, who actually managed to destroy Michelangelo's cartoon for the project because they studied and copied it so much. The surviving copies, which illustrate only the central scenes of the two battles, show a

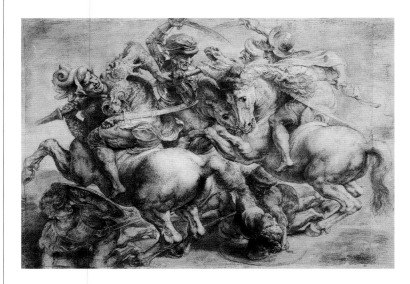

Pieter Paul Rubens (copy after Leonardo)
Battle of Anghiari
c. 1615, black chalk, pen and ink,
retouched with brown, on paper.
Paris, Louvre, Département des Arts Graphiques.

The fulcrum of the furious fighting in this illustration of the 1440 battle between Florentine and Milanese troops is the driving force that drags down men and horses. There are traces of homage to Leonardo's studies of water and air vortexes, in his exploration of the universe's energies.

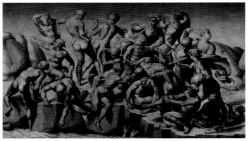

Aristotile da Sangallo
(attr., copy after Michelangelo's cartoon)
Battle of Cascina
c. 1542, wood panel.
Holkham Hall (Norfolk), Viscount Coke and the Trustees of the Holkham Estate.

The episode shows wet, naked Florentine soldiers, surprised by a false alarm of a Pisan enemy attack in 1364, which offered Michelangelo the opportunity to depict countless variations of the male body theme, caught in poses of physical effort.

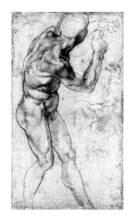

Michelangelo
Study of a Nude for the "Battle of Cascina"
1504–05, black pencil and chalk on paper.
Haarlem, Teylersmuseum.

Michelangelo sought to prove his talent by competing on the terrain where Leonardo reigned supreme: the knowledge of human anatomy, acquired through his life studies and dissection of bodies.

confrontation not only between a painter and sculptor from different generations, but also between two sharply divergent conceptions of art. Da Vinci chose to represent the fulcrum of the battle around the struggle to capture the adversary's standard, in an explosion of violence that piled men and equally ferocious-looking horses together in one mass of figures. Michelangelo chose an episode that preceded the battle proper, depicting Florentine soldiers surprised by a false alarm as they were bathing in the River Arno. His aim was to highlight the tension as the soldiers sprang into action, made clear in the taut muscles of the naked figures trying to dress again quickly. The composition is made up of carefully isolated figures and the scene's sense of unity comes from the relationships among the positions. The rivalry between the two men also came into play in private commissions; it was during this period that Michelangelo sought his own answer to the idea of the Holy Family put forward by Da Vinci in his acclaimed *Saint Anne and the Virgin with the Child Jesus*. In contrast to the fusion between the subjects and the landscape, Michelangelo proposed a more dynamic solution that would unite the different figures along a single line of force. The debate was further complicated by the arrival of Raphael, the rising star in the artistic firmament, who as soon as he reached Florence abandoned the style learned from Perugino and absorbed the example of Da Vinci.

Michelangelo
The Holy Family With Infant Saint John
(Doni Tondo)
1504–06, tempera on wood panel.
Florence, Uffizi Gallery.

The concatenation of the figures, which Leonardo molded in a register of gentle expressions and fluid movements, is resolved by Michelangelo with a vigorous spiral, hinging on the twisting body of a virile Madonna, as she turns towards Saint Joseph and the Child Jesus (detail on page 99).

Leonardo
Saint Anne, the Virgin, Infant Jesus and Infant Saint John (Burlington House Cartoon)
1498, black chalk, whiting, and stump on paper.
London, National Gallery.

In 1501 Leonardo exhibited a cartoon in Florence of *Saint Anne, the Virgin and Infant Jesus* "who seems to escape His mother's arms to reach for a lamb." An initial idea of this lost opus, which was very influential, can be grasped from the London cartoon.

Raphael
Madonna of Belvedere
1506, oil on wood panel.
Vienna, Kunsthistorisches Museum.

Raphael captures the grace of the faces and the pyramidal arrangement of the figures from Leonardo's model, showing their intimate relationship with the landscape, but forsaking the nuanced tones for a more limpid color approach.

Michelangelo, Bramante, and Raphael in Rome

Towards the end of the 1510s, the arena moved to Rome, and this time the clash was between Raphael and Michelangelo. Pope Julius II had summoned Michelangelo in 1505 to carry out the execution of the pope's mausoleum, which was meant to be placed in Saint Peter's. The pope set aside the sculptural project the following year and called on Michelangelo to paint the ceiling of the Sistine Chapel instead. Michelangelo was convinced that the pope's change of heart, which forced him to show his talent in painting, an art form he felt less accomplished in than sculpture, was the result of intrigue and maneuvering by his rival Bramante, chief architect for the new construction project for Saint Peter's. In irritation Michelangelo fled to Florence, but he soon had to resign himself to accepting the pope's will and returned to Rome in 1508. The competitive climate became all the more exasperating with the arrival of Raphael who, through his friend and compatriot Bramante, obtained the commission to decorate the new papal apartments. Michelangelo locked himself away in the Sistine Chapel, carrying out his colossal endeavor in secret. The original idea of representing the twelve apostles was abandoned in favor of a much more ambitious iconographic program, one that embraced episodes from the

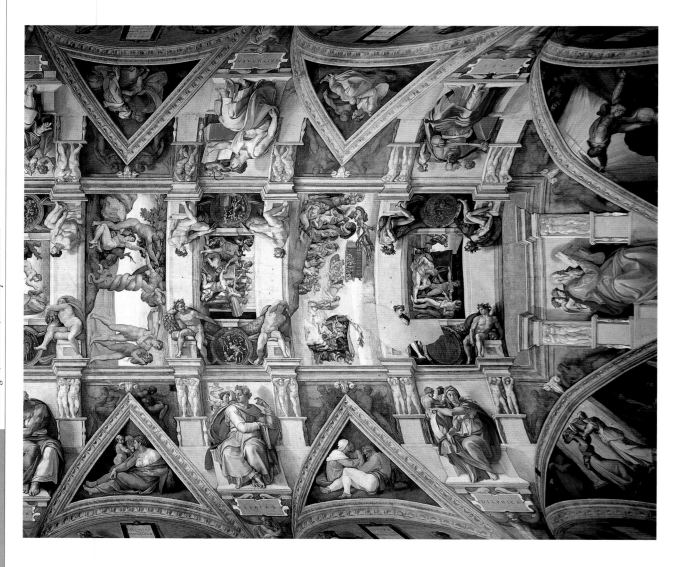

Book of Genesis, the sibyls and prophets, and a number of theories concerning Christ's ancestors and other biblical episodes, all of which were meant to herald the coming of the Messiah. Michelangelo prepared the vast surface to be painted (over 1,000 square meters), making use of the existing pendentives, lunettes, and vaults, and of architecture he created through optical illusion; the solution allowed him to divide up the scenes while maintaining overall compositional unity. Attention is once more focused on the individual human figure, which Michelangelo examines from every point of view to highlight its anatomical perfection, making use of constricted spaces. The imposing architectural trompe l'oeil serves as background and support for numerous variations on the same theme: the enthroned figure ensconced in a niche, the monumental forms of the prophets and sibyls, the pair of putti incorporated into the pillar, the fake marble telamons, the virile nude folded into a triangular space, the fake bronze bas-reliefs, and finally the naked figure seated precariously on a cube, used as a frame for the episodes from Genesis.

The first part of the ceiling was uncovered in 1511, and Raphael was profoundly affected by the vision theron revealed. The frescoes he was painting in the Stanza della Segnatura underwent a noticeable change, as can be seen from the

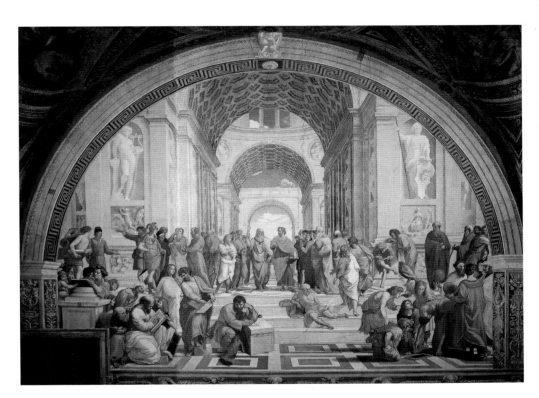

Facing page:
Michelangelo
Sistine Chapel vault
1508–12, fresco.
Vatican.

The vault's painted architecture appears improbable, since the base trompe l'oeil is enclosed by flat squares. To achieve a formal solution to so contradictory a perspective, Michelangelo had the juncture points between the spatial systems for the "transition" figures (that is to say, the famous foreshortened nudes) in unstable positions. These male nudes, holding garlands of acorns and oak leaves—the heraldic emblems of the Della Rovere pope—animate the entire vault thanks to the variety of poses and expressions. They are among the most praised, studied, and copied of Michelangelo's repertoire.

Raphael
The School of Athens
1509–11, fresco.
Vatican, Stanza della Segnatura.

Pope Leo X is said to have declared that Raphael, "when he saw Michelangelo's work, immediately abandoned the manner of Perosino and imitated as closely as he could that of Michelangelo." This fresco sets the greatest philosophers of antiquity against a monumental backdrop inspired by Bramante, and the mighty figures seated in the foreground are clearly drawn from the Sistine Chapel prophets. Raphael gave one figure, the melancholy Heraclites leaning in the squared mass, Buonarroti's face, a homage—not lacking in irony—to the tormented creativity of his great rival.

Mannerism | Michelangelo, Bramante, and Raphael in Rome

explicit references to Michelangelo's prophets, recognizable in certain figures in *The School of Athens*.

Raphael was a "talent ready to absorb" from others, as Paolo Giovio remarked, and the artist did indeed incorporate Michelangelo's style into his own. Michelangelo understood that he could not rival the exceptional talent of Raphael as a painter, all the more so after having seen the extraordinarily skillful handling of light in the nocturnal painting *The Release of Saint Peter*, part of the decorations of the Stanza d'Eliodoro. Michelangelo became a firm associate of Sebastiano Luciani (also known as Sebastiano del Piombo), a young Venetian painter who displayed great talent in the rendering of colors, and who arrived in Rome in 1511. Michelangelo entrusted

Luciani with executing the paintings of a number of his drawings. Even after Michelangelo's return to Florence in 1516, during the reign of Pope Leo X, he managed to prolong the confrontation with Raphael on Roman soil through the work of Luciani. Their rivalry reached its peak in 1517 with a commission from cardinal Giulio de' Medici for two altarpieces for his bishopric of Narbonne: the themes were the *Raising of Lazarus* (assigned to Raphael) and the *Transfiguration* (given to Luciani). Raphael died unexpectedly in 1520 while he was finishing the work, but obtained a posthumous victory: his altarpiece remained in Rome, on the high altar of San Pietro in Montorio, while the painting by Luciani, which was taken from a model by Michelangelo, was sent to France.

Sebastiano del Piombo
Raising of Lazarus
1517–19, oil on
wood panel.
London, National
Gallery.

Sebastiano sets his
monumental figures,
influenced by
Michelangelo, in a deep
landscape with typically
Venetian chromatic
intensity and outstanding
profiles of Roman ruins
and bridges.

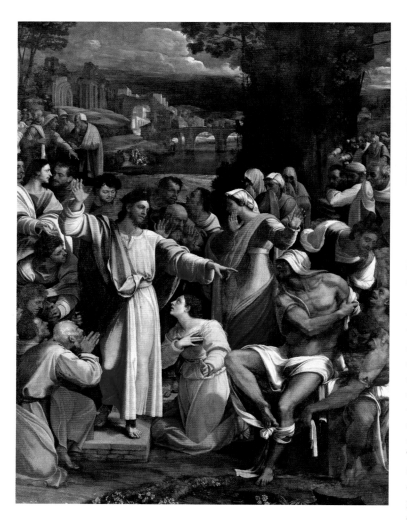

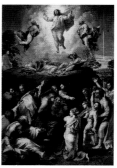

Raphael
Transfiguration
1518–20, oil on wood
panel.
Vatican, Pinacoteca
Vaticana.

This pictorial testament
by Raphael is greatly
admired for the brilliant
radiance of Christ,
revealing His divine
nature, and the expressive
variety in the scene,
depicting the liberation
of the possessed man.
The powerful chiaroscuro
tones reinforce the sense
of restlessness that
pervades and unites the
entire composition.

The most important building project of the age was of course the reconstruction of Saint Peter's Basilica. For over one hundred years, the colossal endeavor would employ the talents of the finest architects of the age, Bramante, Giuliano da Sangallo, Baldassarre Peruzzi, Raphael, Antonio da Sangallo the Younger, and Michelangelo. Constrained by the orientation of Constantine's original basilica, by the central axis defined by Saint Peter's tomb, and by the requirements of papal ceremony, each of the architects was determined to push forward his interpretation of the ideal place of worship. The project had been started under Julius II in 1506, and Bramante was put in charge of construction. He developed the idea of a circular-plan church topped with a cupola or dome, an idea he had already put into practice on a smaller scale with the church of San Pietro in Montorio. Over the next decades, and as an alternative to the original project with a Greek cross plan, which allowed a classical style arrangement of the building's volume, the architects presented plans for a Latin cross layout (closer to the original basilica's) until 1546, when Michelangelo declared that the project had to return to Bramante's "straightforward" plan. He ordered the demolition of the "confused, obscure, and false" work begun by his hated predecessor Antonio da Sangallo. In fact, Michelangelo developed a more contained and simplified Greek cross plan with a view to emphasizing the rise of the enormous cupola.

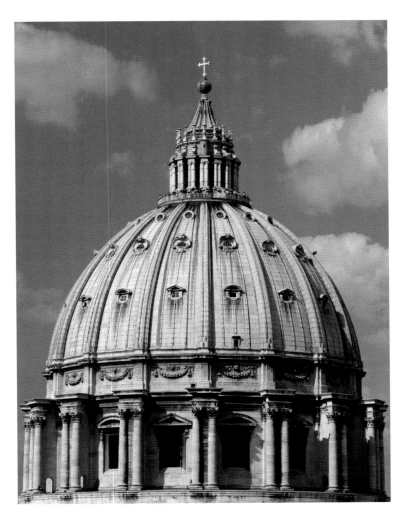

Michelangelo
Saint Peter's Dome
Vatican.

The cadenced columns projecting from the drum are the key to this work's structural and visual continuity. Note the articulation of the colossal order of the walls and ribs of the dome; the rhythm is resumed in the crowning of the lantern in a highly dynamic synthesis. The perfectly hemispheric vault was designed thus largely for reasons of stability, perhaps by Giacomo Della Porta, who finished the work in 1593, after Michelangelo's death. Judged to be of insufficient size, Michelangelo's building (cf. floor plan lower left) was expanded into the present-day Latin cross by Carlo Maderno at the beginning of the seventeenth century.

Bramante (1505–14)
Antonio da Sangallo the Younger (1520–46)
Michelangelo (1546–64)
Floor plans for Saint Peter's.

Mannerism *Michelangelo, Bramante, and Raphael in Rome*

Tuscan Draftsmanship and Venetian Color

The tense rivalry, one-upmanship, and constant comparison that went on between artists and patrons gradually occupied the terrain of scholarly commentary and treatises, setting the Tuscan-Roman and Venetian schools against one another in the persons of the two schools' greatest living exponents, Michelangelo and Titian. The crux of the matter was the conception of artistic perfection, which Tuscan theorists saw as deriving from draftsmanship, the "father" of the sister arts, architecture, sculpture, and painting. The preeminence of what was as much a conceptual as a technical tool made it possible to claim the intellectual nature of the artist's endeavor, freeing it from its old ties with the mechanical arts. Furthermore, through good draftsmanship the artist sought to go beyond the imitation of nature to find the "idea" of beauty, achieved through the select study of the finest parts of natural models, following the example set by classical works. Michelangelo, the universal artist, was certainly not one to accept the "accidents" of nature and was more than capable of equaling or indeed surpassing the classical style. The supporters of draftsmanship elevated Michelangelo to the rank of hero, in particular in the first edition of Giorgio Vasari's *Lives of the Most Excellent Architects, Painters, and Sculptors*, published in 1550. Vasari's *Lives*, in a sense one of the founding texts of art history, charted the rise of

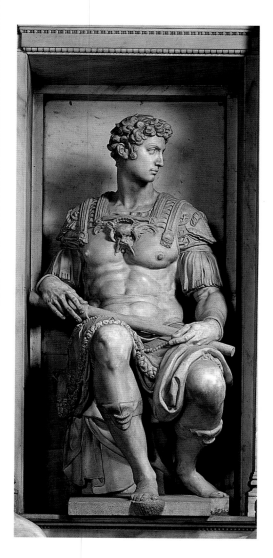

Michelangelo
Duke Giuliano
of Nemours
1526–34, marble.
Florence, San Lorenzo,
Sacrestia Nuova.

Paying little attention to resemblance in the statues for their tomb monuments, Michelangelo gave Lorenzo and Giuliano de' Medici classically beautiful faces intended to express an ideal of greatness.

Above:

Giovan Gerolamo Savoldo
Portrait of a Clad Warrior
c. 1525, oil on canvas.
Paris, Louvre.

The play of reflection on the polished surface here aimed to prove that representation of a figure from multiple angles is not exclusive to sculpture. On the contrary, painting allows a simultaneous view. Giorgione had already experimented with this, painting a nude from behind and showing the face and sides in the reflection in a fountain, mirror, and plate of armor.

art from a purely Florentine perspective, from Cimabue to Michelangelo, emphasizing the significance of the compositional and conceptual supremacy of Tuscan-Roman draftsmanship over Venetian color. Venetian commentators promptly replied to the criticism that artists from Venice were lacking in draftsmanship skills. In 1548 Paolo Pino defined the building up of color as a figurative process that used chiaroscuro tones to merge the outline (that is, the drawn line) with color, understood as pure matter. In 1557 Ludovico Dolce presented his objection to Vasari's claim for the uniqueness of Michelangelo's work. He put forward the much varied art of Raphael and ended by defending Titian, who brought together the "grandeur and monstrousness of Michelangelo, the pleasantness and beauty of Raphael, and the very colors of nature." Tuscan commentators did recognize Titian's skill with color, although in the debate that pitted sculpture against painting. Benedetto Varchi dedicated a Lesson on the superiority of the arts, to the issue in 1547. The story told of how Titian's portraits managed to deceive the viewer because of the strength of their likeness to the subject is the most frequently cited example of the supremacy given to painting by the illusionary power of color.

Titian
Danae
1545, oil on canvas.
Naples, Capodimonte.

Painted for Cardinal Farnese, this became the *casus belli* in the dispute between Tuscan drawing and Venetian color. Michelangelo would state that "he was pleased by the color and manner, but it was a shame that in Venice they did not learn from the start how to draw well."

Right:
Michelangelo
Awakening Slave
1530–34, marble, Florence, Accademia.

Michelangelo avoided getting involved in the debate over the comparison of the arts, although he confessed a preference for sculpture, "what is made through the force of lifting" because "what is made by placement is similar to painting." Chiseling stone gave the idea of drawing forth and liberating the embryonic figure contained in the material, as seen in this statue intended for Pope Julius II's tomb in Rome.

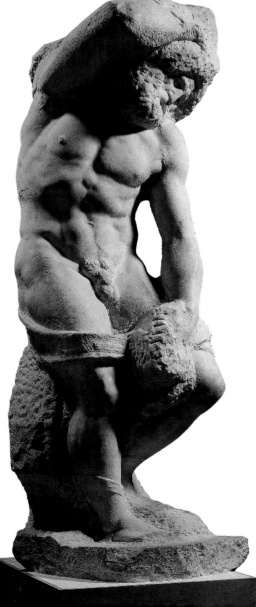

Mannerism | *Tuscan Draftsmanship and Venetian Color*

The Anti-Classical Rebellion

According to Vasari, the *Deposition of Christ from the Cross* that Perugino had completed around 1507 for the church of the Santissima Annunziata (today in the Accademia, Florence) was "criticized by all the new artists, and particularly because Pietro had used those figures that he had already used other times." Perugino had been listed among the major Italian artists in 1500, yet now, in 1507, his successful approach was considered old-fashioned because it had remained unreceptive to the powerful compositional innovations introduced by Da Vinci and Michelangelo. Fra Bartolomeo and Andrea del Sarto, the two painters who would go on to dominate the artistic scene in Florence after the departure of the three great masters between 1505 and 1508, did learn from Da Vinci and Michelangelo as well as adopting some elements from Raphael. In the works of Fra Bartolomeo and Andrea del Sarto, the measured compositions that exhibit the serene balance of late fifteenth-century art are revitalized by a sweeping dynamism that gives the figures and draperies a greater sense of volume and movement while using color to explore the delicacy of *sfumato*, or blurred tonalities. This was an evolution in continuity with the past that sought to define regular classical schemes and it would

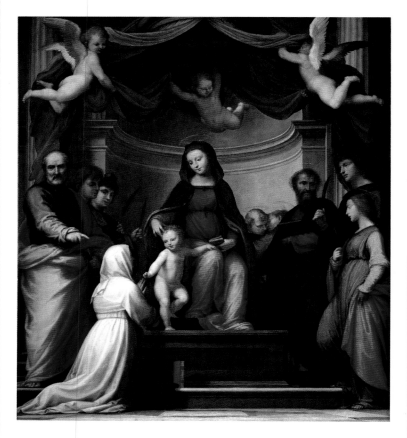

Fra Bartolomeo
Madonna and Child with Saints, and the Mystic Marriage of Saint Catherine of Siena
1511, oil on wood panel.
Paris, Louvre.

The ambassador of Louis XII, King of France, donated this altarpiece, painted for Saint Mark's Basilica. The scenic effect of the canopy animates the sober monumentality of the figures, whose semicircular arrangement around the Virgin follows the curve of the apse.

Below:
Andrea del Sarto
Madonna of the Harpies
1517, oil on wood panel.
Florence, Uffizi Gallery.

The niche and pedestal give this Madonna with Child the ambiguous appearance of a living sculpture. The classic compositional symmetry is further enlivened by the generous draperies and the contrasting positions of Saints Francis and John the Evangelist, reprised by the angels who cling to the vestments of the Virgin.

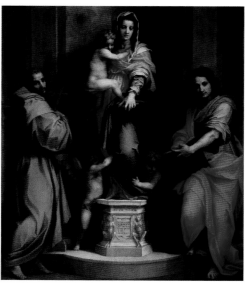

provoke a certain hostility among the younger artists. The first signs could be seen around 1515, among pupils in Andrea del Sarto's own workshop. Pontormo and Rosso Fiorentino reacted to the perfect yet unsurprising art of their master by breaking up established compositional balance and ignoring spatial orderliness, restrained expression, and harmony of color. In the Pala Pucci altarpiece painted by Pontormo in 1518 for the church of San Michele Visdomini, the established traditional pyramidal arrangement of the figures gives way under pressure from dissonant relationships and an imbalance in the distribution of full and empty space, as well as an excess of intensity in the expressions and gestures of the figures. This outburst of instability would lead to a quest for a rhythmical elegance made up of individual figures seemingly suspended in a rolling flow of sinuous lines and the changing hues of swollen clothes. The style reached its peak in the Santa Felicità *Deposition* (see page 124) and the Carmignano *Visitation*. Rosso Fiorentino expressed his dissent in angular and scrawny physiques, limbs as sharp as hooks, screaming faces, and screeching tones. His early works were charged with a violence of expression that appalled some of his commentators. This reaction, described as "early Mannerism" or "anti-classicism,"

Below:

Pontormo
Madonna with Child and Saints Joseph, John the Evangelist, Francis and James (Pala Pucci)
1518, oil on wood panel.
Florence, San Michele Visdomini.

The apparent disorder of the figures, skillfully overturning the traditional symmetry of the pyramid design, echoes the expressive mobility and mystic intensity of the faces. The central role of Joseph, holding the child, reflects dedication to this saint of the funeral chapel of the patron: Francesco Pucci, whose eponymous saint is, in turn, shown in rapt adoration of the Christ Child.

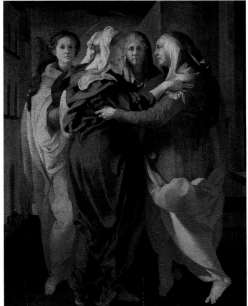

Above:
Albrecht Dürer
Four Witches
1497, engraving.

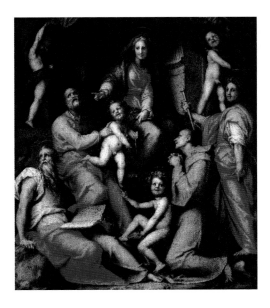

Pontormo
Visitation
c. 1528, oil on wood panel.
Carmignano, Pieve di San Michele.

The Virgin and Elizabeth, inflated in their swelling gowns, embrace with the lightness of dancers, while their two mysterious twins perform a counterpoint in the background. Pontormo was inspired for this compositional doubling by a Dürer engraving, and set his figures in a space beyond any probable measure, as shown by the two tiny figures to the left.

Mannerism | *The Anti-Classical Rebellion*

went beyond Florence, spreading to central and southern Italy. The long, spindly figures, the sharp pointed faces, and the iridescent luminosity in the works of Siena painter Beccafumi are another accomplished example from elsewhere in Tuscany. Sources of inspiration for the extravagant inventions elaborated by this generation of artists can be seen both in graphic art from Northern Europe, particularly in the etchings of Dürer and Luke of Leiden, and in the models of Da Vinci and Michelangelo (the studies of grotesque figures of the former, and the discordant colors of the latter). In this period of intense research into formal innovations, artists experimented with a number of solutions, such as elongating bodies, placing contorted figures in the foreground, skewed perspective foreshortening, or the almost ornamental use of the human form, which would later become staples of the "fine manner." Regardless of these affinities, the eccentric early production of Pontormo, Rosso Fiorentino, Beccafumi and other "anti-classical" artists must be considered as a preliminary yet distinct chapter in the development of Mannerism. In the form it took in Rome in the 1520s, the style was seen as being a seamless progression from its references models (Michelangelo and Raphael), guided by the heights of ancient perfection.

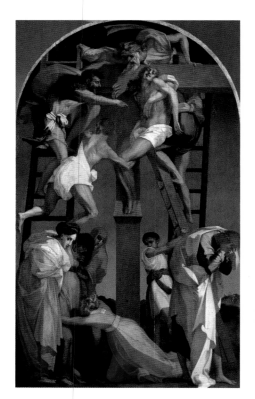

Rosso Fiorentino
Deposition
1521, oil on wood panel.
Volterra, Pinacoteca.

Rosso dramatically reinterprets the canonic scheme of the *Deposition*. The violent suffering is rendered by the extreme expressions, the concatenation of angular bodies, and the dazzling light that sharply draws clear folds on the clothing.

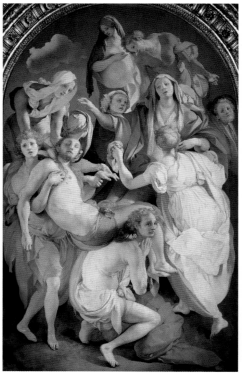

Pontormo
Deposition
1527, oil on wood panel.
Florence, Santa Felicita, Capponi Chapel.

The centrifugal movement of the figures holding up Christ corresponds to the movement that slides from top to bottom following the agony of the Virgin. This extraordinary composition, suspended in an uncertain space, is constructed entirely along these two complementary axes.

Guillaume de Marcillat
Deposition and Entombment of Christ
1526, stained glass.
Florence, Palazzo Capponi (from the Capponi Chapel, Santa Felicita).

Left:
Rosso Fiorentino
The Holy Family
c. 1520, oil on wood panel.
Los Angeles, County Museum of Art.

The unfinished aspect of this work, given by the rapid, transparent brushstrokes, offers proof of a "certain cruel and desperate air" that Vasari felt characterized the sketches of Rosso Fiorentino, later softened in the completion phase.

Below:
Domenico Beccafumi
Saint Michael and the Fall of the Rebellious Angels
c. 1524, oil on wood panel.
Siena, Pinacoteca Nazionale.

Some of the fallen angels recall models in the Sistine Chapel vault, but here Michelangelo's powerful nudes are transfigured into slim, elongated, leaping bodies. The grim lights of hell dissolve in the golden luminosity of the firmament, enclosed in the embrace of a diaphanous but angry Eternal Father.

Alonso Berruguete
Salomé
c. 1515, oil on wood panel.
Florence, Uffizi Gallery.

From the slight gesture of Salomè's long, elegant hand, the platter with the head of John the Baptist seems to slide towards the spectator, following the bold diagonal of the architectural foreshortening in the foreground. Son of Pedro Berruguete, the author of this painting is known to have lived both in Rome and Florence for a decade before his return to Spain in 1518.

Mannerism *The Anti-Classical Rebellion*

The Nude: Perfection in Art, Decorum, and Faith

Michelangelo's *Last Judgment* was unveiled in the Sistine Chapel on All Saints' Day, 1541, and caused a great sensation. The immense work, its sweeping compositions made up entirely of colossal figures, was acknowledged as being the greatest example of Michelangelo's "monstrousness." The anatomical precision and infinite variety of movements and expression of the many nudes bestowed on man every aspect of the perfection of Creation, more than justifying Ariosto's famous verse, "Michel is more divine Angel than mortal man." Vasari had the honor of bestowing the most hyperbolic definition when he wrote that the *Judgment* was that "great painting which God has sent to men on earth." Such fulsome praise was immediately followed by energetic criticism, for iconographic reasons—the beardless Christ, the wingless angels, the fearful Virgin, and the Blessed who exchanged embraces—but above all for reasons of decorum. The more bigoted members of the public considered it "a most shameless thing in such an honored place to have made so many nudes who so disgracefully display their shame, "and which was not a subject for a pope's chapel but the tavern or baths."

These nude figures, which were commonly used in depictions of the *Judgment* to represent the risen and the damned, had been present on the ceiling of the Sistine Chapel for some

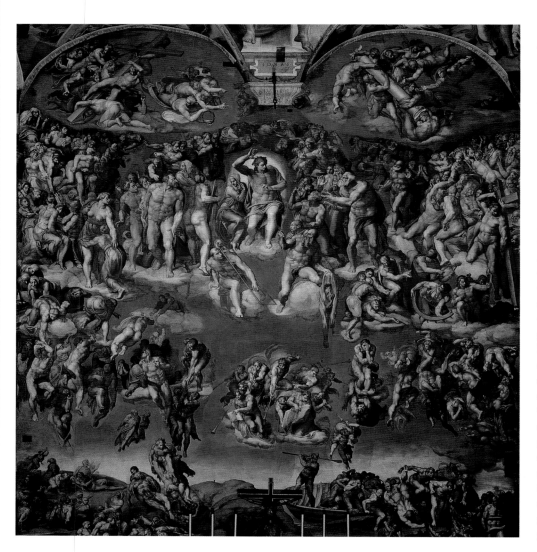

Michelangelo
Last Judgment
1536–41, fresco.
Vatican, Sistine Chapel.

The power of a single gesture made by Christ unleashes the swirling movement that supports, against any gravitational force, the corporeal masses in the emptiness of the sky of an intense, lapis lazuli blue. Even the proportional relationships escape the terrestrial plane because the distance of the figures from Christ establishes their dimensions, thus giving the saints nearest Him the appearance of giants. In this composition, Christ-centered in every sense, the dynamic key was already embryonically present in the young bas-relief from the *Battle of the Centaurs* (Florence, Casa Buonarroti), a tangle of bodies in combat that pivots around Apollo's peremptory gesture.

time without arousing hostility. The hostile reactions did not concern generic nudity, but rather the unclothed representation of saints and angels which was simply without precedent and made it difficult to distinguish the divine host from common souls. In a way, it was the overall novelty of the composition that provoked reservations because although Michelangelo had followed the traditional layout for the *Last Judgment*, he had plunged the traditional linear hierarchy into a dynamic vortex. Against the unstoppable movement of the bodies, nudity represents the equality of all men before the inscrutable divine will, expressed in the imperious gesture of Christ in judgment, a figure so terrifying that even the Virgin and saints are fearful. This deeply mystical reading of the Final Day was for the most part misunderstood, and the criticism that Michelangelo had sacrificed decorum and faith to the perfection of art became the dominant refrain. In the Counter-Reformation's climate of sober rigor, a decree from the Council of Trent saved the frescoes from demolition but required the nudes to be painted over to hide their shame. Shortly after Michelangelo's death, the censorious measures were implemented and continued until the mid-eighteenth century, to be partially undone by the 1994 restoration project.

Right:

Michelangelo
Minos, detail of the
Last Judgment
1536–41, fresco.
Vatican, Sistine Chapel.

This fresco was still being created when Biagio da Cesena, master of ceremonies for Paul III, expressed a negative opinion of nudes. Michelangelo took revenge by giving Biagio's face to the demonic Minos, and the protests of the master of ceremonies were to no avail, for the Pope replied "You know I have power in heaven and on earth, but my authority does not extend to hell; you must understand I cannot liberate you."

Marcello Venusti
Saints Blaise, Catherine and Sebastian, detail of the *Last Judgment*, after Michelangelo (before its censure) 1549, egg-oil tempera on canvas. Naples, Capodimonte.

Michelangelo
Saints Blaise, Catherine and Sebastian, detail of the *Last Judgment* 1536–41, fresco. Vatican, Sistine Chapel.

As can be seen in comparison with the older copy illustrated here to the side, the censorship of Michelangelo's fresco was limited to covering the incriminating parts with clothing painted on the dry plaster. The exceptions were the figures of Saints Blaise and Catherine. Their ambiguous position, judged indecent, was changed in a radical "al fresco" revision by Daniele da Volterra that earned him the nickname, "Braghettone" or "The Breeches Maker."

Pontormo and Bronzino

In the years in which the Sistine Chapel *Last Judgment* provoked increasingly bitter debate over the decorum that was to be respected in religious painting and indeed among churches in general, two artists who had been profoundly influenced by Michelangelo, Pontormo and his pupil Bronzino, decided to render open tribute to Michelangelo in the frescoes they were to execute in the Florentine church of San Lorenzo, when they were both at the end of their careers. These testaments in paint, the product of deep reflection on Michelangelo's message, were also harshly condemned. Given the task of painting the choir with episodes from *Genesis* arranged around a central scene from the *Last Judgment*, gave his own very personal interpretation of Michelangelo's model, pushing it to extreme limits of form, as can be seen from the preparatory sketches for the work, which was destroyed in the eighteenth century. The powerful physiques, elongated or cramped, improbably twisted, seem almost boneless, bereft of any supporting structure, bloodless. The compositional dynamic did not rest on lines of force, but rather on variations in the bodily masses, which, depending on their density, remain either firmly attached to the ground or slightly raised in the air.

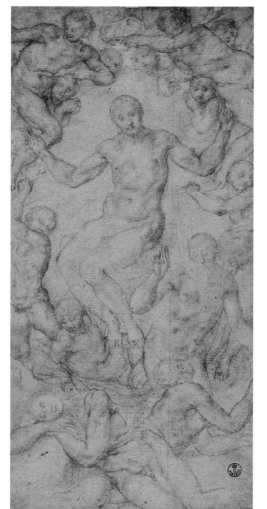

Left:

Pontormo
Christ the Judge with the Creation of Eve
1547–56, black chalk on paper.
Florence, GDSU, 6609F.

Despite the explicit reference to Michelangelo's *Judgment*, the gesture of Pontormo's Christ is not animated by kinetic power, but seems driven by the slight circular motion of the figures that rotate around him.

Above:

Pontormo
Diary
1554–46. Florence, B.N.C.F., c.5.

In the last three years of his life, Pontormo carefully noted in his diary his meager diet, the state of his health, and, in small sketches, the figures he frescoed in the choir of San Lorenzo.

Pontormo
Study for the fresco with the "Resurrection of the flesh"
1547–56, black chalk on paper. Florence, GDSU, 6528F.

Pontormo also took from Michelangelo the "raw and savage" character that distinguished his gloomy temperament, and the way of working in great secrecy, banning anyone from seeing the work before it was finished. He actually had the choir in San Lorenzo sealed off with beams while he was sequestered with the company of the occasional apprentice for the ten years it took to complete the frescoes, of which only a series of preparatory drawings remains.

Vasari's judgment of this experimental work was implacable. In his opinion the fresco was "full of nudes, with order, forms, invention, arrangement, color, and painting done without criteria, with much melancholy and little pleasure for those who look at it." Bronzino finished the work after the death of his master in 1556 and in all likelihood expressed his own position ten years later when he executed the *Martyrdom of Saint Laurence*, just after the Council of Trent had issued its definitive condemnation against nudity in religious art, the grounds for which were defended in contemporary artistic treatises, such as the *Dialogue* on the errors and abuses of painters written by Giovanni Andrea Gilio (1564). In this context, Bronzino's decision to fill his composition with references to the whole range of Michelangelo's nudes, from the *Battle of Cascina* to the *Last Judgment*, was not only a challenge, but an act of artistic faith. Perhaps in an attempt to thwart the censors, Bronzino was careful to plan ahead; he covered his nudes' shameful parts using very flimsy drapes similar to the "loincloths" that were being used to cover Michelangelo's frescos. In any case, the composition did not avoid censure. Writing in *Rest* (1584), Raffaello Borghini acknowledged the quality of the draftsmanship evident in the figures but reserved harsh criticism for the nudity, which was not in keeping with either the narrative or the holy nature of the church.

Michelangelo
Last Judgment, detail of
one of the risen
1536–41, fresco.
Vatican, Sistine Chapel.

Bronzino
*Study for the "Martyrdom
of Saint Laurence"*
c. 1565. Florence, G.D.S.

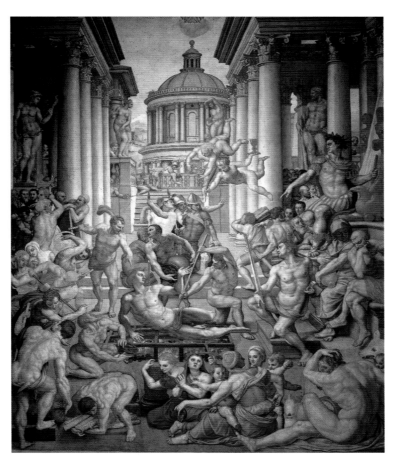

Bronzino
*Martyrdom of
Saint Laurence*
1565–69, fresco.
Florence, San Lorenzo.

Bronzino's homage to
Michelangelo's nudes
consisted not of a simple
transposition, but of an
interpretation that
testified a perfect
knowledge and deep
assimilation of
Buonarroti's works.
The artist proceeds by
conflating various models
into one single figure or
taking inspiration for a
part of the body that he
then completed alone,
with the help of studies
from life.

Feminine Beauty: Comeliness and Grace

During the sixteenth century, the imitation of nature, which was seen as the final goal of art, was increasingly undermined by the search for beauty. The situation led to a major technical contradiction. It was a generally held opinion that nature, corrupted by matter, could not offer models of absolute perfection. In an attempt to provide a solution to the conundrum, the commentators often cited the story of Zeusi, who had drawn inspiration from the five prettiest girls in Crotone in order to paint an ideally beautiful Helen. In this sense, the study of nature had to be tied to an exercise in discernment so that the artist could formulate a mental idea of that perfect beauty.

This issue embraced the whole concept of art but was in particular linked to the representation of the female form, as beauty was a fundamental attribute of women. The perfection of the female form, which corresponded to exact measurements, absorbed a range of nuances that did not comply with mathematical rules, and were tied instead to words such as *venustà* ("comeliness"), *vaghezza* ("beauty"), *leggiadria* ("prettiness"), and *grazia* ("grace"). The words varied widely in how they were understood and used, and expressed a certain indefinable quality, an intrinsic part of airs and gestures, that displayed the secret measure of an inner harmony and was capable of conferring beauty on even the most irregular features

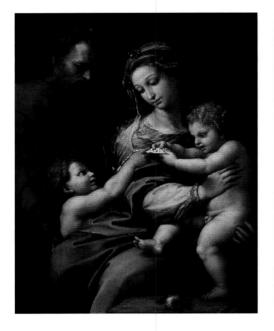

Raffaello
Madonna of the Rose
1518, oil on wood panel.
Madrid, Prado.

The innate grace of Raphael is also the result of long research. As he wrote in 1514, in a famous letter to Castiglione, "to paint someone beautiful," not knowing any sufficiently perfect models, "I will use a certain idea that comes to mind. Whether or not this has any artistic excellence in itself, I do not know. But I work hard to try and achieve it."

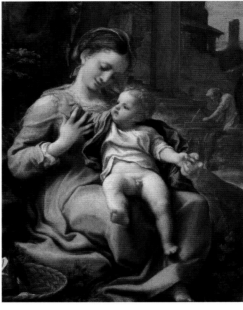

Correggio
Madonna of the Basket
c. 1525, oil on wood panel.
London, National Gallery.

Vasari praised the Parma Master's skillful use of colors, the softness of the flesh, and "the grace with which he finished his work," despite the use of drawing considered less than excellent, based on Tuscan portraitist plastic criteria.

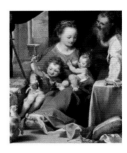

Federico Barocci
The Madonna of the Cat
1574–75,
oil on wood panel.
London, National
Gallery.

According to art historian Giovanni Pietro Bellori (*Lives*, 1672), Federico Barocci "shaped the beautiful appearance of his heads" with a special procedure, observing passers-by on the street and noting the best parts, for example, "a well-shaped eye, a lovely profile of the nose, or a beautiful mouth."

and eliciting a certain sense of desire. The idea of grace was a key element in writings on good manners; Baldassare Castiglione's *Book of the Courtier* (1528) defined an ideal of social beauty, composed of elegance and restraint that were acquired through artfully concealed hard work. The link between behavior and style became more accentuated, and grace was very much part of both the art and the character of affable Raphael, who stood in contrast to the "monstrousness" of Michelangelo's grandiose and virile artistic ideal and his somewhat remote and inaccessible temperament. Raphael's model of grace would reach the peak of its expression in his female figures, but would also generate a range of different interpretations. Painters who remained on the edge of Mannerism, such as Correggio and Barocci, would apply a naturalist reading to developing the delicacy of Raphael's affects and the physical softness of his compositions. They liberally used *sfumato*, blurred lines, and indistinct colors. Elegance of physique and gesture would lead to the elongation of form that was characteristic of the works of some of the greatest exponents of the "manner," first and foremost Parmigianino, followed by those artists from Bologna who would go on to dominate the artistic scene at the court of Francis I in Fontainebleau, namely Primaticcio and Niccolò dell'Abate.

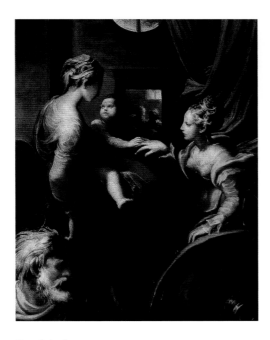

Parmigianino
Mystic Marriage of Saint Catherine
1526–27, oil on wood panel.
London, National Gallery.

Parmiginiano was considered the spiritual heir of Raphael because of his "gentle, graceful manner" and "a certain beauty, softness, and lightness in attitude" of his figures, emerging in the elegance of supple, slender lines, the delicateness of the long proportions, and the gestures made by the slim fingers and limbs.

Primaticcio
Caryatids depicted on the side of one section of the cycle of *The Loves of Alexander the Great*
1541–44, stucco and fresco.
Fontainebleau Castle, Duchesse d' Étampes Apartments.

The female figure undergoes an extreme yet purely ornamental lengthening that deprives her of support. On the other hand, in the decorative scheme of this room for the consort of Francis I, these caryatids performed no load-bearing function and served, instead, to decorate the frescoed panels with the loves of Alexander the Great.

Mannerism | *The Female Nude: Eros, Myth, and Allegory*

The Female Nude: Eros, Myth, and Allegory

In the figure of the reclining nude, that highly charged rhetorical representation of female beauty, the pursuit of artistic perfection had to engage with the evocation of eroticism. Freed from the reclusive space of wedding chests, where this figure had first been established, life-size paintings of the female nude began to appear on the walls of palaces. Shown without clothes, or partially covered by flimsy veils the better to emphasize the subject's beauty, the female nude was wrapped up in the cloak of mythology. The viewer was offered the voluptuous spectacle of resting nymphs, or Venus or Flora, with the viewer taking on the role of the satyr who used to surprise defenseless maidens

in the woods as they lay deep in sleep. The distance introduced by the use of myth was willingly (indeed, perhaps willfully) contradicted by certain figurative elements that acted as a bridge between the inaccessible world of the naked goddesses and the modern world of the beholder. The nymphs left their leafy meadows and ended up on soft beds in sumptuous palaces, no longer drowsy but wide awake and smiling, their gaze inviting. The greater visibility acquired by the female nude and the figurative development of the relationship with the viewer paved the way for an interpretation grounded in an eroticism governed and permitted by the ties of matrimony, in that the possibility of admiring bodily beauty in the privacy of the nuptial

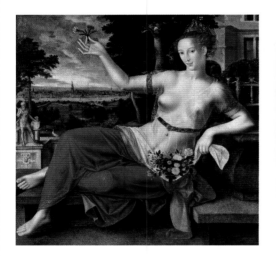

Jan Metsys
Flora
1559, oil on wood panel.
Private collection.

Against the background of a scenic view of Antwerp, this Flemish Flora, inspired by Italian models, gracefully offers the charms of her flowered bosom. Her clothes skim her body, turned in a movement as elegant as it is complex, to enhance the suggestion of her most secret beauty.

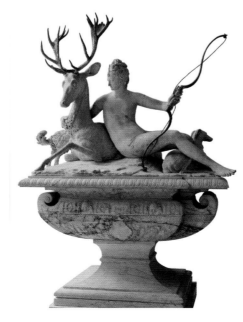

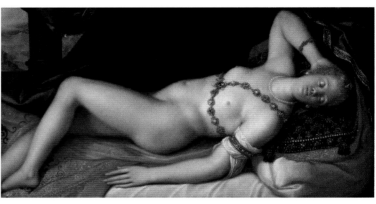

Dirck van Ravesteyn
Sleeping Venus
c. 1608, oil on wood panel. Vienna, Kunsthistorisches Museum.

In Rudolph II's Prague, the theme of the female nude was celebrated in its most worldly sensuality. Abandoning herself to lascivious sleep, Venus reveals her graces in a bold, serpentine turning movement that pushes her to the edge of the bed and invites the spectator to catch her potential fall.

Left:
Anonymous
Diana
c. 1549, marble. Paris, Louvre.

At the court of Fontainebleau, the illustrations of reclining goddesses developed into monumental proportions, as in this statue from a fountain at Anet Castle, whose name and the gentle embrace with the royal deer evoke the name of the patron: Diane de Poitiers, the renowned mistress of Henry II.

chamber had a positive influence on the chances of conceiving. This type of work was especially favored by the male public and often found its way into the private collections of princes and even cardinals. Venetian painters, and Titian in particular, achieved considerable success with their depictions of Venus because of the powerfully evocative force of the colors used, which lent the flesh of the subjects such "natural" delicacy as to suggest a flush of desire and the pounding of the blood. Mannerist painters responded with the pursuit of a formal elegance based on the extension of the reclining nude, giving their subjects' sinuous limbs all the sensual grace of restrained movement. Reclining nymphs became a recurring motif in European Mannerism, which spread from the princely courts of Italy and reached as far as Prague and Fontainebleau. This female nude became a kind of counterpart to the figures of powerful and heroic male nudes. In a subtle play of dynamic opposites and corresponding relationships between virile muscular tension and linear feminine elegance, these bodies with their opposing but complementary features could come together in amorous contact by means of a range of varied and complex positions which showed nothing and suggested everything. As they took part in many acts of love with the gods, the nymphs shook off their evocative slumber to display themselves in sensual poses that were, however, always

Bronzino
Venus and Cupid
1544–45, oil on
wood panel.
London, National
Gallery.

Intended for the private contemplation of the King of France, Francis I, the eroticism of the embrace between Venus and Cupid is uncovered by Time, who also reveals the unfortunate consequences, personified by allegorical figures such as Deceit, Folly, and Jealousy.

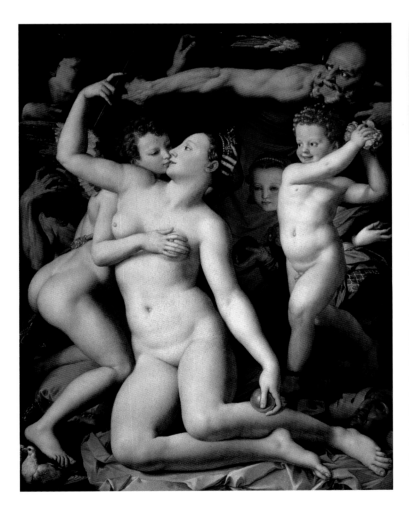

Above:
Jacopo Zucchi
Cupid and Psyche,
work signed and dated 1589, oil on canvas. Rome, Galleria Borghese.

The artifice of the movement and slender proportions give Psyche a lightness that contributes to suspending the scene of the birth of Desire, when the beauty discovers the identity of her mysterious lover. The drop of oil that falls from the lamp will awaken Cupid, forcing him to flee.

Mannerism | *The Female Nude: Eros, Myth, and Allegory*

legitimized by the precautionary mythological setting. This iconographic justification was sometimes further supported by an allegorical proposition that applied a moral reading to carnal love, such as in Bronzino's *Venus and Cupid* (National Gallery, London). In a few very rare cases, no such care was taken. For example, the duke of Mantua, Federico Gonzaga, freely mentioned in his letters the mythological paintings he had commissioned from Titian, referring to them as "naked women" or "bathing women." He was probably the recipient of a very large and startling painting by Giulio Romano, which depicts the effusions of a couple without the pretext of mythology or marriage (Hermitage, St. Petersburg). The exact nature of the relationship between the man and woman is made clear by the presence of an old woman, clearly a go-between, and the heads of horses and donkeys carved into the bedstead, signs of illicit loves (perhaps a reference to the duke's own affair with Isabella Boschetti). The consequences of their embrace are further explained in the explicitly erotic scenes carved at the base of the bed. The scenes derive from the infamous series of so-called *Modi* ("Manners") which Giulio Romano had drawn before, causing one of the most clamorous scandals in early sixteenth-century Rome. Before the Sack of Rome (1527), there was a relatively permissive atmosphere in the papal court concerning images, yet this series depicting positions of

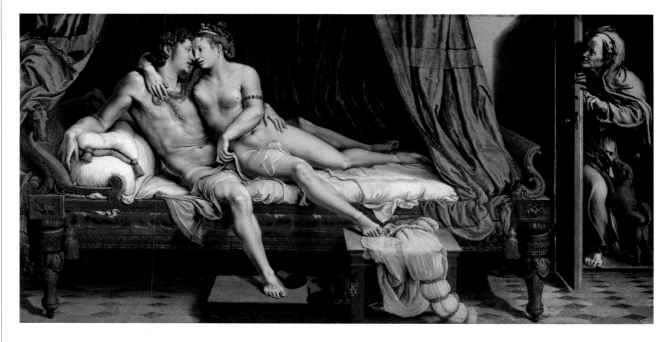

Giulio Romano
Amanti (Two Lovers)
in full and in detail
c. 1525, wood panel transferred to canvas.
Saint Petersburg, Hermitage.

In the sensuality of the embrace, underlined by the caress of locks of hair, the final veils are about to fall. The scene discovered by the old madam seems to be the preliminary of a similar composition illustrated in the eleventh position of Romano's *I Modi*.

"dishonest" lovemaking was severely condemned, not only because of the very direct nature of the scenes but also because, copied in prints by Marcantonio Raimondi and accompanied by the somewhat lascivious verses of Pietro Aretino, the series met with wide success, even finding its way into the collections of cardinals. The "scandalous" drawings were seized by the authorities and destroyed , the engraver was put in prison, the writer had to withdraw from court for a while, and Giulio Romano, the creator of this little Renaissance *Kamasutra*, escaped repression because he was already in Mantua at the time. The court of a prince who was more interested in earthly pleasure than religion, as was Federico

Gonzaga, was one of the very rare settings where it was possible to pursue formal research into openly erotic subjects. Elsewhere, the mythological theme was the necessary framework for artists to represent the sensuality of nude figures without fear of censure. In Rome, a few years after the scandal of the *Modi*, Rosso Fiorentino and Perin del Vaga met with considerable success with their series *Loves of the Gods*, engraved by Jacopo Caraglio. The series offered a range of variations on the theme of the embrace between male and female figures, artfully hiding the act of lovemaking through the positions of the bodies.

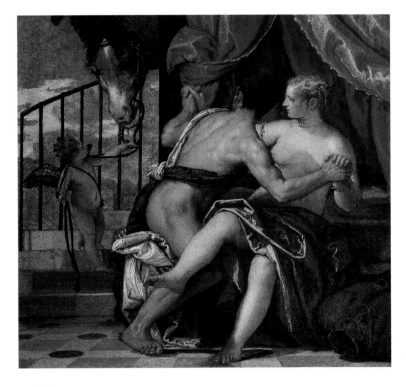

Paolo Veronese
Mars and Venus United by Love
c. 1575, oil on canvas.
Turin, Galleria Sabauda.

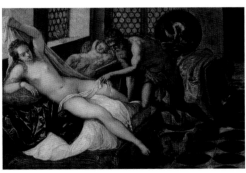

Above:
Tintoretto
Mars and Venus Surprised by Vulcan
1551–52, oil on canvas.
Munich, Alte Pinakothek.

Tintoretto suggests the consequences of the scene's eroticism in the mirror reflection. The different visual elements of the composition bring together the bodies of Venus and Vulcan, giving the impression that the old god, dazzled by the graces of his wife, forgets her recent betrayal with Mars and, in turn, succumbs to his own carnal desire.

Figures of Mannerism

The research into form that focused on the nude figure, which Michelangelo considered the paradigm of artistic perfection, was achieved in the serpentine figure. Lomazzo provided a very precise definition of this figure, and attributed its origin to Michelangelo, who was said to have advised Marco Pino to "always make the pyramidal figure, serpentine and multiplied by one, two and three" (*Trattato dell'arte*, "Treatise on Art," 1585). The author went on, "this precept seems to hold the secret of painting, because the greatest grace and loveliness that a figure may possess lies in showing that it moves, what the painters call the 'fury of the figure.' And to represent this movement,

there is no more suitable figure than the flames of a fire." If the pyramidal cone provided the structural grid of the figure, the sense of movement within was obtained through the play of opposites and matching elements in how the limbs were arranged, following the form of an S which recalled the "tortuousness of a living, moving snake, which is the very form of the flickering flame." In a sense, this serpentine figure was the extreme consequence of the powerful asymmetries created through *contrapposto*, the arrangement of opposing figures, but the movement of the figure is not so much a function of the story as an end in itself. Indeed, the infinite and complex range of formal solutions, achieved through the use of a fixed overall

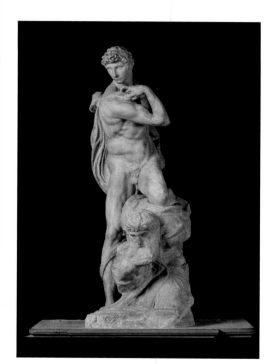

Michelangelo
Victory
c. 1530, marble.
Florence, Palazzo Vecchio.

This statue is considered among the founding models of the serpentine figure. Following a lengthened pyramid form, the width of the base gradually narrows, ending at the head of the young man, while the position of the characters constructs a dynamic, flaming spiral.

Below:
Giambologna, *Rape of a Sabine Woman*
1582, marble. Florence, Loggia dei Lanzi.

The formal research into the dynamic arrangement of three figures in a single block prevailed in creating this sculpture in which, according to Raffaello Borghini, the subject was discovered only after its completion. The masterpiece's weaving of serpentine lines upholds the structural unity of the group and, at the same time, multiplies the visual solutions based on preset points of view.

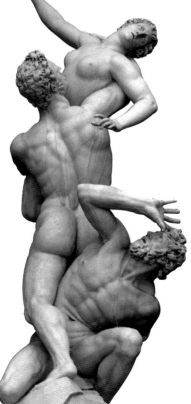

Adriaen de Vries
Mercury and Psyche
1593, bronze.
Paris, Louvre.

Mindful of Giambologna's teaching, De Vries developed the serpentine lines to give energy to this bold balance that challenges the weight of the material. The spectator is invited to move around the bronze statue to appreciate the constantly changing variations of movement.

scheme and a moving figure, demonstrate some of the key concepts of Mannerism, such as *variety*, and *facility* (ease of manner) which conceals *difficulty*. The artifice of seemingly natural positions obtained using the serpentine approach allowed the artist to show different sides of the body in a single view. The artistic qualities of these figures, which showed "both back and front," and their great power of attraction, were achieved through "effortless force and with the grace of forced effortlessness," as Aretino wrote, making use of a rather serpentine oxymoron. The serpentine figure was much used in sculpture, due to its formal unity and the potential for a multitude of variations. Michelangelo produced a very early example in his *Genio della Vittoria*, where the opposing twists in the bodies of the vanquished and victor are arranged in an S shape. This particular marble statue was meant to be placed in a niche in the tomb of Julius II and seen from one particular viewpoint. Giambologna would explore the possibilities from 360 degrees, providing a variety of solutions linked to a multitude of viewpoints. The increasingly complex arrangements of quivering lines, meant to express movement, would find their most significant counterpart in painting of daringly foreshortened serpentine figures.

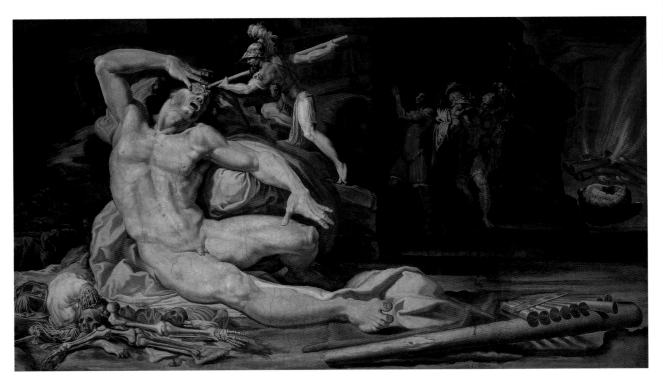

Primaticcio
Dance of the Hours
c. 1549–50, study for a lost fresco for the Gallerie d'Ulysse vault at Fontainebleau.
Frankfurt, Städelsches, Kunstinstitut, inv. 615.

The serpentine figure is rendered by the repetitive rhythm of slightly different positions that explore the grace and lightness of feminine movement. Foreshortening multiplies the visual angles, creating a remarkable trompe l'oeil.

Above:
Pellegrino Tibaldi
Blinding of Polyphemus
1550–51.
Bologna, Palazzo Poggi, Sala di Ulisse.

From the model of Michelangelo's nudes, Pellegrino Tibaldi drew the idea of unstable positions that led to extreme consequences with increasingly complex twists and foreshortening.

Difficult Figures and Secondary Characters

In the formal, almost ornamental treatment of the human body, the serpentine figure was freed from the rules of lifelike anatomy and narrative function as part of the representation, and it became a demonstration of Mannerism's underlying principles. Writing in his *Dialogo di pittura* ("Dialogue on Painting," 1548), Paolo Pino commented on the possibility that stylistic elements could go beyond the requirements of the story depicted. Pino advised painters to include in their works "at least one twisted figure, mysterious and difficult, so that you [the painter] would be noted as someone who understands the perfection of art." It may seem paradoxical for a Venetian commentator to take

a stance to defend one of the recurring motifs of Mannerism, namely a structurally complex figure, displaying excessive movement, or, indeed, movement superfluous to the needs of the story, placed on the edge of the scene in a highly visible position, usually in the foreground. The "mystery" behind such intrusive figures, or the narrative incongruity they represented, would prove attractive to the public of connoisseurs who, no longer satisfied with a simple iconographic reading of the work, sought instead "pleasure." In a sense, these "difficult" figures were a coded message the painter sent to a select group of viewers whose artistic appreciation would be influential in securing the work's success and further commissions. This

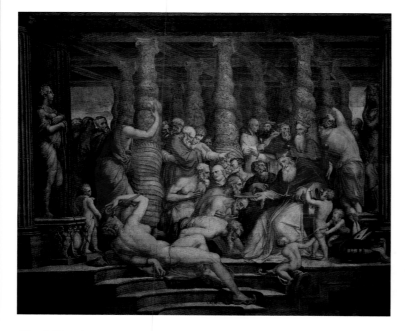

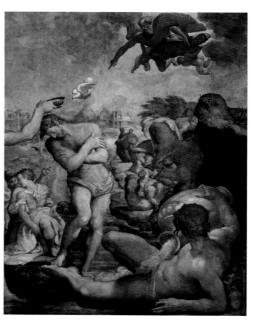

Giorgio Vasari
Reward of Virtue
1546, fresco.
Rome, Palazzo della Cancelleria, Room of 100 Days.

The improbable twists of the nude in the foreground, extended across the steps, at the edge of the narrative scene, are justified in the literary description by the artist, Giorgio Vasari, thanks to the reference to the allegory of Envy "that eats vipers and appears to die from venom."

Jacopino del Conte
Baptism of Christ, detail
1541, fresco.
Rome, oratory of San Giovanni Decollato.

With its out-of-scale dimensions and powerful relief, the Michelangeloesque figure of the River Jordan—in the right foreground of the composition—seems to emerge from the surface to underline the distance between the spectator and the scene, simultaneously guiding the eye.

Mannerism *Difficult Figures and Secondary Characters*

position on the edge was shared by another Mannerist leitmotif: the figure that acted as a bridge between the space of the painting and the space occupied by the viewer. These bridging figures were usually secondary figures, often shown from behind, their faces cut off by the arrangement of the composition. They tended to look at the scene from the sidelines, as it were, and acted as an "inside" transmitter for the attitude of the viewer on the "outside." Alberti's closed painting, the window that surrounded and limited the *istoria*, was transformed into an open backdrop designed to evoke the illusion of continuity in space. The freedom, or license, of these key Mannerist figures in relation to the requirements of the narrative would be severely condemned by the commentators of the Counter-Reformation who considered such a figure not as a demonstration of artistic skill, but a sign that the artist was ignorant of decorum. Giovanni Andrea Gilio would not fail to deride those painters who, depicting a saint, would place "all their skill and diligence in distortion of his or her limbs, or shortened neck, often in an unfitting and displeasing show of force." (*Dialogo degli errori e degli abusi de' pittori*, "Dialogue on the errors and abuses of painters," 1584).

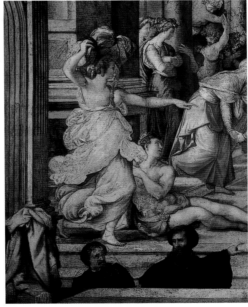

Raphael
The Expulsion of Heliodorus from the Temple, detail
1511–12, fresco.
Vatican, Room of Heliodorus.

If Michelangelo is the father of the serpentine figure, the motif of the spectator inside the composition comes in part from two successful creations by Raphael: the water carrier in *Fire in the Borgo* (page 140) and the two young people clinging to the column that watch from above in the *Expulsion of Heliodorus*.

Francesco Salviati
Visitation, detail
1538, fresco.
Rome, oratory of San Giovanni Decollato.

The basket-bearing nymph of late fifteenth-century Florentine painting was made contemporary by Salviati with classic draperies and the typical swirls that evoke the Raphael model. In the outstretched movement of the pointing finger, the young girl becomes a dynamic figure introducing the composition.

Tintoretto
The Miracle of the Slave
detail, 1548, oil on canvas.
Venice, Accademia.

The figure of the internal spectator is multiplied here thanks to a descending serpentine movement, expressed in the two bowed men towards the bottom, the women from behind, and a person in profile connected to the commissioning patron.

Difficult Figures and Secondary Characters

Themes, Models, Style

Invention, Composition

In the artistic treatises of the sixteenth century, *invention* was defined as being the first stage in painting and corresponded to both the choice of subject and how the composition was formulated; once arranged, the work was created in the next stages of draftsmanship and color. This three-part division, established in particular by Paolo Pino and Ludovico Dolce, was derived from ancient rhetoric, often the source of inspiration for theories of poetry in the sixteenth century, in which *inventio* was the choice of material for the discourse and preceded the elaboration stage — *dispositio* — and the implementation stage, *elocutio*. The parallel between painting and poetry, distilled in Horace's well-known expression, *ut pictura poesis*, literally, "as in painting so in poetry," underlined the noble nature of art as an intellectual activity. This was further emphasized in the notion of invention, because only a learned painter, "familiar with the stories and fables of poets," would be able to represent the subject, or *istoria*, in the proper manner. The artist's erudition was considered a necessary condition for the proper narration of the theme taken from religious texts or mythology, or for the elaboration of allegorical subjects based on a clearly identifiable iconographic repertoire (which could be the choice of the artist or decided by the commissioning patron). Invention, in this sense, was not limited to ensuring

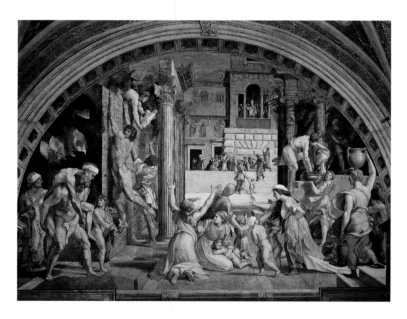

Raffaello
The Fire in the Borgo
1514, fresco.
Vatican, Stanza dell'Incendio.

Pulling back for a broad view, Raphael reveals the general context in which the miraculous episode occurs. This marginal narrative space, turned around in the foreground, gives the scene its dramatic tension and allows the artist to show his talent with monumental figures that convey the various expressions of fear.

Right:
Mirabello Cavalori
Sacrifice of Lavinia
1570–72, oil on wood panel.
Florence, Studiolo di Palazzo Vecchio.

Reversing the narrative was an established compositional formula by the time this painting was realized for Francesco I de' Medici's small study. Following a twisting course, the eye of the spectator is guided into the heart of the scene by a series of intermediary figures: the two complementary characters cut off in the foreground, the youth clinging to the column, and the kneeling women with outstretched arms.

relevance to the sources used; it also raised the issue of inventiveness, or the "painter's ingenuity," to use a contemporary expression. This referred to the painter's ability to interpret even very familiar subjects in unusual ways, or to combine the traditional symbolic lexicon to produce new semantic readings. Mannerist invention was a learned, cultured procedure, which employed artistic license within established limits and in keeping with decorum, and according to the principle of variety. One of the most characteristic elements of this compositional research was the overturning of the traditional hierarchy of the narrative order. The fulcrum of the scene was no longer given a central, preeminent place and was often pushed into the background, under pressure from a lateral slant, while figures which were of secondary importance in the story were allowed to invade the foreground. The first example of this particular *topos* of Mannerist composition was given by Raphael in his *Fire in the Borgo* (shown on the opposite page). Raphael was praised for being a painter "rich in invention." The episode of the fire miraculously extinguished by a gesture of benediction from Pope Leo IV is shown almost off-stage, as it were, in the midground along an axis that is slightly skewed to the right, leaving the entire front stage of the composition for the depiction of the effects of the dramatic situation, in the emotional juxtaposition of figures fleeing the

Right:
Abraham Bloemaert
Saint John the Baptist Preaching
c. 1600, oil on canvas.
Amsterdam,
Rijksmuseum.

Dutch Mannerist painters skillfully developed the reversal of the narrative order, portraying their Biblical scenes with tiny figures scattered across broad landscape views and the foreground dominated by processions of secondary characters.

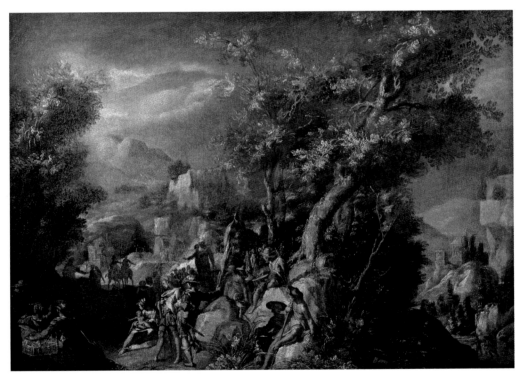

Pieter Aertsen
Christ in the House of Martha and Mary
1552, oil on wood panel.
Vienna, Kunsthistorisches Museum.

Almost a painting inside a painting, the scene by Aertsen is introduced by a proscenium, no longer defined by secondary figures but elements that announce the arrival of the still life. The correlation between the two places depicted is achieved with symbolic references: the display of the meat in the foreground, the affirmation of the incarnation of Christ in the background.

Themes, Models, Style | *Invention, Composition*

flames while others try to put out the fire. Mannerist painters' attention to the edges, or margins, of their representations did not focus only on secondary figures placed in the foreground to frame the composition, but also on the material limits of the painting. The handling of the margins of the composition and the edges of the painting defined the role of the painting's surface, which was either closed and circumscribed, or a detail of a notionally more extensive space, depending on whether the marginal figures were contained entirely within the limits of the canvas or panel, or cut off by the lines of the supporting frame. Much of the formal research into ways to suggest continuity between the figurative dimension and the viewer's

space focused on the painting in its dual material and compositional role. The question became even more complex with wall decorations, where the frame for the *istoria* did not systematically coincide with the limits of the wall. The principal problem was how to organize the vast surface to be painted in relation to the need to represent either a single subject or different scenes. As the major fresco cycles of the fifteenth century had shown, either the artist could emphasize the role of the wall as a supporting medium where he collocated a sequence of stories arranged in a regular subdivision, or the wall itself could be subsumed under an illusionistic background that dissolved the physical limits of the wall. In the course of the

Rosso Fiorentino
Elephant with Fleur-de-Lis
c. 1533–40,
fresco and stucco.
Fontainebleau, Gallery of
Francis I.

The stucco frame reinforces the two-dimensional place of the surface in the central scene, conceived as an attached painting, while the absence of borders in the lateral frescoes suggests an illusionistic background.

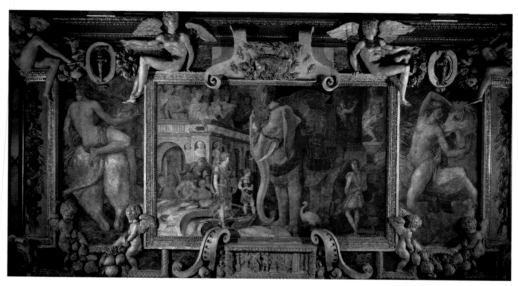

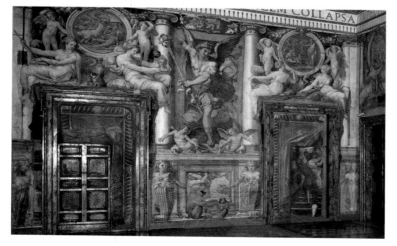

Left:
Perin del Vaga and assistants
Saint Michael
1545–46, fresco.
Rome, Castel Sant'Angelo, Sala Paolina.

The complexity of the painted wall structure confuses perception of the various levels of the illustration. Compared with the narrative scenes in faux bronze and the minute allegorical figures, the monumental archangel at the center seems to acquire the immanence of an apparition, although contradicted by the trompe-l'oeil baboons in the immediate foreground (barely visible here below, in the center) and the opening of a false door inside real jambs.

sixteenth century, artists freely engaged in combinations of these two opposing solutions in order to elaborate not an illusionistic space, but an illusionistic mural structure that managed both to highlight and erase the architectural support. The painting surface was no longer articulated on a single plane; rather, it was developed through the play of depth and relief, introducing different levels of faux material. For example, the narrative scenes, surrounded by frames, were presented as the images of paintings, supported by architectural or sculptural devices in faux relief, which sometimes opened onto illusionistic scenes, while the foreground could be occupied by a number of natural, trompe-l'oeil elements. The definition or conceal-ment of the work's margins provided the grounds for a multitude of compositional variations, which may have included contradictory elements aimed at surprising and deceiving the viewer. These spatially complex compositions developed a principle that Michelangelo had already put into practice in the ceiling of the Sistine Chapel. They also borrowed from different solutions elaborated by Raphael, such as the successful motif of the fake tapestry hung on a painted architectural surface, as can be seen in the Loggia of Psyche and the Hall of Constantine.

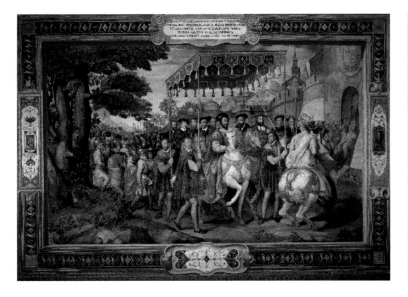

Taddeo Zuccari
Solemn Arrival of Emperor Charles V in Paris
1562–63, fresco.
Caprarola, Palazzo Farnese, Sala dei Fasti Farnesiani.

The Sala dei Fasti Farnesiani is decorated with a linear sequence of the family's exploits, bordered by the broad ornamental frame painted in perspective, combining the false tapestry border motif with that of the window. The frame does not, however, surround the entire story, but cuts out a detail from the compositional space that ideally extends beyond the margins.

Oratory of Santa Lucia del Gonfalone, detail from the two walls frescoed with *The Flagellation of Christ*, by Federico Zuccari, and the *Crowning with thorns*, by Cesare Nebbia
1569–77.
Rome.

The monumental painted architecture that unifies the composition of the entire wall, establishes flat surfaces and three-dimensional spaces; the lower section, divided by tortuous columns, shows evangelical scenes conceived as mounted paintings, the trabeation being animated by figures of David, other prophets, and sibyls arranged inside the niches.

Mannerism Invention, Composition

Poetics of the Monumental

Alongside its exploration of elegance and formal variety, Mannerism also sought to develop a poetics of the monumental, with Michelangelo serving as the main source of inspiration. With his giant nude figures in the Sistine Chapel or his colossal marble statues, Michelangelo had already set out "the direction of the grand manner" and shown his supreme command of "the difficulty of draftsmanship," as artistic perfection could be gauged all the better in huge works. The idea, taken up by Vasari, had already been put forward by Alberti, who had observed that in "small compositions great defects can be easily concealed, whereas in large compositions it is easy to see even lesser defects." The "grand manner" was not only a function of the physical size of these "grand figures," but also of the monumental effect achieved by the proportions of the composition. In other words, the gigantic nature of the figures was further emphasized both by the powerful representation of the bodies and by their predominant position within the compositional space. Michelangelo's followers, and in particular Daniele da Volterra, explored this compositional approach based on colossal and heroic figures. In the works of this painter, space is defined with great economy in order to highlight the figures as much as possible, using tight framing and lack of depth. The underlying principle of the "grand

Daniele da Volterra
Descent From the Cross
c. 1541–45, fresco transferred to canvas.
Rome, Trinità dei Monti, Bonfil Chapel, originally in the Orsini Chapel.

The outlined spatial structure is the plastic support to the figures, whose monumentality is also accentuated by a mighty musculature, lavish draperies, and scant ornamentation.

Giulio Clovio
Christ in Judgment
page from Cardinal Alessandro *Farnese's Book of Hours*
1546, parchment.
New York, The Pierpont Morgan Library, ms. M.69, c. 59v.

The essence of Michelangelo's "grand manner," here condensed into a miniature, is a realistic expression of powerful anatomical structure and of the predominant position of figures within the spatial construction.

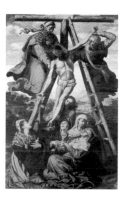

Pedro de Campaña
Descent From the Cross
1547, oil on wood panel.
Seville, cathedral.

In this painting, realized in Seville, the Flemish artist underscored the pathos inherent in a theme whose monumental compositional elements he had studied in Italy. Francisco Pacheco later wrote that the opus aroused in him such *"pavor y miedo"* [dread and fear], that he did not wish to be left alone with it.

manner" was thus the issue of scale within the composition, which could also be achieved in small works. The case of Giulio Clovio, a Croatian illuminator active in Rome, is a telling example. Despite his specialization as a painter "of small things," Clovio was listed as one of the leading artists of the age because he had learned from Michelangelo's example and executed figures "which although very small seemed to be great giants" (Vasari). At the other extreme, inverting the proportional relationships allowed the artist to enlarge the architectural structures while reducing the scale of the figures depicted. This approach that used "small figures" was widely used to highlight the incomparable grandeur of ancient monuments, for example, in the works of Flemish painters such as Posthumus and Van Heemskerck, who had studied classical ruins in Rome in the 1530s. Similar compositional methods met with great success not only in Flanders but also at the court of Fontainebleau, where Niccolò dell'Abate painted miniature mythological scenes within huge landscapes, and Antoine Caron re-created episodes from ancient history by filling wide views of an imaginary Rome with small figures.

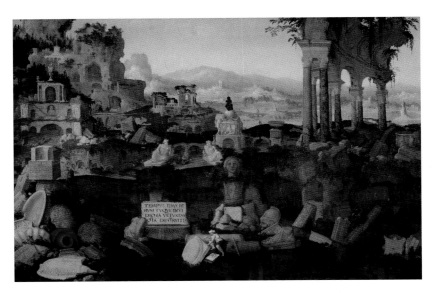

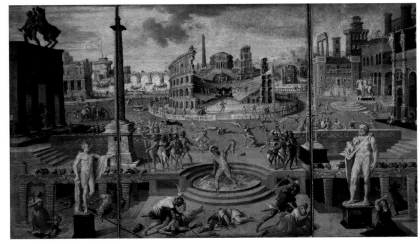

Top left:
Hermannus Posthumus
Landscape With
Roman Ruins
1536, oil on canvas.
Vaduz, Sammlung der
Regierenden Fürsten
von Liechtenstein.

Above:
Marten van
Heemskerck
Antiquities of Palazzo
dei Conservatori
c. 1552, pencil
on paper.
Berlin,
Kupferstichkabinett.

Left:
Antoine Caron
Massacres of The Triumvirate
1566, oil on canvas.
Paris, Louvre.

Caron depicts a Rome of the most famous buildings in antiquity, which he elaborated from prints and arranged according to the perspective principle of a theatrical stage, sacrificing topographic reality. Despite the small figures, the stage setting of the architecture deprives the classical buildings of their actual monumental fiber.

Naturalistic or Visionary Characters

The highly intellectual concept of the artistic process as well as the pursuit of increasingly complex spatial schemes and figurative forms gradually detached Mannerism from the natural model. The extreme consequences of this development, which in Central Italy was based on the plastic potential of draftsmanship, produced the ornamental handling of representation. In more peripheral centers, the concentration on light and color led artists to give their compositions a visionary quality. In Reggio Emilia, Lelio Orsi used powerful chiaroscuro effects in his small devotional works, which displayed the immanence of the divine and intensified the works' dramatic tones. More than in any other city, Venice was the place where artists explored the formal abstractions of Mannerism in an effort to express the supernatural nature of the divine. Tuscan commentators may have considered the Venetian focus on color in opposition to Tuscan-Roman draftsmanship, but artists in the Most Serene Republic were not indifferent to Mannerist models, which they knew firsthand, thanks to the presence in the city in the 1540s of artists such as Vasari, Salviati, and Giuseppe Porta; to the proximity of Parma and Mantua; and to the many prints in circulation. The critical appropriation of these examples can be seen briefly in the work of Titian, while Tintoretto went further in his exploration of the

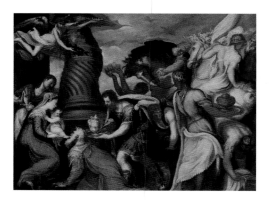

Above:

Schiavone, *Adoration of the Magi*
c. 1547, oil on canvas. Milan, Pinacoteca Ambrosiana.

Schiavone translated Mannerist elongated forms into the idiom of color. The figures are weightless, and the entire composition seems to hover in a vague—almost dreamlike—space.

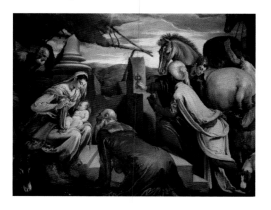

Jacopo Bassano
Adoration of the Magi
c. 1560, oil on canvas.
Vienna, Kunsthistorisches Museum.

Bassano was inspired by Schiavone's painting, but nonetheless chose a spatial arrangement of greater severity and more vibrant handling of light.
The elegance of his figures is offset by several more naturalistic elements that characterize the composition, like a derelict shack at the top or the animals in the lower corners.

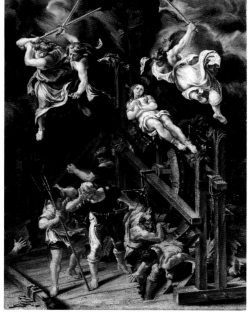

Lelio Orsi
The Martyrdom of Saint Catherine
c. 1565, oil on canvas. Modena, Pinacoteca Estense.

The light contrasts that symbolize divine intervention in favor of the martyr saint intensify the impression of instability in a boldly foreshortened spatial arrangement, closed in the depths of the composition's *horror vacui.*

Facing page:
El Greco
Annunciation
c. 1597, oil on canvas.
Madrid, Museo Thyssen-Bornemisza.

The revelation erupts like an explosion of light; the figures shake off matter and the earthly world.

figurative potential to be found in the synthesis between color and draftsmanship. He did so in powerfully energetic spatial compositions that were sometimes sustained by an unreal handling of light in keeping with the miraculous nature of the subject, such as in the series of *teleri* (ornamental compositions spread over a number of canvases) that he executed for the Scuola Grande di San Marco. This unnatural luminescent vibrancy, which pervaded the religious scene, could also be found in the works of Jacopo Bassano who, with a certain lively energy, was able to combine distortions of form and highly natural descriptions in his elegant compositions, in his handling of animals and landscape that heralded the approach that

would be taken in genre painting. This dual figurative register was also a hallmark of the most "visionary" painter of the age, El Greco, who spent a crucial formative period in Venice between 1568 and 1570 before settling in Toledo. The artistic path followed by the artist while he was in Spain tended towards highly abstract and luminous solutions that were suitable for visualizing the image of mystic contemplation. Later works feature examples of still life in the foreground, such as surprisingly natural bunches of flowers.

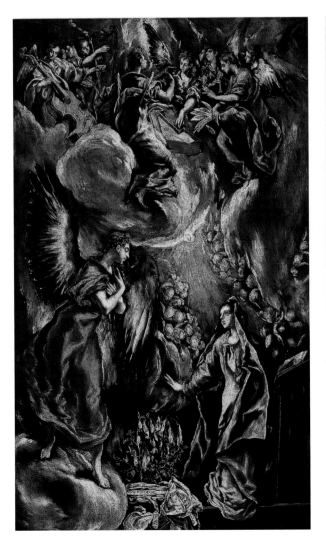

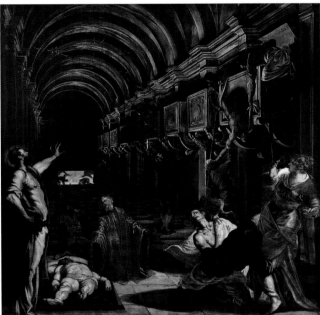

Above:
Tintoretto
Finding of the Body of Saint Mark
1562–66, oil on canvas.
Milan, Brera.

The immanence of the divine in the tale, with the miraculous apparition of Saint Mark in the left foreground, is rendered by the use of light: the gleam that picks out the arcade in dramatic acceleration; the light emanating from the foreshortened mortal remains of the saint on the floor; the filaments of light that suggest angelic presences in the air.

Ornament: In Praise of the Caprice and the Bizarre

In its restless quest for variety and the renewal of formal and semantic solutions, Mannerism sought to go beyond the rules of art within their own regulatory framework. Having borrowed the notion of license from poetry, the figurative arts tried to acquire a margin of freedom which would have enhanced invention and inventiveness without betraying their foundations, and would reach its most exuberant expression in the ornament. Freed from the impositions laid down by textual sources, ornaments represented a field open to the bizarre and capricious, or unusual forms and paradoxical associations that could be pushed to the edge of extravagance and relied on the creative potential of the imagination and the technical skill of the artist. It should not be thought that the bizarre and the caprice were the fruit of some uncontrollable flights of fancy that adhered to no rule. In its pursuit of the infinite number of possible forms, art examined the creative processes of nature, so even the most surprising figures were the result of careful combinations of natural elements, such as the chimera that recalled the way dreams work. Moreover, for the encyclopedic culture of the age, the existence of chimeras and monsters

Marco da Faenza
Foyer with Grotesques
1555–56, fresco.
Florence, Palazzo Vecchio, Area of the Elements.

"Proud, resolute and terrible"; Vasari listed Marco da Faenza as one of the period's best painters of grotesques, acknowledging qualities that overstep the decorative dimension and evoke promptness of production and expressive potential.

Raphael
Loggetta of Cardinal Bibbiena
1516, fresco.
Vatican, Palazzi Vaticani.

For the humanist Cardinal, Raphael designed old-fashioned apartments, with a stove and *loggetta*. The decoration in grotesque style is an archeological reconstruction of the motifs studied in the Domus Aurea in Rome, and in Hadrian's villa at Tivoli, gracefully balancing fantastic and naturalistic elements.

belonged to the realm of the possible, as could be seen from the hugely successful *Wunderkammern*, those chambers full of marvels that presented proof of the "miracles of nature," such as the "horn of the unicorn," or the teeth of the marine creature we today call the narwhal. The bizarre and the capricious were not limited to formal representation; they also involved semantic values. Drawing inspiration from the conceit of the emblem, incongruous associations of symbolic or hieroglyphic figures produced unusual reformulations of concepts that were difficult to interpret, much to the delight of the more knowledgeable public who rose to the challenge of deciphering them.

The success of the ornament as an element of Mannerism must be seen in this context, as it explains the extraordinary inventive creativity the artists applied to compiling a lexicon of infinite variations that could be used to decorate any kind of furnishing or support, from pieces of jewelry to whole architectural settings. The basic principle of this language was the idea of metamorphosis: the mutation of species and materials driven by scientifically improbable, but figuratively continuous, generative forces that could be used to form constantly renewable compositional models. A vegetable candelabra from which sprout animal or humanoid figures,

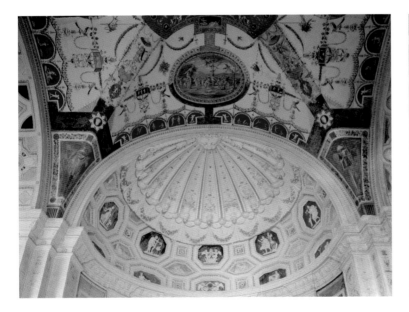

Giulio Romano and Giovanni da Udine
Loggia
1520–24, fresco.
Rome, Villa Madama.

On the loggia of Cardinal Giulio de' Medici's villa, Raphael's pupils created a fabulous stucco and fresco decoration, of which only the vault has survived. A rigorously compartmentalized and carefully executed scheme means that the painted or modeled grotesques frame scenes from mythology.

Giovanni da Udine
A Squash Penetrating a Fig, fresco detail
1517–18, fresco.
Rome, Villa Farnesina, Loggia di Psiche.

Even decoration based on natural motifs, like the festoons of flowers and fruit that were Giovanni da Udine's specialty, could engender a "capriccio," in other words a singular and pithy invention, like the seemingly casual combination of a squash, plums, and figs, to form a vegetable "Priapus."

flouting natural order and the laws of gravity, could thus become the fundamental element of the most popular system of wall decoration of the time: the grotesques. The use of plant clusters and the marvelous monsters that sprouted from their flowers, recalled the marginalia of medieval illuminated miniatures. They were given a justification in humanist terms in the example of ancient painting that had been rediscovered at the end of the fifteenth century in the "grottos" which gave them their name, namely the buried rooms of Nero's Domus Aurea. Filippino Lippi, Pinturicchio, and Luca Signorelli adopted the motif in the last twenty years of the fifteenth century, but credit for the archeological "invention" of the grotesques goes to Raphael and his school; they carefully reconstructed the inherent figurative logic behind the grotesques. Part of the same process was the rediscovery of the ancient technique of stucco by Giovanni da Udine, one of Raphael's pupils. The use of stucco made it possible to compartmentalize huge surfaces using ornamental modules, while giving new life to models from the imperial age. The approach was versatile and the technique meant that the artist could create frames for sacred or profane scenes of decorative motifs in their own right, as Raphael showed in his vast decorative feats, such as the Vatican Loggias, the apartment of Cardinal Bibbiena, or the posthumous completion of the loggia in Villa Madama. Thanks

Bernardo Buontalenti and Jacques Bylivelt
Vase
1587, lapis lazuli and gold.
Florence, Palazzo Pitti, Museo degli Argenti.

Down in the Palazzo Vecchio foundries, Francesco I de' Medici investigated the mutational properties of materials using alchemic procedures to discover new techniques, for instance, the production of glass or highly sought-after porcelain, and thus collected objects of marvelous material and form, wrought by the refined talent of court artists.

Above:
Wenzel Jamnitzer
Plate with Serpents, Frogs and Lobsters
c. 1560, gilt silver and enamel.
Paris, Louvre.

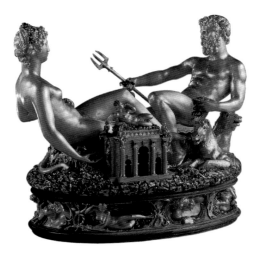

Mannerism | *Ornament: In Praise of the Caprice and the Bizarre*

to its potential for invention and variety, the idiom of the grotesque easily lent itself to Mannerism's investigations of form, and in Italy the grotesque underwent an extraordinary pictorial evolution; like an exuberant climbing plant, it invaded the walls of palaces and villas and even, in some cases, churches. The assimilation of classical models gradually gave way to a syntactical elaboration in which classical-style elements and naturalistic motifs were given increasingly paradoxical and extravagant metaphorical interpretations which recalled figures from rhetoric, poetics, and the burlesque. The grotesques met with success across Europe, disseminated through engravings and prints, and the compilation of repertoires of models for the decorative arts—enamels, ceramics, fabrics, armor, and jewelry. It was in the field of the goldsmith's art that the notion of metamorphosis went beyond external ornamental application and became instead an intrinsic operational element, capable of producing new forms and transforming the material used. Artists who were acclaimed for their large decorative feats, such as Giulio Romano, Rosso Fiorentino, or Francesco Salviati, also applied themselves to producing refined water jugs, basins, vases, and salt cellars, taking up once more the idea of composite associations between the vegetable, animal, and humanoid in order to give objects new configurations. Thanks to the high degree of

Above:
Perin del Vaga
Triumphal Arches Erected on the Occasion of Charles V's Arrival in Genoa
1529, drawing.
London, Courtauld Institute Galleries.

Facing page, below:
Benvenuto Cellini
Salt Cellar
1540–43, gold and enamel.
stolen and returned to Vienna, Kunsthistorisches Museum.

In *Lives*, Cellini explained the invention of the salt cellar intended for Francis I. It was an outright downscaled sculpture with personifications of the Sea and the Earth, evoking the origin of salt and pepper, "their legs entwined as can be seen in some branches of long seas that penetrate the land."

Above:
Bernardo Buontalenti
Inferno, fourth intermezzo from *La Pellegrina*
1589, pen and ink, bistre, watercolor.
Paris, Louvre, Département des Arts Graphiques.

The design for one of the intermezzos of the comedy *La Pellegrina*, staged in Florence in 1589, offers an idea of the astounding effects achieved by Buontalenti when creating natural and supernatural effects for the theatre, including the fires of hell, the council of the gods appearing in the heavens, and the flight of the enchantress Circe on a chariot drawn by dragons.

The repertoire of classical forms was brought up to date in a triumphal idiom of great ingenuity to celebrate Emperor Charles V's arrival in Italian cities. These ephemera played a crucial role in the search for new figurative solutions, while their success made a significant contribution to the diffusion of Mannerism to the European courts.

technical skill reached by artists, the process managed to combine the mutations of form and material, enhancing pieces of the goldsmith's art with the addition of gems, rock crystal, coral, and even ostrich eggs or bezoars (the ossified remains of marine mammals). The meshing of nature and artifice became even more inextricable, as artists sought to make copies of live insects, shells, shellfish, small reptiles, and mammals, which were used, for example, by Wenzel Jamnitzer in Germany (see page 150) or by Bernard Palissy in France to achieve astounding hyperreal effects in their respective fields of silverware and ceramics. On a wider scale, this poetics of ambiguity, caught between the real and the fictitious, was to

find its most fertile ground for expression and experimentation in the ephemeral. The mutability of forms affected celebrations, from the banquet table where the dishes were recast in allegorical or natural forms as though they were real sculptures, to public squares which, during jousts and tournaments, displayed parades of colossal figures, gigantic animals, or enchanted mountains set in motion by hidden mechanisms. The use of transformations reached their peak in the theater, with scenes being changed in full view of the audience thanks to the mechanism of the movable scene, invented at the Medici court, which made it possible to transform the stage continuously, shifting from idyllic landscapes to infernal chasms,

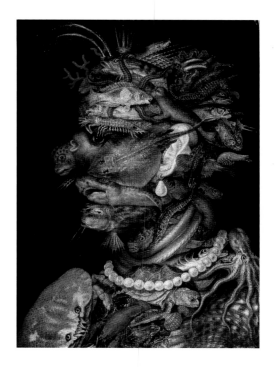

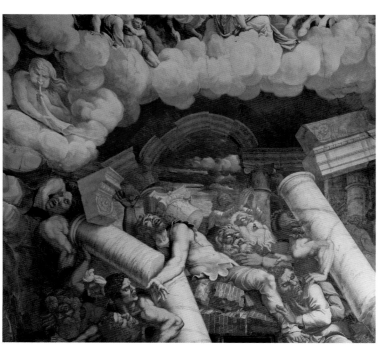

Giuseppe Arcimboldo
Water
1566, oil on wood panel.
Vienna, Kunsthistorisches Museum.

The variety of sea species—depicted with a descriptive precision that presaged the still-life form—provides the metaphorical material for embodying the personification of the water element, following the playful, pithy course typical of the capriccio.

Giulio Romano
Hall of the Giants
1532–34, fresco.
Mantua, Palazzo Te.

Giulio Romano exploited the ambivalence between architectural structure and pictorial fiction to conceive an all-round depiction of the *Fall of the Giants*, seamlessly frescoing the entire vaulted room and rounding off all the corners so that viewers were so drawn into the opus that they felt threatened by the rocks crushing the Giants.

Facing page:
Federico Zuccari
Window
post-1593.
Rome, Palazzetto
Zuccari.

thanks to complex and carefully concealed machinery. Whole cities could be transformed into a classical-style setting used to welcome the triumphal entry of powerful sovereigns, using ephemeral materials to create temporary architectural or monumental scenery, such as arches or equestrian statues, which would be later repeated in permanent bronze or marble versions (see page 151). The tension between nature and artifice also produced a number of "bizarre" or " capricious" forms of expression that went beyond mere ornamentation. The casual combination of natural elements—flowers, fruit, vegetables—took on a decidedly anthropomorphic turn in the well-known composite heads created by Arcimboldo, while doorways and fireplaces were transformed into the mouths of menacing masks, as can be seen in Palazzo Thiene in Vicenza, or in Federico Zuccari's building and garden in Rome. And it was in gardens that art came head to head, as it were, with nature, transforming stones into fabulous monsters and skillfully re-creating artificial grottos—caverns containing a thousand surprises as well as playful fountains. This capacity for changing space also involved the interiors of buildings, with fake tottering rustic buildings, as in the decorations that Giulio Romano executed for the Palazzo Te Sala dei gigantic in Mantua.

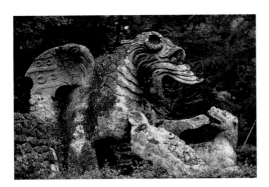

Assault of the Dragon
c. 1552–80.
Bomarzo, Park of Monsters.

The forms of Nature include marvelous figures not contemplated by reason, in the drawing of the clouds, the traces of damp, the irregularity of the stones. In this order of ideas, the natural rocks of the Vicino Orsini woods appear as petrified monsters.

Left:
Bernardo Buontalenti
first ***Grotta Grande chamber***
1583–93. Florence, Boboli Gardens
(after restoration, 2004).

The addition of Michelangelo's unfinished slaves among the grotto's fake stalactites underscores the tension of the form and the material, offering a dialectic reflection on the creative process of Nature and art.

Above:
Giambologna
Apennine
c. 1571.
Pratolino, Villa
Demidoff park.

The giant, 14 meters (46 feet) in height, seems to loom out of the ground like a form obtained from natural concretions stratifying over the centuries.

Mannerism Ornament: In Praise of the Caprice and the Bizarre

From the Loggia to the Gallery

In his biography, Benvenuto Cellini described the "fine gallery" in Fontainebleau Castle, using a form of words that underlined how unusual such a space was for the time. It was "as we would say in Tuscany, a *loggia*, or perhaps rather a hall; in fact, hall would be better, because what we call a loggia are those rooms that are open on one side." The gallery of Francis I, King of France, presented a number of affinities with the Italian loggia: its length, its use as passageway, the way the walls were open to the exterior, the rhythm of the stucco and fresco wall decorations completed by Rosso Fiorentino in 1539, recall the ornamental scheme Raphael devised for the Vatican loggias, or the plan used by Giulio Romano in Palazzo Te. There are of course numerous divergences, as the loggia typically includes a wall punctured by wide arcades supporting a vaulted ceiling and which establishes a sense of continuity with the garden (on the ground floor), or with the panoramic view of the city (on the upper floors). In effect a covered area for taking a stroll in a cool and well-ventilated environment, the loggia gives a certain sense of movement to the building's façade through the dynamic use of full and empty space and provides a practical distributive arrangement to connect the interior rooms. Despite its luminous windows (which were originally located on both sides), the Fontainebleau gallery

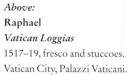

Above:
Raphael
Vatican Loggias
1517–19, fresco and stuccoes.
Vatican City, Palazzi Vaticani.

Bramante rationalized the prospect of the Vatican buildings with a facade of various orders of loggias, later completed by Raphael, who also designed the fresco and stucco decoration for the second floor. The loggias were an area where the Pope and his retinue strolled and relaxed, containing a collection of antiquities, and was a formula later developed at Fontainebleau.

Left:
Raphael
Loggia of Psyche
1517–18, fresco.
Rome, Villa Farnesina.

In the loggia of the villa built by Baldassarre Peruzzi for Siena banker Agostino Chigi, Raphael used the garden to underscore spatial continuity, arranging the episodes of the Eros and Psyche myth around a faux arbor enclosed by trompe-l'oeil tapestries.

Below:
Marten van Heemskerck
View of the Vatican Loggias
1534–35, drawing.
Vienna, Albertina.

gives the appearance of being a closed space, anchored to its longitudinal axis. It is, in effect, a corridor on the second story of a detached building, designed as a passageway connecting the royal apartments in the old tower with the Palatine chapel in the old convent. Nevertheless, the gallery's originality does not lie in the idea of the covered corridor, which Bramante had already used to connect the Vatican buildings with the Belvedere; rather, the novelty came from the transformation of a handy passageway into a space for the representation of the king, made possible by the magnificent and markedly political nature of the gallery's decorations. The king quickly decided that he would have exclusive access to the gallery, and occasionally invited members of his court, or illustrious guests, to admire the collection of ancient or classical-style sculptures housed in the gallery and to decipher the complex decorative scheme which emphasized the successes and the difficulties overcome of his reign. This first attempt in Fontainebleau would ensure the success of the gallery as a space in which to house collections of art meant to showcase the ruler's power. A direct and monumental successor was the *Antiquarium* in the Munich Residence, which was created to organize and highlight the collection of antiquities belong to Alberto V of Bavaria.

Left:
Rosso Fiorentino
Gallery of Francis I
1533–39. Fontainebleau Castle.

The gallery, with its complex iconographic scheme, offers an emblematic portrait of Francis I. The place was both a private space and his place of entertainment, so its political and cultural significance should be perceived in relation to the collection of paintings in the bathing quarters and lavish library, located respectively downstairs and upstairs.

Antiquarium
1567–68. Munich, Bavaria, residence.

The *Antiquarium* of the Dukes of Bavaria (shown here in an old photograph) is the first example of monumental architecture conceived specifically to house antiquity collections; these were in the vast first-floor hall, with a library upstairs. The name of the architect is unknown, but his designs were endorsed by the Imperial antiquarian, Jacopo Strada.

Above:
Hendrick III van Cleef
View of the Belvedere
1589, oil on wood panel.
Brussels, Musées Royaux des Beaux-Arts.

Mannerism | *From the Loggia to the Gallery*

The Palazzo and the Villa

The idea that the three sister arts, architecture, painting, and sculpture, were the progeny of the same parent, drawing, was not only the fruit of a theoretical construction elaborated by sixteenth-century commentators, but was evident in artistic concepts and practice. As was the case with loggias (pages 154–155), the plans for palaces and villas were often closely linked to ornamental arrangements of frescoes or stucco that contributed to establishing the relationship between exterior and interior, underlining the visual rhythms of the architecture or dissolving the physical limits of walls using trompe-l'oeil effects. This interpenetration of architecture, painting, and sculpture had more profound foundations and outcomes which involved the formulation of a common linguistic structure built on respect for and the desire to go beyond the rules. In the case of architecture, more so than the other arts, the rule was clearly based on the canons of antiquity, that is, on knowledge of Vitruvius's text *On Architecture* and of the venerated surviving monuments which were discussed and made known to the public in a series of practical and theoretical treatises that would meet with great success across Europe. The authors of these texts were among the leading architects of their time, Sebastiano Serlio, Jacopo Barozzi (known as Vignola), Andrea Palladio, and Vincenzo Scamozzi.

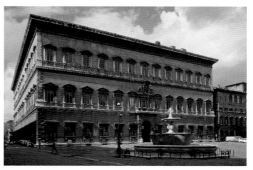

Left, above:
Pedro Machuca
Palace of Charles V
from 1527.
Granada.

Above:
Antonio da Sangallo the Younger
Palazzo Farnese
Rome.

This was the first "Roman-style" building erected out of Italy. It was the work of Pedro Machuca, a painter and architect who trained in Italy, showing such a contemporary familiarity with Raphael's architectural language, both in the layout and in the plastic arrangement of the elevations, that it was even suggested they were invented by an Italian artist, like Giulio Romano.

Left, below:
Jacopo Vignola
Palazzo Farnese
from 1559.
Caprarola.

Vignola completed the project begun by Baldassarre Peruzzi and continued by Antonio da Sangallo the Younger, opening the pentagonal building's closed layout towards the city, with the generous embrace of a double ramp of stairs.

Of course, it was almost second nature to refer to classical models right from the planning stage. In this sense, the suburban villas created by Raphael or Giulio Romano, with their succession of rooms from the vestibule to the atrium to the peristyle, deliberately evoked the intrinsic relationship that existed between house and garden in imperial times, while the villas of Palladio, which merged building and landscape (four porticos on each side that afforded just as many views of the countryside), explored how the ancients perceived nature. The study of classical central or circular plan buildings paved the way for further reflection on the form of a closed, isolated building, marked by geometric purity, that could be used to represent political power. This produced a number of imposing and inaccessible buildings that introduced a break with the town or stood over it like a fortress, like the palace of Charles V in Granada, an oblong anchored around a circular courtyard built by Pedro Machuca, or the cubelike Palazzo Farnese in Rome, designed by Antonio da Sangallo the Younger, or the pentagon with circular courtyard that Vignola designed for the Farnese at Caprarola. Among the basic principles of the classical canon, the greatest attention was paid to the definition and (occasionally rather freely construed) philological reconstruction of the five classical orders—Doric, Ionic, Corinthian, Tuscan, Composite—for which contemporary

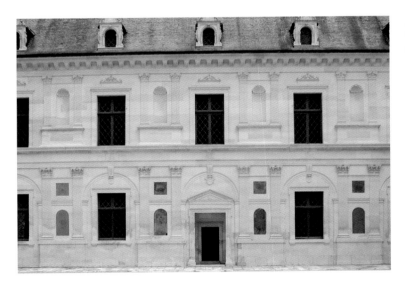

Sebastiano Serlio
Courtyard
1545–50.
Ancy-le-Franc, castle.

The tempo of the classical orders is adapted to the typical structures of French architecture, like the pitched roof with skylights.

Andrea Palladio
Villa Rotonda
1566–69. Vicenza.

Palladio drew on ancient temples for the configuration of his most famous villa, its impeccable symmetry opening onto the surrounding landscape via four classical porches.

Above:

Giulio Romano
Courtyard
detail, 1525–34.
Mantua, Palazzo Te.

The courtyard facades of Palazzo Te were composed with a remarkable freedom of expression, with great plastic effects, playing out on the contrasting forms of rustic ashlar and classical orders, while the equilibrium of this mighty structure is contradicted by the falling triglyphs that cadence the regularity of the entablature.

Mannerism The Palazzo and the Villa

treatises offered handy illustrated catalogs. And architecture made use of the five orders with their associated columns, pilasters, capitols, plinths, and pediments to develop the idiom that would be used in the composition of clearly defined facades distinguished by the play of light and shadow, making use of rhythmical sequences and interruptions, the opposition of full and empty spaces, protruding edges and hollows, rugged and smooth surfaces. The lexicon of structural elements could be adapted to an infinite range of variations and new inventions which, spurred on by artistic license, could produce surprising, though not necessarily functional, solutions, such as the falling triglyphs that Giulio Romano designed to decorate the entablature of the courtyard of Palazzo Te (see page 157), or the inverted pediment designed by Buontalenti for the *Porta delle Suppliche* (Door of Application) in the Uffizi portico (see page 170). The investigation of pictorial and sculptural values in dealing with architectural surfaces led inevitably to the path of ornamental development, just as it did to the use of real elements from painting and sculpture, temporary, ad-hoc public projects contributed to experimentation in these fields. An early, permanent formulation was in the faux bas-reliefs frescoed in a single color and used to add a sense of movement to the façades of urban buildings; later, the chiaroscuro effect

Above:
Polidoro da Caravaggio
Facade decoration design
c. 1523–25, pen and
brown ink.
Weimar, Goethe
National Museum.

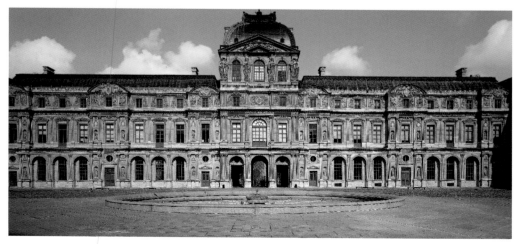

Left:
Anonymous
Facade overlooking Villa Medici gardens in Rome
seventeenth century,
oil on canvas.
Valence, Musée des
Beaux-Arts.

Ornamentation of bas-reliefs and classical busts, framed or finished in stucco, was part of the presentation of the rich collection of antiquities belonging to Cardinal Ferdinando de' Medici and kept in the garden of his lavish Roman villa.

Pierre Lescot
Facade of the Cour Carrée
1545–46. Paris, Louvre.

For the new Louvre court, commissioned by Francis I and continued by Henry II, Lescot conceived the left wing of the facade, completed later in the 1600s. The magnificent ornamentation of the architecture is intrinsically connected to Goujon's bas-relief sculpted language.

would be rendered by the protruding edges of stucco decorations, statues, and even archeological finds wedged into the walls. Now entirely decorated, the façade could become a display case for antiquity, like the prospect overlooking the garden of the Villa Medici in Rome. These variations in form within the syntax of classical order would lead to the creation of a linguistic structure accepted and used across Europe, where it could be easily adapted to local rhythms. There are some fine examples in France, created by Pierre Lescot; in the Cour Carrée of the Louvre finely embossed with bas-reliefs by Jean Goujon; in the sumptuously worked portals of Chateau Anet designed by Philibert de

l'Orme; or in Germany, in the polychrome façade of the Ottheinrichsbau in Heidelberg (not shown here), marked by a host of caryatids, statues, and reliefs created by the Flemish sculptor Alexandre Colin. The monumental scale of most buildings, was also influenced by the interplay of emphasizing form or concealing limits. Michelangelo gave his own very dynamic interpretation of this tension in the rolling rhythm of the vestibule of the Biblioteca Laurenziana in Florence; in turn, Vignola brilliantly accentuated the sense of spiral movement in Palazzo Farnese in Caprarola.

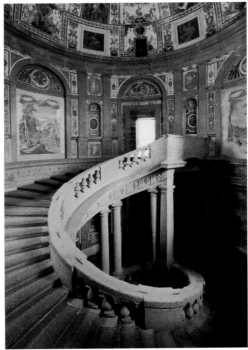

Above:
Francesco Salviati
Bathsheba Visiting David
c. 1552, fresco. Rome, Palazzo Ricci Sacchetti.

Michelangelo
Vestibule with Stairs
1558–59. Florence, Biblioteca Medicea Laurenziana.

Michelangelo played out the color contrast between the *pietra serena* (Firenzuola stone) and the plaster, achieving a truly plastic configuration of the vestibule walls in the Biblioteca Laurenziana, where the monumental staircase bursts forth as a fluid cascade in the expanding wave of movement.

Jacopo Vignola
Stairs
1559. Caprarola, Palazzo Farnese.

Vignola developed the spiral staircase motif, preferred by Mannerist painters for its lightness of form, a coil seemingly free of any tectonic constriction, emerging into the void created by the vault and proceeding ideally into the grotesque decoration design.

The Colossus and the Piazza

The public monument, in its role as a focal point for urban space, was given new life in the sixteenth century, thanks to the development of two fundamental ideas that encounter lasting success across Europe. In 1538, the ancient bronze equestrian statue of Marcus Aurelius was moved from the Lateran and relocated at the center of the new Campidoglio in Rome, designed by Michelangelo. This one event was highly influential in producing the idea that the square could act as a container or setting for a colossal sculpture. The erection of the equestrian statue of Cosimo I de' Medici (the work of Giambologna) in the Piazza della Signoria in Florence in 1594 was further evidence of the close ties between public statuary and the figure of the ruler. After a century of apparent silence, which was, however, marked by productive reflection, fleeting experimentation, and various projects with no concrete outcome, the equestrian statue was poised to make its return to the squares of Italian towns. This time they would not celebrate the military prowess of a *condottiero* such as Gattamelata or Colleoni, but rather the power of the Medici as represented in the figure of the dynasty's founder, legitimizing the authority of his successor, namely Ferdinando I, Cosimo's second child and commissioning patron of the posthumous monument. Set right in the very heart of Florence, Giambologna's colossal bronze statue was part of the final stage of a major theorization of the role of the statue which had clearly political overtones, although, perhaps

Bernardino Gaffuri and **Jacques Bylivelt**
View of Piazza della Signoria
c. 1599, gold and hardstones.
Florence, Palazzo Pitti, Museo degli Argenti.

The side view of Piazza Signoria allows the alignment of the bronze and marble colossi, the symbol of Medici power, in continuity with Vasari's perspective trompe l'oeil of the Uffizi, the center of the Grand Duchy's administrative "good government."

Étienne Dupérac
Piazza del Campidoglio in Rome
1569, engraving.

Michelangelo's Campidoglio was the result of the first design for a modern Roman plaza, and was commissioned by Pope Paul III to house his gift to the people of Rome: the equestrian statue of Marcus Aurelius. With this dramatic gesture, the Pope was able to restore luster to the imperial image of the Eternal City, but he also reestablished the supremacy of spiritual over temporal power.

paradoxically, the reflection had begun on the ashes of Medici power during the brief return to a republican government. Indeed, after Piero de' Medici had been forcibly banished, Donatello's statue of *Judith and Holofernes* had been taken from the family residence and then placed, in 1494, in Piazza della Signoria, where it was to be joined ten years later by Michelangelo's *David*, which originally had been meant to be located on the cathedral buttresses. The two slayers of tyrants were transformed into emblems of the city, embodying ideals of justice and freedom as a warning to Florence's enemies. The restoration of Medici power, especially after 1530, was inscribed seamlessly in the very same Piazza della Signoria, as the Medici appropriated the triumphal language of the republic to flaunt the dynasty's victory over its internal enemies and to place the emphasis on its own good government with a series of colossal mythological figures: *Hercules and Cacus* by Baccio Bandinelli (shown below), Benvenuto Cellini's *Perseus* (p. 171) and the *Fountain of Neptune* by Bartolomeo Ammannati (1576). While the *Equestrian Statue of Cosimo I* fitted easily into this program of political affirmation, it was a clear break with past tradition—the explicit insertion of the figure of the prince into the heart of urban space marked the definitive transformation of the republican forum into the ducal square.

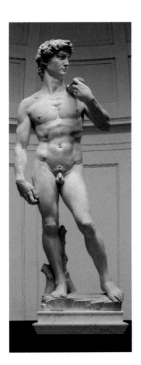

Michelangelo
David
1501–04, marble. Florence, Accademia.

It was a commission of artists that decided to install Michelangelo's "giant" alongside the entrance to Palazzo Vecchio, thus inaugurating the custom of a critical-artistic debate around the works intended for the square, which explains the 1583 inclusion in the Loggia dei Lanzi of a sculptural masterpiece lacking any political intent: Giambologna's *Rape of the Sabine Women*.

Baccio Bandinelli
Hercules and Cacus
1525–34, marble. Florence, Piazza della Signoria.

Giambologna
Equestrian Statue of Cosimo I
1581–94, bronze. Florence, Piazza della Signoria.

The colossus initiated a style for representing power that was soon applied to the reigning prince and echoed around Europe. Giambologna's workshop then provided the *Equestrian Statue of Ferdinando I* for Piazza Santissima Annunziata and, in the same format, statues of Henry IV and Philip III, sent respectively to Paris and to Madrid.

The Escorial

In Spain, Italian artistic models found a surprising and highly idiosyncratic interpretation in the royal monastery, the Escorial, which Philip II dedicated to Saint Laurence, in thanksgiving for the Spanish victory at Saint-Quentin on August 10, 1557. The sovereign followed every single phase of the mammoth project, begun in 1563, until he was sure he had produced a building that mirrored his ideal of monarchy, which brought together in an unprecedented combination a family mausoleum for the dynasty, a royal palace, a monastery, and a religious college. A single quadrilateral plan divided by courtyards (similar to the grid design of San Lorenzo) distributed the building's various functions around the central bulk of the basilica, while the royal apartments were located behind the presbytery. In this way, the king could see from his bed chamber both the high altar and the funeral memorial to his father, Charles V, as well as the surrounding countryside. This singular arrangement stratified the building's different levels of meaning. It emphasized the power of the new Hapsburg dynasty in Spain, founded by Charles V, and the Hapsburgs' solemnly proclaimed role as defenders of the Catholic faith. It also embodied the concept that monarchical power should be invisible but omnipresent, its control spreading out from the secluded royal apartments to cover the whole of the king's vast domains. The gravitas of Philip II's style of government was reflected in architectural choices full of classical references but free of any ornamentation,

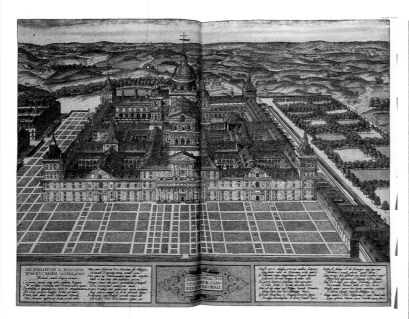

The Monastery of San Lorenzo
(designed by Juan Bautista de Toledo and Juan de Herrera, 1563–84), from *Civitates Orbis Terrarum* (Citizens of the World) by Georg Braun and Frans Hogenberg
c. 1585, colored etching by Joris Hoefnagel.

The prospect's only decoration are the orders of the central block, whose stark simplicity pays homage to Roman Counter-Reformist architecture, in particular Giacomo della Porta's Gesù facade. The monumental uniqueness of the building soon brought comparisons with the Temple of Solomon and praise as the "eighth wonder of the world."

Pompeo Leoni
Funeral Monument for Philip II and His Family
1588–1600, gilded bronze and enamel.
El Escorial, monastery of San Lorenzo.

The entire dynasty gathered in prayer at the sides of the choir, while the remains are kept in the crypt. In his intense devoutness, Philip II contributed to this tomb while he was still alive, sleeping in a chamber under his own monument.

their execution entrusted to Juan Bautista de Toledo and, after his death in 1567, to Juan de Herrera. Both artists had trained in Italy. The austere *desadornamento* (removal of ornamentation) of the figures and forms, inspired by the Counter-Reformation's precepts of simplicity and legibility, would also have far-reaching repercussions on the decorative scheme of the basilica, in effect curbing the creative spirit of the Italian Mannerist painters who were called to court in the 1580s to carry out the decoration. These artists were Federico Zuccari, Luca Cambiaso, and Pellegrino Tibaldi. Philip II demanded absolute respect for decorum in the execution of the forty side altars that contained the relics of saints, the fresco cycles on the vaulted ceiling, and the funerary monuments for the families of Charles V and Philip on either side of the choir, as well as the monumental altarpiece. For Philip, such decorum meant total adherence to textual sources. In this context, the sovereign's seemingly paradoxical rejection of El Greco's *Martyrdom of Saint Maurice* must be assessed, especially in light of El Greco being paid the princely sum of 800 ducats for his work. The criteria for religious decorum applied to the basilica did not, however, disguise the king's deep knowledge of painting. He was a great collector and receptive to a wide range of figurative idioms—from the evocative colors of Titian to the extravagant minutia of Hieronymus Bosch.

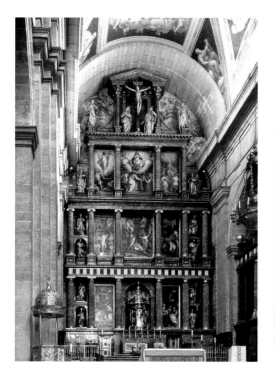

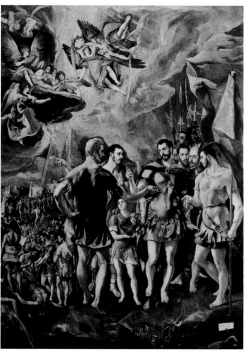

Romulo Cincinnato
Martyrdom of Saint Maurice
1586, oil on canvas.
El Escorial, monastery
of San Lorenzo.

Philip II preferred Romulo Cincinnato's more low-key composition to El Greco's vibrant and visionary interpretation. It met his demands for narrative "truth and certainty" respecting unity of time and place, as well as focusing on the martyrdom.

Leone and Pompeo Leoni (sculptures),
Jacopo da Trezzo (tabernacle), **Pellegrino Tibaldi and Federico Zuccari** (paintings)
retable for the high altar, 1579–92.
Escorial, monastery of San Lorenzo.

The design brought up to date the classic form of the Spanish retable. The decoration was entrusted to Italian Mannerists and was modified many times, replacing a Venetian-style design originally inspired by Titian's *Martyrdom of Saint Laurence*.

El Greco
Martyrdom of Saint Maurice
1580, oil on canvas. El Escorial, palace.

Fray José de Sigüenza, the Escorial historiographer, wrote of El Greco's work that "His majesty disliked it, but that is not important, for many do like it, and they say it is great art and that its author has great skill, as can be seen in the excellent items made by his hand."

The Portrait

During the age of Mannerism, and within a theoretical system which saw art's final goal to be the achievement of the original and perfect beauty of *natura naturans* (Nature acting as Nature should), the portrait, which was so dependent on *natura naturata* (Nature already created), namely on a descriptive representation of the natural model, including all its defects, presented quite a contradiction in terms. The gap between the requirements of portraiture and the guiding criteria of the fine manner was highlighted by Michelangelo who, in creating the statues for the Medici tombs in San Lorenzo, preferred to give the dukes Lorenzo and Giuliano a certain heroic grandeur rather than bend to the dictates regarding lifelike resemblance. Michelangelo, in the mood to provoke, argued that "in a thousand years' time, no one [would] be able to claim that they were otherwise." While this type of consideration would later lead to gradual disapproval of the portrait because of its status as an inferior art form, according to the classification of genre painting that would be compiled in the seventeenth century, portrait artists in the sixteenth century attempted to resolve the technical issue by reincorporating the portrait into the process of *electio* that was the distinctive feature of the concept of art they defended. This act of discernment or choice as applied to portraiture took place on two levels. First, the artist had to

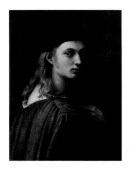

Raphael
Portrait of Bindo Altoviti
1515, oil on wood panel.
Washington, National
Gallery.

Raphael's portraits beckon to the onlooker: close-ups, light and fleeting gestures, faces turning, penetrating gazes. The consoling power of this invitation to dialogue was praised by Castiglione in an elegy on the portrait that Sanzio painted of him.

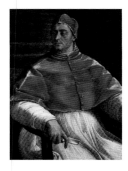

Sebastiano del Piombo
Portrait of Clement VII
c. 1525–26, oil on canvas.
Naples, Capodimonte.

Using the finest chiaroscuro and color effects, Sebastiano Luciani confers on the Pope an incumbent yet distant monumentality, for the detachment of the serious face and fleeting gaze.

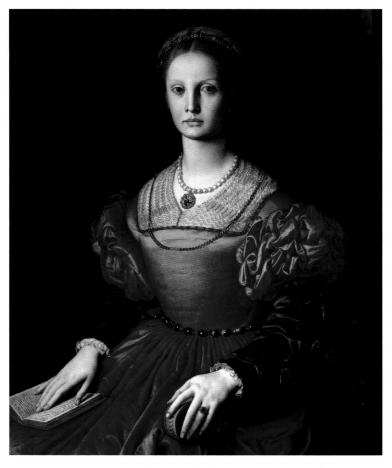

Bronzino
Portrait of Lucrezia Panciatichi
c. 1541, oil on wood panel.
Florence, Uffizi Gallery.

The purity of the faces and sumptuousness of the clothes and jewels identify the social status of Bronzino's models. The pendant necklace shown in this painting, with the inscription *Amour dure sans fin*, was a gift from Lucrezia's husband.

make a selection of the models to be represented, and the models had to be sufficiently worthy due to their virtue and social position, so the image of their physiognomy transmitted by the portrait would act as an *exemplum* (worthy example) for posterity. Second, the artist had to choose the subject's best features, so as to highlight his or her best qualities. In his crucial chapter on composition of portraying from nature (from his *Trattato dell'arte*—"Treatise on Art," 1584), Lomazo wrote that "for the painter it is always better to enhance greatness and majesty in [the subjects'] faces, covering the defect of nature, as the ancient painters did, who usually always artfully dissimulated and indeed concealed natural imperfections."

The virtues and qualities that were emphasized in the portrait did not correspond so much to the individual qualities of the subject depicted, but rather to the social qualities that were fitting for his or her rank. Lomazzo commented that "the emperor above all, as every king and prince, seeks majesty, and to have an air that suits such rank, must emanate nobility and gravity, even if he were not naturally so made." Every social category had its particular qualities, and representing them while respecting facial resemblance was especially difficult in the case of female subjects, because the principal quality of women was not intangible; It was something physical, namely, their beauty. There was an evident process of

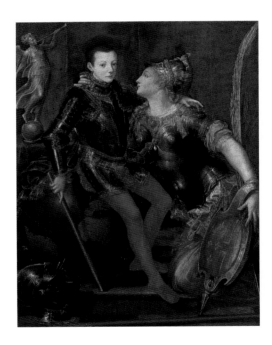

Girolamo Mazzola Bedoli
Parma Embraces the Young Alessandro Farnese
1555–56, oil on canvas.
Parma, Galleria Nazionale.

The priority given to the quest for realism did not exclude recourse to allegorical language to define the portrait's political message. In this painting, the personification of Parma embraces the young Alessandro Farnese, legitimating his future succession to the dukedom, placed under the auspices of Fame.

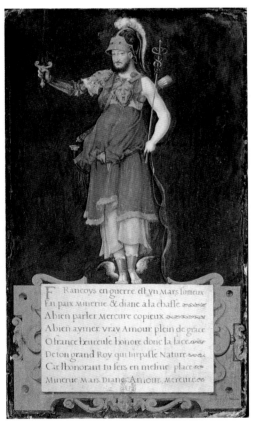

Nicoletto da Modena (attr.)
Allegorical Portrait of Francis I
c. 1545, oil on wood panel.
Paris, Bibliothèque Nationale.

Mars, Minerva, Diana, Mercury, and Cupid embody the excellence of the monarch's virtues, contained in this single, surprising figure.

Marcus Gheeraerts the Younger (attr.)
Elizabeth I (Ditchley Portrait)
c. 1592, oil on canvas.
London, National Portrait Gallery.

The rigid solemnity of portraits of Elizabeth I avoid any illusionism in order to construct an emblematic icon of the sovereign's incorruptible virgin power. The Queen, whose expression is as impassable as a mask, wears a bejeweled gown, dominating the globe, and at her feet the geography of her domains is solidly defended by the royal fleet.

Mannerism | The Portrait

idealization underpinning the theoretical injunctions, and it was also clear, for example, from the crystalline geometry of the faces in portraits by Bronzino. It is worth noting that the term "ideal" is absent from the sixteenth century's definition of the portrait, and that even the watchword "dissimulation" of defects is severely circumscribed by the need to conserve some sense of resemblance. Paradoxically, at the time, the assessment of a portrait's worth rested on the notion of resemblance, which had, however, to be understood in two ways; a "good" portrait had to resemble the subject, but it also had to reflect the social person in such a way that the viewer would be able to recognize not only the subject's particular features, but also his or her rank in society. This moral and social concept of the portrait codified by commentators and treatise writers reflected the extraordinary success of the genre in sixteenth-century Italy. Portraits enhanced their models in life-size paintings of increasingly greater format, with frames that brought the subject to the very edge of the painted surface, in close contact with the viewer. Raphael and Sebastiano del Piombo were among the first to abandon the traditional half-length portrait for more imposing three-quarter length depictions. They were followed by the most acclaimed exponents of Mannerism, Parmigianino, Pontormo, and Bronzino. Titian was recognized as the greatest interpreter

Titian
*Emperor Charles V
at Mühlberg*
1548, oil on canvas.
Madrid, Prado.

The first equestrian portrait
on a removable support.
The exceptional nature of
Titian's opus was suited to
the equally exceptional
episode it was celebrating:
Charles V's astonishing vic-
tory at Mühlberg, against
Smalcada's Protestant League.

Anthonis Mor
Portrait of Philip II
c. 1557, oil on wood panel. Madrid, Prado.

Mor interpreted Titian's famous full-figure models
in the thorough language of Flemish art.

Sofonisba Anguissola
*Portrait of Elizabeth
of Valois*
c. 1561–65, oil on canvas.
Madrid, Prado.

In Madrid the Cremonese
artist adapted to the language
of the Spanish portrait,
developed at that time by
Mor and Sánchez Coello.

of the new format, which accentuated the portrait's physical presence and allowed it to fulfill its role as the substitute for an absent person all the more forcefully. Titian's vivid use of color was held to produce results so natural, so lifelike, that the viewer would be fooled into thinking that the subject was actually present, to such a degree that the viewer could carry on the much desired dialogue with the absent person. Titian's portraits of Charles V constituted a crucial episode in the evolution of the genre. The artist developed new formats to represent the emperor that would be immensely successful, depicting him full-length, standing, sitting, on horseback. Moreover, thanks to Titian's incomparable skill with color, he managed to dissimulate the emperor's protruding lower jaw under the hazy charm of his brushstrokes, turning a grave defect into a majestic expression fitting for the sovereign. Titian thus contributed to the imperial image that would be circulated all over Europe. The social and artistic success of Titian, who gained not only international recognition from Charles V's patronage but also annuities and titles of nobility, would become the touchstone for artists far beyond Italy. His models, copied and reinterpreted according to local figurative criteria, would have a major influence on portraiture in the courts of Europe.

Right:
Leone Leoni
Charles V
c. 1553, bronze.
Madrid, Prado.

To borrow Aretino's famous oxymoron, Leoni conceived the "anciently modern, modernly ancient bust." In fact, if the pedestal solution refers explicitly to a bust of Commodus (Rome, Musei Capitolini), our Emperor is actually shown here in a classic pose but with modern armor. By making topical an ancient model, the Roman Empire's ideal parentage of Charles V is transmitted; the motif was soon recovered for depiction of one of his successors, Rudolph II.

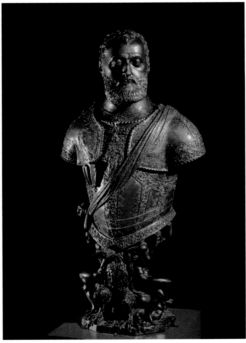

Adriaen de Vries
Rudolph II
1603, bronze.
Vienna, Kunsthistorisches Museum, Kunstkammer.

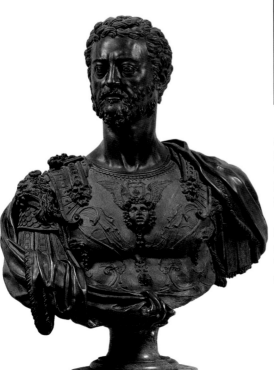

Left:
Benvenuto Cellini
Cosimo I
1545–47, bronze.
Florence, Bargello.

For its allusion to the Roman Empire, the ancient style of the sculpted bust stands as another example of the representation of sovereignty. Cellini's Cosimo I has a "leonine" expression and, in physiognomic codes, this denotes the pride and majesty appropriate to the prince's figure.

Mannerism | *The Portrait*

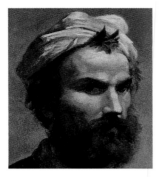

Domenico Beccafumi
Self-Portrait
c. 1527, oil on paper
mounted on wood panel.
Florence, Uffizi Gallery.

Domenico Beccafumi
(Valdibiana c. 1486–1551 Siena)

Apart from a stay in Rome (c. 1510–12) and another trip there in 1519, very little is known about Beccafumi's artistic training. His somewhat eccentric explorations of figurative style show similarities with the work of the younger Pontormo and Rosso Fiorentino, although he took a different direction in Siena. The first works attributed to him, such as the decoration of the Manto chapel (1513), show his understanding of Florentine approaches to art as well as early signs of the graceful ethereal quality, the use of almost diaphanous lighting, and the variable hues that would become characteristic Beccafumi features. He was known for his altarpieces and devotional paintings, and undertook two major fresco cycles based on classical themes, one in Palazzo Casini Casuccini (1519–20) and the other in Palazzo Pubblico. He realized the floor in Siena cathedral (1519–44), painted frescoes for the apse (1544), and worked as an engraver and sculptor. He was also active in Genoa and Pisa.

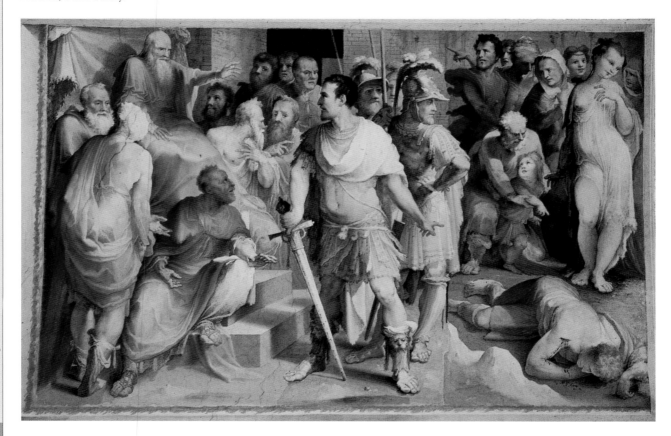

Domenico Beccafumi
The Killing of the Wrong Melius
1529–35, fresco.
Siena, Palazzo Pubblico, Sala del Concistoro.

Pontormo, *presumed portrait of Bronzino as a young man*, detail from *Joseph in Egypt* 1518–19, oil on wood panel. London, National Gallery.

Bronzino
Agnolo di Cosimo (Florence 1503–1572)

A pupil of Pontormo, Bronzino took part in the decoration of the Certosa del Galluzzo monastery (1522–25) and the Capponi Chapel in Santa Felicità (1525–28), developing a highly stylized approach that was crisply geometric in its purity. Bronzino remained a close collaborator of Pontormo for many years, and when Pontormo died, Bronzino finished the fresco cycle for the choir of San Lorenzo (1558). After two years in the service of the Della Rovere family (1530–32), on his return to Florence, Bronzino obtained a prestigious place as court painter to the Medici. For Cosimo I, he executed a stunning series of portraits of family members, and decorated the chapel of Eleonora of Toledo in Palazzo Vecchio (1540–64). He also prepared the cartoons for the tapestries depicting *Stories from the Life of Joseph*, 1546–1553. He contributed to the foundation of the *Accademia delle arti del disegno* in 1563. He helped organize the funeral celebration for Michelangelo in 1564 and was also a poet.

Bronzino
The Panciatichi Holy Family
c. 1541, oil on wood panel.
Florence, Uffizi Gallery.

Right:
Bronzino
Descent From the Cross
1543–45, oil on wood panel.
Besançon, Musée des Beaux-Arts.

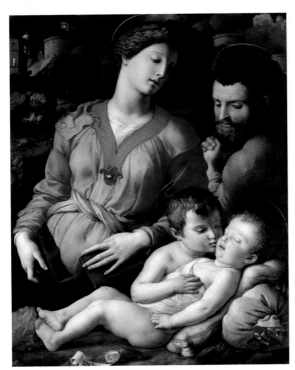

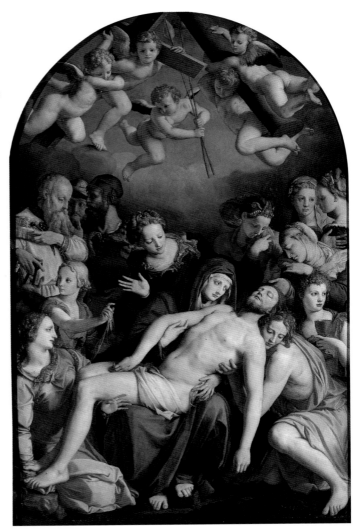

Bernardo Buontalenti

Bernardo Delle Girandole (Florence 1530–1608)

Architect, painter, illuminator, sculptor, stage designer, and court engineer in Florence, Buontalenti was equally at home applying his creative and technical verve to construction projects (Forte Belvedere, 1590; Palazzo Nonfinito, 1593–1600), formidable cannons, designs for jewelry and ornaments in gold, ephemeral devices, stage machinery, and pyrotechnic or hydraulic equipment. A protégé of the Medici family, at the age of 15 he built an imaginative mobile lantern that earned him the nickname of "Bernardo dalle Girandole" and gave a glimpse of his future vocation as an "orchestrator of marvels" at the court of the Grand Duke, where he would specialize in spectacular scenery and stage settings (he designed the intervals to *Pellegrina*, performed to celebrate the wedding of Ferdinando I and Christine of Lorraine, 1589), as well as grottos for gardens (the *Grotta grande* in the Boboli Gardens, 1589–93). In architecture, he brought new life to traditional forms, making use of different orders with little regard to their structural function (Steps of the Santa Trinità altar, 1574; *Porta delle suppliche* doorway).

Francesco Morandini called **Poppi**, *Portrait of Bernardo Buontalenti*, c. 1590, pencil on paper. Florence, GDSU, 4290A.

Above:
Bernardo Buontalenti
Studies for the Casino Mediceo at San Marco
pen and ink, traces of black pencil on white paper.
Florence,GDSU, 2380A.

Left:
Bernardo Buontalenti
Dragon
Sketch for La Pellegrina
pen and watercolor.
Florence, B.N.C., Pal. C.B.3.53.II, c. 25r.

Bernardo Buontalenti
Door of Supplication
the door in full before its restoration (top right) and a detail of a wooden panel and a bronze leaf (near right), c. 1577.
Florence, Uffizi portico.

Benvenuto Cellini
(Florence 1500–1571)

Cellini left a powerful account of his tumultuous life in his autobiography, a life that saw acts of violence, trials for sodomy, attempts at escape, and time in prison, as well as vehement rivalries with other artists and heroic technical endeavors. He achieved fame as a goldsmith in the service of Clement VII, whom he followed to Castel Sant'Angelo during the Sack of Rome (1527). He went on to work for the Farnese, the Gonzaga, and the d'Este families. He crafted his celebrated salt-cellar at the court of Francis I (1540–1545), and tried to make a name for himself as a sculptor with the (unfinished) reliefs for the *Porte Dorée* and a massive statue of *Mars*. He earned recognition for his work on statuary in Florence, working on technically demanding bronze, producing a *Bust of Cosimo* I (1545). He also demonstrated his skill in marble (*Crucifix*, Escorial, 1556). In 1568 he published his *Trattati dell'oreficieria e della scultura* (Treatises on the Goldsmith's Art and on Sculpture).

Benvenuto Cellini, etching inspired by Giorgio Vasari's portrait of him in Palazzo Vecchio. Quartiere di Leone X, Sala di Cosimo I.

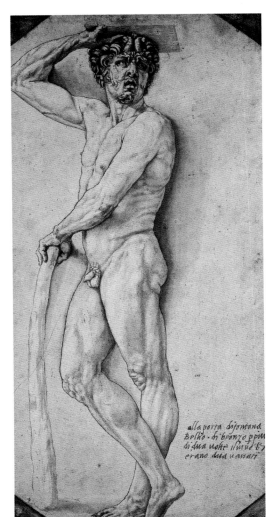

Left:
Benvenuto Cellini
Satyr, study for a statue set in the Fontainebleau Porte Dorée
1542–43, pen and watercolor.
New York, Woodner Family Collection.

Right:
Benvenuto Cellini
Perseus
1545–54, bronze.
Florence, Loggia dei Lanzi.

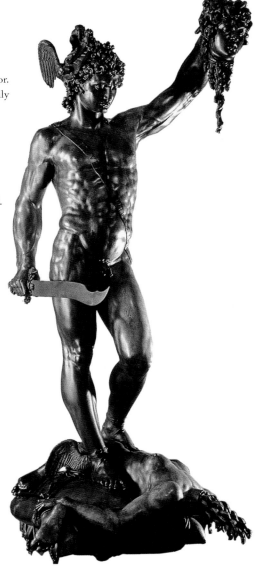

Correggio, *Saint Anthony of Padua*, presumed self-portrait, detail of *Madonna with Saint Francis*, 1514–15. Dresden, Gemäldegalerie.

Correggio

Antonio Allegri da Correggio **(Correggio 1489–1534 Parma)**

In all likelihood he completed his training (begun in Parma) in Mantegna's Padua workshop. His style displayed particularly delicate nuances of tone and softness of the flesh of his subjects. He showed the full maturity of his talent (perhaps after having visited Rome in 1519), when he painted astounding pergola frescoes for the ceiling vault of the *Camera di San Paolo* (in actual fact the abbess's private dining room) in the Convent of San Paolo, in Parma. This commission was followed by the decorations for the dome of San Giovanni Evangelista (1520–23) and the cathedral (1526–29), where he made use of open-air, illusionistic backgrounds. The evocative delicacy of his style was ideal for the representation of strong emotion, whether displays of tenderness or mystic ecstasy in religious works (*Martyrdom of Four Saints*, 1524–26; *Madonna della Scodella* [Madonna with a Bowl], 1529–30), or a certain sensuality in mythological scenes (*Loves of Jupiter*, c. 1529). These qualities may have isolated him from the other formal developments in Mannerism, though he was influential in the work of Barocci and early seventeenth-century painting in the Emilia region.

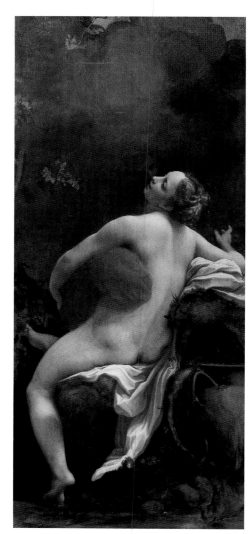

Left:
Correggio
Ego
1531, oil on canvas.
Vienna, Kunsthistorisches Museum.

Above:
Correggio
Vision of Saint John at Patmos
1520–23, fresco.
Parma, San Giovanni Evangelista.

Giambologna

Jean Boulogne, or Giovanni da Bologna (Douai 1529–1608 Florence)

Born in Flanders, Giambologna made a visit to Rome to study art (c. 1550) and on his journey home stopped over in Florence, a city he was never to leave again. He entered the service of Cosimo I (1558) and later went on to work with equal success for Francesco I and Ferdinando I. He developed his skill as a sculptor working in bronze and marble, displaying incredible talent in his daring handling of the material, and giving his figures features that seemed to change depending on one's viewpoint (*Rape of a Sabine Woman*, 1582; different versions of *Mercury*, 1565–80). He made a name for himself in the production of statues for public display (*Nettuno*, a fountain for Bologna, 1563–67), and equestrian monuments (Cosimo I, and later, with his assistants Pietro Tacca and Pietro Francavilla, *Ferdinando I, Enrico IV, Filippo III*), as well as works meant to decorate public gardens (*Appennino*, Pratolino; *Fontana di Oceano* and *Venere della Grotticella*, Boboli Gardens, 1565–75). He also produced a great many bronzes that would have a profund influence on sculpture in Europe.

Hendrik Goltzius, *Portrait of Giambologna*, 1591, chalk on paper. Haarlem, Teylers Museum.

Left:
Giambologna
Mercury
c. 1580, bronze.
Florence, Bargello.

Above:
Giambologna
Equestrian Monument to Cosimo I, detail
1594–98, bronze.
Florence, Piazza della Signoria.

Titian, *Portrait of*
Giulio Romano
1536–38, oil on canvas.

Giulio Romano
(Rome c. 1499–1546 Mantua)

After Raphael's death, Romano took over supervision of the master's workshop, and completed unfinished projects such as the decoration of Villa Madama and the frescoes in the Vatican's *Sala di Costantino*. He left Rome in 1524, and took up residence at the court of Federico Gonzaga in Mantua, where he was to exercise unrivaled dominion over the arts in his role as Prefect of the Gonzaga workshops. He was a tireless worker and made numerous plans for religious and civilian projects, paintings and sculptures, pieces of jewelry, tapestries, temporary devices, and engineering works for city improvements. All were executed by a large workshop strongly influenced by Raphael, but the other artists were for the most part modest talents who would have cast no shadow on the master's skill. Among his most significant works are the now lost Marmirolo Villa, Palazzo Te, the Troy apartment and cavalry parade in the ducal palace, the refurbishment of the Mantua cathedral, the abbey of San Benedetto Po, and the artist's own home.

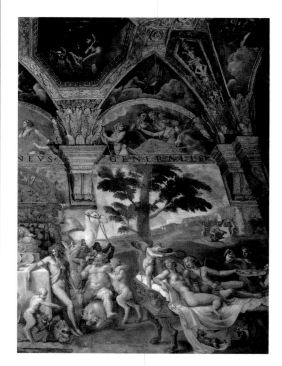

Giulio Romano
Hall of Love and Psyche
wall detail
c. 1528, fresco.
Mantua, Palazzo Te.

Giulio Romano
The Wedding Feast of
Cupid and Psyche
ceiling detail
1528–29, fresco.
Mantua, Palazzo Te.

Facing page:
El Greco
Laocoonte
c. 1610, oil on canvas.
Washington, National
Gallery of Art, Samuel H.
Kress Collection, 1946.

El Greco

Doménicos Theotokópoulos (Candia, Crete 1541–1614 Toledo)

He began his career in Crete as a painter of icons, and arrived in Venice towards the end of the 1560s. Although he was more receptive to the approach employed by Tintoretto, in 1570 Giulio Clovio introduced him to Cardinal Alessandro Farnese as "a young man from Candia, a disciple of Titian." It was during this period that he produced different versions of *Christ Restoring Sight to the Blind Man* and *Christ Driving the Merchants from the Temple*, and an early nocturnal work, *Youth Blowing on a Burning Coal*. He is recorded as being in Toledo from 1577 (*El Espolio*), and tried unsuccessfully to enter the service of Philip II (*The Dream of Philip II*, 1577–79, and the *Martyrdom of Saint Maurice*, 1580–82). Despite the sovereign's refusal, El Greco still included an image of the king among the blessed in his masterpiece, *The Burial of Count Orgáz* (1586–88). El Greco's career in Spain was spent entirely in the religious capital, Toledo, where he carried out a number of commissions for the clergy and local humanists, including devotional paintings and portraits executed in an astounding and incomparable visionary style.

El Greco, *Self-Portrait*, detail c. 1600. New York, Metropolitan Museum.

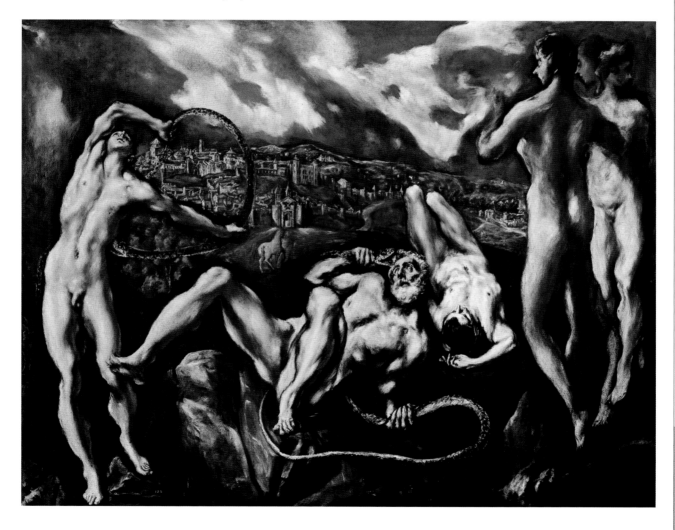

Michelangelo, *Presumed Self-Portrait as Nicodemus*, detail of the *Pietà Rondanini* c. 1555. Florence, Museo dell'Opera del Duomo.

Michelangelo Buonarroti

Michelangelo di Lodovico Buonarroti Simoni, or Michelangelo (Caprese, Arezzo 1475–1564 Rome)

Michelangelo may well have been considered the incarnation of the universal artist, but he thought of himself first and foremost as a sculptor. His first works were in marble (*Battle of the Centaurs*, c. 1492), and marble was to be the medium for the consecration of his talent (*Pietà*, Saint Peter's, 1498–99; *David*, 1501–04). In 1504 he was summoned to paint the fresco of the *Battle of Cascina* in Palazzo della Signoria, and although Pope Julius II originally called Michelangelo to Rome in 1505 to work on the Pope's funeral monument, he gave the artist the task of painting the ceiling of the Sistine Chapel (1508–12); Pope Paul III would later commission him to paint the *Last Judgment* (1534–41). During different stays in Florence he worked for the Medici family in San Lorenzo. In the last decades of his life in Rome, he worked for the most part on architectural projects (Piazza del Campidoglio, 1538–52; Saint Peter's Basilica, 1546–64), while his many poems, sketches, and sculptures show that he meditated deeply on religious issues (*Pietà Rondanini*, c. 1555).

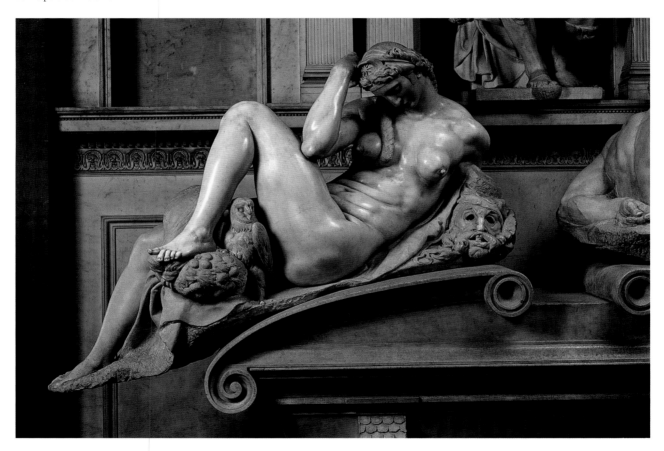

Michelangelo
Night
1526–34, marble.
Florence, San Lorenzo,
Sagrestia Nuova.

Parmigianino

Girolamo Francesco Maria Mazzola (Parma 1503–1540 Casalmaggiore, Parma)

Born into a family of painters from Parma, Parmigianino was a precocious talent and was receptive to Correggio's style, which he interpreted with Mannerist elegance. After his frescoes for the bed chamber of Paola Gonzaga (Rocca di Fontanellato), and the portrait of her husband Galeazzo Sanvitale, Parmigianino went to Rome in 1524, and took his *Self-Portrait in a Convex Mirror* as a kind of calling card (today in the Kunsthistorisches Museum, Vienna). He was inspired by the work of Raphael and was indeed considered by many to be Raphael's successor because of his grace, freshness, and reliability. He was working on the *Vision of the Saint Jerome*, when the city was shaken by the Sack of Rome (1527) and fled to Bologna, where he painted a number of religious works. He returned to Parma in 1530, but found it increasingly difficult to complete his commissions (*Madonna of the Long Neck*, 1534–39; frescoes for the church of Santa Maria della Steccata, 1531–39), as he was distracted by his studies of alchemy, which "almost turned him into a savage" (Vasari).

Parmigianino, *Self-Portrait in a Convex Mirror*, detail 1523–24. Vienna, Kunsthistorisches Museum.

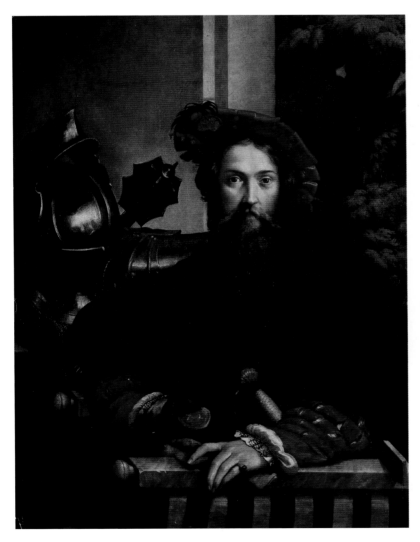

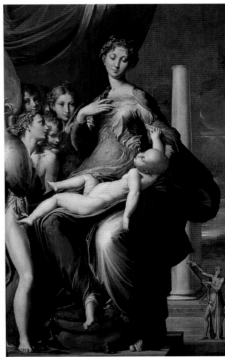

Left:
Parmigianino
Portrait of Galeazzo Sanvitale
1524, oil on wood panel.
Naples, Capodimonte.

Above:
Parmigianino
Madonna With the Long Neck
c. 1534–39, oil on wood panel.
Florence, Uffizi Gallery.

Pontormo
Study for a Self-Portrait
1516, red chalk on paper.
Florence, GDSU

Pontormo

Jacopo Carucci **(Pontorme, Empoli 1494–1556 Florence)**

In Florence, as part of Andrea del Sarto's workshop, he took part in the decoration of the Annunziata church cloister (*Visitation*, 1514–16), and the Borgherini bed chamber (*Stories from the Life of Joseph*, 1515–19), but he soon moved away from the classically balanced compositions of his master, as can be seen in the *Pala Pucci* altarpiece (San Michele Visdomini, 1518). His style, with distinctive suspended figures and unpredictable rhythms, reached full maturity in the 1520s (*Passion*, Galluzzo, 1522–24; *Deposition*, Santa Felicità, 1525–28; *Visitation*, Carmignano, c. 1528). He was an excellent portraitist and enjoyed the protection of the Medici family, who commissioned him to decorate their villas (*Vertunno e Pomona*, Poggio a Caiano, 1519–21; the lost cycles painted at Careggi, 1535–36, and Castello, 1537–43). He dedicated the last ten years of his life to the frescoes commissioned by Cosimo I for San Lorenzo. Vasari had very little fellow feeling towards Pontormo and criticized the artist for his solitary character and eccentric forms.

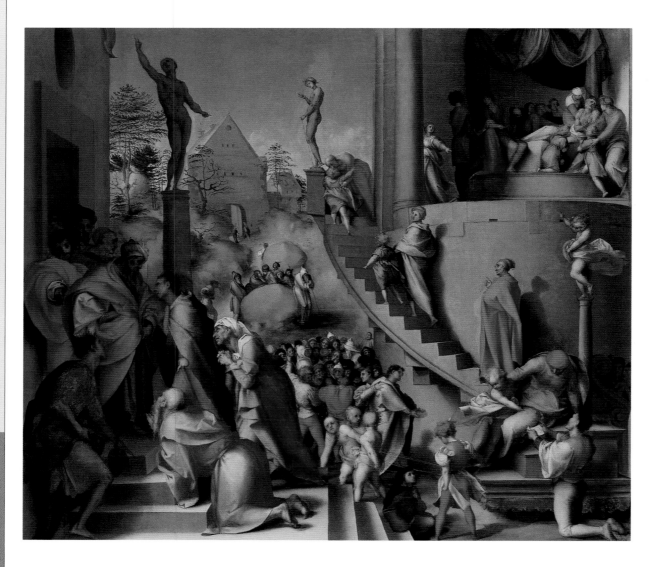

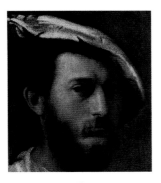

Primaticcio, *Self-Portrait*
c. 1525–30, oil on canvas.
Florence, Uffizi Gallery.

Francesco Primaticcio
(Bologna 1504–1570 Paris)

From 1526 he was part of Giulio Romano's workshop in Mantua (the only artist of any real talent), before joining the court of Francis I in 1532. He worked alongside Rosso Fiorentino (on separate commissions) on the decorations for the royal palace at Fontainebleau. He took over supervision of the project after Rosso Fiorentino's death, replicating the organizational approach he had learned in Mantua, and assisted by artists such as Niccolò dell'Abate who joined him in 1552 and Germain Pilon. Very little now remains of his extensive decorative endeavors (the chamber of the Duchesse d'Étampes, 1541–44; the ruined Ballroom, 1552–56), which are however recorded in numerous sketches. He took advantage of various stays in Italy (1540, 1542, 1546) to obtain molds of famous classical statues from which he cast bronzes. Under the regency of Catherine de' Medici, he was placed charge of the Royal Workshops. He experimented as an architect (a wing of the *Belle cheminée*, Fontainebleau), and designed the tomb of Henri II for the basilica of Saint-Denis.

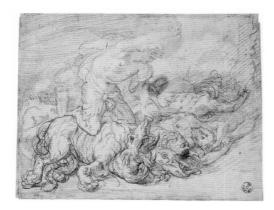

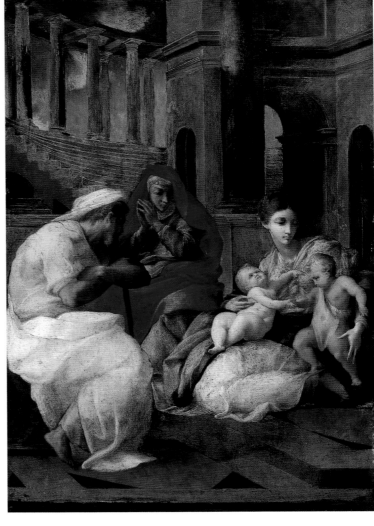

Above:
Primaticcio
*Cadmus Killing the
Dragon Guarding the
Fountain of Mars*
1541–44, red and black
pencil.
Florence, GDSU, 475F.

Right:
Primaticcio
*The Holy Family with
Saint Anne and the
Infant Saint John*
c. 1541–43, oil on slate.
Saint Petersburg,
Hermitage.

Facing page:
Pontormo
Joseph in Egypt
1518–19, oil on wood panel.
London, National Gallery.

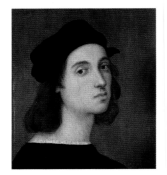

Raphael, *Self-Portrait*
c. 1506, tempera on wood panel.
Florence, Uffizi Gallery.

Raphael
Raffaello Sanzio (Urbino 1483–1520 Rome)

Raphael was the son of painter Giovanni Santi, and in his early work he showed an affinity with Perugino (*Wedding of the Virgin*, 1504). Later, in Florence, he would absorb the style of Leonardo da Vinci (*Madonna with Goldfinch*, 1506), as well as adopting some elements from the work of Michelangelo (*Deposition of Christ*, 1507). He returned to Rome in 1508, as much a rival to Michelangelo as he was an imitator, as can be seen in the decorations for the *Stanza della Segnatura* (1509–11). During the papacy of Leo X, Raphael was the leading figure on Rome's artistic stage, working both on major papal commissions (the *Stanza di Eliodoro* and the *Stanza dell'Incendio al borgo*, 1511–17; cartoons for tapestries in the Sistine Chapel, 1515; the Vatican Loggias, 1517–19; the site of Saint Peter's, 1514–20) and prestigious private commissions for the wealthy banker Agostino Chigi, Giulio de' Medici, or King Francis I. He was a keen student of antiquity and was made superintendent of excavations in 1515; he was working on compiling a map of ancient Rome when he died in 1520.

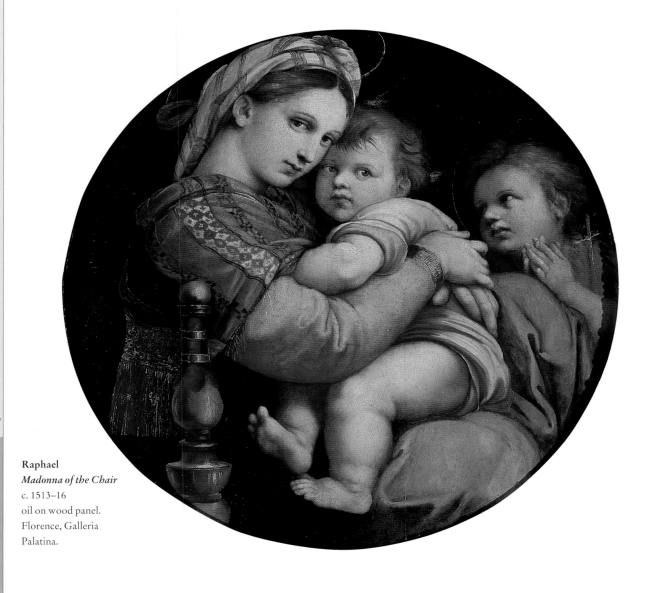

Raphael
Madonna of the Chair
c. 1513–16
oil on wood panel.
Florence, Galleria
Palatina.

Portrait of Rosso Fiorentino etching from Giorgio Vasari's *Lives*, Edizione Giuntina. Florence 1568.

Rosso Fiorentino

Giovanni Battista di Jacopo (Florence 1495–1540 Fontainebleau)

Rosso Fiorentino trained in Andrea del Sarto's circle, but like Pontormo he shared the polemical shift away from Florentine tradition which led him to develop a sharp-edged figurative idiom that was not without a hint of violence (*Deposition of Christ*, Volterra). Present in Rome in 1524, he began to soften his style, rendering it more sensual, after coming into contact with Perin del Vaga and Parmigianino (*Christ Borne Aloft by Angels*). Forced to flee because of the Sack of Rome, he took refuge in Borgo San Sepolcro (*Deposition of Christ*, 1528) and Città di Castello, before heading for Venice in 1530, where he was a guest of Aretino, who sent one of his drawings to the French court (Mars and Venus) and secured an introduction to Francis I. Rosso Fiorentino became court painter at Fontainebleau, but the only remaining work of his many decorative projects is the Gallery of Francis I, which played a major role in spreading the Mannerist style in France. He designed a number of pieces of jewelry for the king, as well as masks and temporary structures for court celebrations. According to Vasari, he committed suicide in 1540.

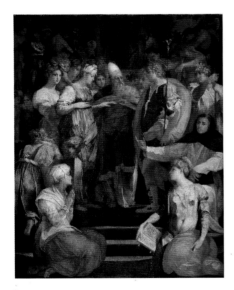

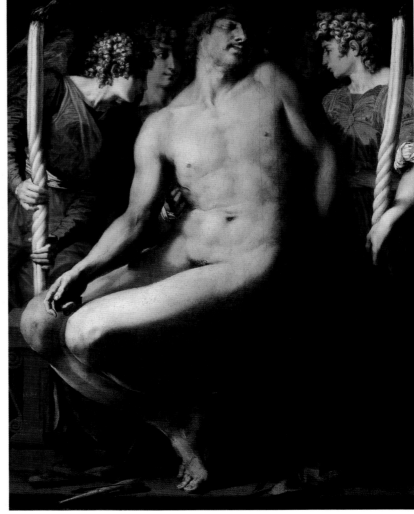

Rosso Fiorentino
Marriage of the Virgin
1523, oil on wood panel. Florence, San Lorenzo.

Right:
Rosso Fiorentino
Dead Christ Borne Aloft by Angels
1525–26, oil on wood panel. Boston, Museum of Fine Arts.

Jacopo Sansovino

Jacopo d'Antonio Sansovino **(Florence 1486–1570 Venice)**

He took the name of the sculptor Andrea Sansovino, with whom he trained in Florence and Rome (1502–11), while he learned about architecture from Giuliano da Sangallo. His early career was spent between Rome and Florence, restoring classical statues and carving marble statues in an ancient style (*Bacchus*, c. 1511; *Madonna del parto*, c. 1518). He was less successful in his attempts to work as an architect, hindered by the hegemony of Michelangelo, Raphael, and Antonio da Sangallo the Younger. In the wake of the Sack of Rome, he fled to Venice, where he entered into a long-lasting association with Titian and Aretino. In 1529 he was designated chief architect and superintendent of the properties by the Procurators of Saint Mark's, and in this role he had a significant impact on the modernization of the city's political center, supervising the construction of a number of buildings around Saint Mark's Square, including the Libreria (1536–60), the Loggetta (1537–60), the Zecca (Public Mint, 1535–47), and the monumental steps *Scala d'Oro* and *Scala dei Giganti* (1557–58).

Tintoretto, *Portrait of Jacopo Sansovino*
c. 1566, oil on canvas.
Florence, Uffizi Gallery.

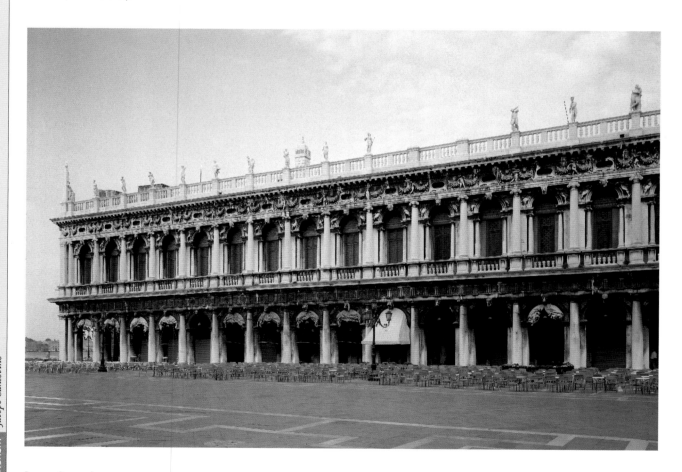

Jacopo Sansovino
Libreria Marciana
1536–60.
Venice, Piazza San Marco.

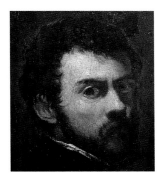

Tintoretto, *Self-portrait*, detail c. 1548, oil on canvas. London, Victoria and Albert Museum.

Tintoretto

Jacopo Comin, or Jacopo Robusti (Venice 1518–1594)

Tintoretto was briefly a pupil of Titian, but was also open to the figurative models of Mannerism. He first made a name for himself on the Venetian scene with his provocative *Miracle of Saint Mark* or *Miracle of the Slave* (1547), which heralded a pictorial ideal in keeping with the definition of Paolo Pino, the union of Titian's use of color with Michelangelo's compositional style. With the "rage" and "ready" energy of his particular style, he created powerfully rhythmical compositions with a daring and ambitious handling of perspective, making use of spectacular visual and lighting effects which he first studied using wax models. These explorations into new forms dismayed Vasari, who condemned Tintoretto for his "new and capricious inventions and the strange extravagances produced by his creativity, which [had] worked without order or plan." He was a prolific artist and his production is linked mostly with Venice and the city's confraternities and guilds, which commissioned many of Venice's most acclaimed cycles from him, such as the *Stories from the Life of Saint Mark*, executed for the Grande Scuola di San Marco (1547, 1562–66) and the decoration of the Scuola di San Rocco (1564–1588).

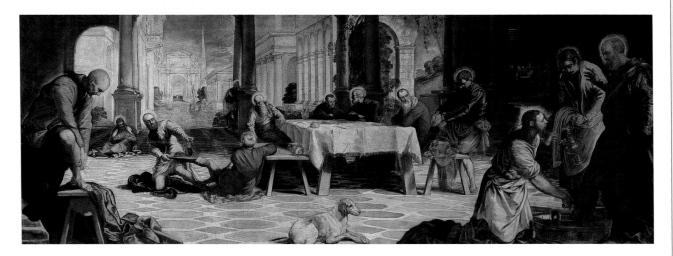

Above:
Tintoretto
The Maundy Thursday (Christ Washing the Feet of His Disciples)
1547, oil on canvas.
Madrid, Prado.

Right:
Tintoretto
Saint Catherine Series, Flogging
1580–85, oil on canvas.
Venice, Palazzo Patriarcale.

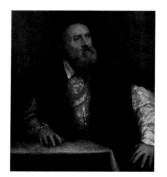

Titian, *Self-Portrait*
c. 1550–62, oil on canvas.
Berlin, Gemäldegalerie.

Titian
Tiziano Vecellio (Pieve di Cadore 1480/1485–1576 Venice)

Pupil of Giovanni Bellini and assistant to Giorgione, he affirmed his own talent with the magnificent *Frari Assumption* (1518). As early as 1517, he enjoyed a certain prestige in "La Serenissima," the Most Serene Republic of Venice, which gave the freedom him to work for distant, and influential, rulers, such as the d'Este (*Baccanali*, 1518–24), the Gonzaga (*Cesari*, 1538–40), the Della Rovere (*Urbino Venus*, 1538), and the Farnese (*Danae*, 1545). His major patron was Emperor Charles V (*Equestrian Portrait*, 1548), followed by the emperor's son, Philip II (Poesie, "Poems," 1554–62). Titian's exceptional command of color was acknowledged as having "miraculous" evocative powers, seen in the intense emotion of the religious works, the fleshy sensuality of the mythological pieces, and in the vivid brushstrokes of his portraiture. It was because of his particular use of "natural" color that Titian found himself involved in the debate over "maniera," style or manner, in opposition to Michelangelo's "intellectual" approach to composition. However, Titian did adopt, if only for a short time, a number of Mannerist elements in the 1540s (*Christ Crowned with Thorns*; the ceiling of Santo Spirito in Isola, 1544).

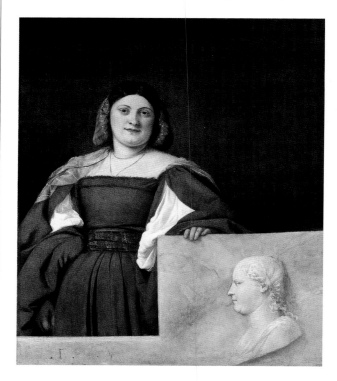

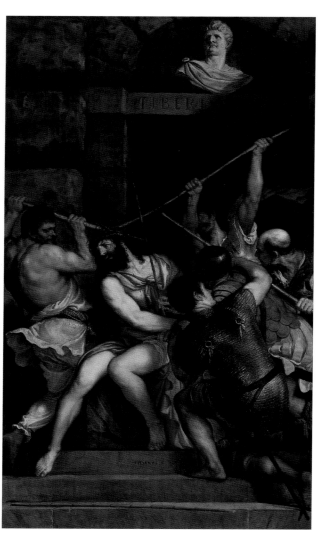

Titian
Portrait of a Lady
(La Schiavona)
c. 1511, oil on canvas.
London, National
Gallery.

Right:
Titian
Crowning with Thorns
1542–44, oil on canvas.
Paris, Louvre.

Giorgio Vasari
(Arezzo 1511–1574 Florence)

For better or worse, Vasari must be considered the "father" of art history, thanks to his *Lives*, published in 1550 and revised in 1568. In this collection of biographies, Vasari traced the evolution of art through the course of three "ages," from an admittedly partial Tuscan viewpoint, from the start of the "rebirth" with Giotto and Cimabue, to the soaring heights achieved by the incomparable Michelangelo. The second edition included prints, living artists, and his own auto-biography, as Vasari was also a painter of some success. After his formative years in Tuscany, his career took him to Bologna (1530, 1539), Venice (1542), Rome (*Sala dei Cento Giorni*, Palazzo della Cancelleria, 1546), and Naples, before Cosimo I summoned him to Florence in 1554. Vasari supervised the wide-ranging project to decorate the Palazzo Vecchio (1555–73). During the same period he contributed to founding the "Accademia delle arti del disegno" (1563) and participated in organizing the funeral service for Michelangelo.

Giorgio Vasari, *Self-Portrait*
c. 1566–68, oil on canvas.
Florence, Uffizi Gallery.

Left:
View of the Corridoio Vasariano in the section that connects Lungarno degli Archibusieri to Ponte Vecchio.

Above:
Giorgio Vasari the Younger
Design for the Southern Block of the Uffizi
conceived by Giorgio Vasari. Florence, GDSU.

BIBLIOGRAPHY

SOURCES

– Leon Battista ALBERTI, *La Peinture. Texte latin, traduction française, version italienne* (*De Pictura*, 1435; *Della Pittura*, 1436), edited by Thomas Golsenne and Bertrand Prévost,Seuil, Paris 2004.

– Leon Battista ALBERTI, *L'architecture* (*De Re Aedificatoria*), edited by Giovanni Orlando and Paolo Portoghesi, Polifilo, Milano 1966.

– Pietro ARETINO, *Lettere sull'arte*, edited by Fidenzio Pertile and Ettore Camesasca, Milione, Milano 1957-1960.

– Giovanni Battista ARMENINI, *De' veri precetti della pittura* (Ravenna 1586), edited by Marina Gorreri, Einaudi, Torino 1988.

– Raffaele BORGHINI, *Il Riposo* (Firenze 1584), edited by Mario Rosci, Labor, Milano 1967.

– Baldassare CASTIGLIONE, *Il libro del cortegiano* (Venezia-Firenze 1528), edited by Amedeo Quondam and Nicola Longo, Garzanti, Milano 1992.

– Benvenuto CELLINI, *La vita*, edited by Guido Davico Bonino, Einaudi, Torino 1982.

– Cennino CENNINI, *Il libro dell'arte*, edited by Antonio P. Torresi, Liberty House, Ferrara 2004.

– Albrecht DURER, *Underweysung der Messungmit dem Zirkel und Richtscheyt, in Linien, ebenen und gantzen Corporen*, Nürnberg 1525.

– FILARETE (Antonio AVERULINO), *Trattato di architettura*, edited by Anna Maria Finoli and Liliana Grassi, Polifilo, Milano 1972.

– Pomponio GAURICO, *De sculptura* (1504), edited by André Chastel and Robert Klein, Droz, Genève 1969.

– Lorenzo GHIBERTI, *I commentarii*, edited by Ottavio Morisani, Ricciardi, Napoli 1947

– Lorenzo GHIBERTI, *I commentarii*, edited by Lorenzo Bartoli, Giunti, Firenze 1998.

– Francisco de HOLLANDA, *Diàlogos em Roma*, edited by Grazia Dolores Folliero-Metz, Winter, Heidelberg 1999 (Italian translation by Antonietta Maria Bessone Aurelj, *I dialoghi michelangioleschi di Francisco d'Olanda*, Successori Loescher, Roma 1926).

– LEONARDO da VINCI, *Libro di pittura*, edited by Carlo Pedretti, Giunti, Firenze 1995.

– Giovanni Paolo LOMAZZO, *Scritti sulle arti*, edited by Roberto Paolo Ciardi, Centro Di, Firenze 1973-1974.

– Karel van MANDER, *The Lives of the Illustrious Netherlandish and German Painters, from the First Edition of the "Schilder-boeck"* (1603-1604), edited by Hessel Miedema, Davaco, Doornspijk 1994.

– Francesco di Giorgio MARTINI, *Trattato di architettura*, edited by Pietro C. Marani, Giunti, Firenze 1994.

– Andrea PALLADIO, *I Quattro Libri dell'Architettura* (Venezia 1570), edited by Erik Forssman, Olms, Hildesheim 1999.

– Piero della FRANCESCA, *De Prospectiva pingendi*, edited by Giusta Nicco-Fasola, with additions by Eugenio Battisti, Le Lettere, Firenze 1984.

– *Scritti d'arte del Cinquecento*, edited by Paola Barocchi, Einaudi, Torino 1971.

– Sebastiano SERLIO, *Tutte l'opere d'architettura e prospettiva* (Venezia 1619), Gregg Press, Ridgewood, N. J. 1964.

– *Trattati d'arte del Cinquecento. Fra Manierismo e Controriforma*, edited by Paola Barocchi, Laterza, Bari 1960-1962.

– Giorgio VASARI, *Le Vite de' piùeccellenti pittori, scultori e architettori nelle redazioni del 1550 e del 1568*, edited by Rosanna Bettarini and Paola Barocchi, 7 vol., Spes, Firenze 1966-1987.

– Jacopo BAROZZI da VIGNOLA, *Regola delli cinque ordini d'architettura* (Rome 1562), edited by Christoph Thoenes, Cassa di Risparmio di Vignola, Vignola 1974.

– Federico ZUCCARI, *L'idea de' scultori, pittori e architetti* (1607), edited by Detlef Heikamp, Olschki, Firenze 1961.

GENERAL WORKS

– Frederick ANTAL, *Florentine Painting and Its Social Background*, 1948 (Italian edition, Einaudi, Torino 1960).

– Daniel ARASSE, *L'Annonciation italienne. Une histoire de perspective*, Hazan, Paris 1999.

– Daniel ARASSE and Andreas TONNESMANN, *La Renaissance Maniériste*, Gallimard, Paris 1997.

– Eugenio BATTISTI, *L'Antirinascimento*, Garzanti, Milano 1989.

– Michael BAXANDALL, *Giotto and the Orators: Humanist Observers of Painting in Italy and the Discovery of Pictorial Composition*, 1971 (Italian edition, Jaca Book, Milano, 1994).

– Michael BAXANDALL, *Painting and Experience in Renaissance Italy*, 1972 (Italian edition, Einaudi, Torino 1978).

– Hans BELTING, *Bild und Kult. Eine Geschichte des Bildes vor dem Zeitalter der Kunst*, C. H. Beck'sche Vlg, München 1990.

– Jan BIALOSTOCKI, *Il Quattrocento nell'Europa settentrionale*, Utet, Torino 1989.

– Anthony BLUNT, *Artistic Theory in Italy, 1450–1600*, II ed., Oxford University Press, London 1956.

– Ferdinando BOLOGNA, *Napoli e le rotte del Mediterraneo della pittura da Alfonso il Magnanimo a Ferdinando il Cattolico*, Società Napoletana di Storia Patria, Napoli 1977.

– Giuliano BRIGANTI, *La Maniera italiana*, Sansoni, Firenze 1985.

– Jacob BURCKHARDT, *La civiltà del Rinascimento in italia* (1860), edited by Eugenio Garin, Sansoni, Firenze 1974.

– Peter BURKE, *The Italian Renaissance. Culture and Society in Italy*, Polity Press, Cambridge 1987.

– Lorne CAMPBELL, *Renaissance Portraits. European Portrait Painting in the 14th, 15th, and 16th Centuries*, Yale University Press, New Haven–London 1990.

– David S. CHAMBERS, *Patrons and Artists in the Italian Renaissance*, Macmillan, London 1970.

– André CHASTEL, *Art et Humanisme à Florence au temps de Laurent le Magnifique*, PUF, Paris 1961 (Italian edition, Einaudi, Torino 1964).

– André CHASTEL, *Le Grand Atelier. Italie 1460–1500*, Gallimard, Paris 1965 (Italian edition, Rizzoli, Milano 1966).

– André CHASTEL, *Il sacco di Roma. 1527*, Einaudi, Torino 1983.

– Fernando CHECA, *Felipe II. Mecenas de las artes*, Nerea, Madrid 1992.

– Fernando CHECA, *Pintura y escultura del Renacimiento en España*, Ediciones Cátedra, Madrid 1993.

– Alison COLE, *Virtue and Magnificence. Art of the Italian Renaissance Courts*, Calmann and King, London 1995.

– Janet COX-REARICK, *Chefs-d'oeuvre de la Renaissance. La collection de François Ier*, Albin Michel, Paris 1995.

– Hubert DAMISCH, *L'origine de la perspective*, Flammarion, Paris 1987.

– Patricia FALGUIERES, *Le Maniérisme. Une avant-garde au XVIe siècle*, Gallimard, Paris 2004.

– Sydney J. FREEDBERG, *Painting in Italy, 1500–1600*, 1971 (Italian edition, Nuova Alfa Editoriale, Bologna 1988).

– Walter FRIEDLAENDER, *Mannerism and Anti-Mannerism in Italian Painting*, Columbia University Press, New York 1957.

– Eugenio GARIN, *La cultura del Rinascimento*, Il Saggiatore, Milano 1968.

– Rona GOFFEN, *Renaissance Rivals. Michelangelo, Leonardo, Raphael, Titian*, Yale University Press, New Haven–London 2002.

– Ernst H. GOMBRICH, *Norm and Form: Studies in the Art of Renaissance*, 1966 (Italian edition, Einaudi, Torino 1973).

– Ernst H. GOMBRICH, *The Heritage of Apelles: Studies in the Art of Renaissance*, 1976 (Italian edition, Einaudi, Torino 1986).

– Craig HARBISON, *The Art of the Northern Renaissance*, Wiedenfeld and Nicolson, London 1995.

– Michel HOCHMANN, *Venise et Rome. 1500–1600. Deux écoles de peinture et leurs échanges*, Droz, Genève 2004.

– Peter HUMPHREY, Martin KEMP, eds. *The Altarpiece in the Renaissance*, Cambridge University Press, Cambridge–New York, 1990.

– Thomas DACOSTA KAUFFMANN, *L'école de Prague. La peinture à la cour de Rodolphe II*, Flammarion, Paris 1985.

– Martin KEMP, *The Science of Art*, 1990 (Italian edition, Giunti, Firenze 1994 & 2005).

– Robert KLEIN, *La forme et l'intelligible. Ecrits sur la Renaissance et l'art moderne*, Gallimard, Paris 1970.

– Julian KLIEMANN, *Gesta dipinte. La grande decorazione delle dimore Italiane dal Quattrocento al Seicento*, Silvana editoriale, Milano 1993.

– Paul Oskar KRISTELLER, *Renaissance Thought and Its Sources*, 1965 (Italian edition, La Nuova Italia, Firenze 1975).

– Rennsselaer W. LEE, *Ut Pictura Poesis. The Humanistic Theory of Painting*, 1940 (Italian edition, Sansoni, Firenze 1974).

– Julius Schlosser MAGNINO, *Die Kunstlitteratur*, 1924 (Italian edition, La Nuova Italia, Firenze 1935).

– Charles McCORQUODALE, *Rinascimento. I pittori e le opere*, Giunti, Firenze 1995.

– Philippe MOREL, *Les grotesques. Les figures de l'imaginaire dans la peinture italienne de la fin de la Renaissance*, Flammarion, Paris 1997.

– Paula NUTTAL, *From Flanders to Florence. The Impact of Netherlandish Painting, 1400–1500*, Yale University Press, New Haven–London 2004.

– *Officina della Maniera*, exhibition catalog (Florence, Uffizi Gallery), edited by Alessandro Cecchi, Antonio Natali, Carlo Sisi, Marsilio, Venezia 1996.

– Erwin PANOFSKY, *Idea*, 1924 (Italian edition, La Nuova Italia, Firenze 1952).

– Erwin PANOFSKY, *Die Perspective als "symbolische Form,"* 1927 (Italian edition, Feltrinelli, Milano 1966).

– Erwin PANOFSKY, *Early Netherlandish Painting: Its Origin and Character*, Harvard University Press, Cambridge, MA 1953.

– Erwin PANOFSKY, *Renaissance and Renascences in Western Art*, 1960 (Italian edition, Feltrinelli, Milano 1971).

– Antonio PINELLI, *La Bella Maniera. Artisti del cinquecento tra regola e licenza*, Einaudi, Torino 1993.

– *La Pittura in Italia. Il Quattrocento*, edited by Federico Zeri, 2 vols., Electa, Milano 1987.

– *La Pittura in Italia. Il Cinquecento*, edited by Giuliano Briganti, 2 vols., Electa, Milano 1988.

– John POPE-HENNESSY, *Italian Renaissance Sculpture*, Phaidon, New York 1985.

– *El Renacimiento Mediterráneo. Los viajes de artistas e itinerarios de obras entre Italia, Francia y España en el Siglo XV*, exhibition catalog (Madrid–Valencia), edited by Mauro Natale, Museo Thyssen-Bornemisza, Madrid 2001.

– *Il Rinascimento a Venezia e la pittura del Nord ai tempi di Bellini, Dürer, Tiziano*, exhibition catalog (Venezia, Palazzo Grassi), edited by Bernard Aikema, Beverly Louise Brown, and Giovanna Nepi Scirè, Bompiani, Milano 1999.

– David ROSAND, *Painting in Cinquecento Venice: Titian, Veronese, Tintoretto*, Yale University Press, New Haven–London 1982.

– Jean SEZNEC, *The Survival of the Pagan Gods*, 1953 (Italian edition, Boringhieri, Torino 1980).

– John SHEARMAN, *Mannerism*, 1967 (Italian edition, Spes, Firenze 1983).

– John SHEARMAN, *Only Connect. Art and the Spectator in the Italian Renaissance*, 1992 (Italian edition, Jaca Book, Milano 1995).

– Craig Hugh SMYTH, *Mannerism and Maniera* (1962), Irsa, Wien 1992.

– Manfredo TAFURI, *L'architettura del Manierismo nel Cinquecento Europeo*, Officina ed., Rome 1966.

– Manfredo TAFURI, Ricerca del Rinascimento. Principi, città, architetti, Einaudi, Torino 1992.

– *Da Tiziano a El Greco. Per la storia del Manierismo a Venezia (1540–1590)*, exhibition catalog (Venezia), edited by Rodolfo Pallucchini and Stefania Mason Rinaldi, Electa, Milano 1981.

– Aby WARBURG. The Renewal of Pagan Antiquity, edited by Kurt W. Forster, The Getty Research Institute, Los Angeles 1999.

– Martin WARNKE, Hofkünstler. Zur Vorgeschichte des modernen Künstlers, 1985 (Italian edition, Istituto della Enciclopedia Italiana, Roma 1991).

– John WHITE, The Birth and Rebirth of Pictorial Space, 1957 (Italian edition, Il Saggiatore, Milano 1971).

– Margot and Rudolf WITTKOWER, Born under Saturn. The Character and Conduct of Artists, 1960 (Italian edition, Einaudi, Torino 1988).

– Rudolf WITTKOWER, Architectural Principles in the Age of Humanism, 1962 (Italian edition, Einaudi, Torino 1964).

– Henri ZERNER, L'art de la Renaissance en France. L'invention du classicisme, Flammarion, Paris 1996.

INDEX OF NAMES

Note: Page numbers in *italics* include references to captions, and **bold** page numbers include biographical sketches.

INDEX OF OF PLACES

Note: Page numbers in *italics* include references to captions.

Index